EVERYTHING YOU EVER WANTED TO KNOW ABOUT
OIL PAINTING

EVERYTHING YOU EVER WANTED TO KNOW ABOUT
OIL PAINTING

EDITED BY
MARIAN APPELLOF

WATSON-GUPTILL PUBLICATIONS
NEW YORK

For Ernie

Thanks must go first to all of the artists who graciously agreed to have their work included in this book; their enthusiasm for the project was a constant encouragement. I'd also like to thank my colleagues Mary Suffudy, Sharon Kaplan, and Ellen Greene for their unstinting support (and patience), as well as Lauren Shanahan and Michael Shilling for their help with logistics.

I wish to thank Deborah Short and Mary Beth Brewer for their always wise counsel, and Dan, Mike, Rick, Chris, Trixi, and Abby for providing asylum.

Last but not least, Jay Anning deserves special thanks, not just for making this book come together smoothly and efficiently, but for the skill, intelligence, fun, and generous spirit he brings to work every day.

Cover illustration:
APPLES, FLOWERS, AND BOTTLES (DETAIL)
by Alfred C. Chadbourn. Oil, 30 x 30" (76 x 76 cm), private collection.

Copyright © 1993 by Watson-Guptill Publications

First published in 1993 in New York by Watson-Guptill Publications,
a division of VNU Business Media, Inc., 770 Broadway, New York, NY 10003
www.watsonguptill.com

Library of Congress Cataloging-in-Publication Data

Everything you ever wanted to know about oil painting / edited by Marian E. Appellof.
 p. cm.
 Includes index.
 ISBN 0-8230-1606-4 : (pbk.)
 1. Painting—Technique. I. Appellof, Marian E.
ND1500.E93 1993
751.45—dc20 93-32224
 CIP

Manufactured in Japan

9 10 11 12 / 06 05 04 03 02

Text set in Goudy Oldstyle
Designed by Jay Anning
Graphic production by Ellen Greene

CONTENTS

Landscape Painting

Figure and Portrait Painting

Still Life

Index 254

INTRODUCTION

Oil painting as we know it today has existed at least since the early fifteenth century, when Flemish artists such as Jan van Eyck and Rogier van der Weyden were making technical inroads that allowed them to produce works characterized by unparalleled richness of color and depth of tone. Since that time, no other medium has had the enduring appeal of oil. Perhaps, then, it's no coincidence that the most influential paintings in the history of art were executed in oil paints.

With oil paints, you can achieve both transparent and opaque effects; pile paint on thickly to create heavy impasto or float sheer veils of color over the canvas; build a composition slowly and deliberately in layers or work rapidly in a direct, expressionistic manner. In short, oil is an incredibly versatile medium that permits a broad spectrum of styles and techniques, making it suitable for many different kinds of painters and subjects. Over the centuries, as artists explored the technical possibilities of this medium, countless painting methods and materials developed. Thus, there is no one, "traditional" oil painting method, but many—and the potential for more, if you have an open mind and a willingness to experiment.

Precisely because oil painting is so multifaceted, you would be best served by learning about it not from just one teacher but from several, each with a unique viewpoint to share. For the more styles and approaches you are exposed to, the more you enrich your technical knowledge and visual experience—all to the good of mastering the medium and developing your own, confident style.

Everything You Ever Wanted to Know About Oil Painting was conceived with just that idea in mind: to provide you with a well-rounded education by presenting the work and teachings of a variety of instructors who are masters of their craft. Here, in a single handy volume, you will find the collected expertise, advice, and inspired artwork of more than a dozen different artists, culled from some of the best art instruction books Watson-Guptill has ever published.

This compilation contains something for everyone, from straightforward advice about painting surfaces, pigments, and color mixing, to lessons in handling light and shadow, painting the landscape, capturing the human form, and setting up an interesting still life. The book can be used to suit different needs. You can follow it in sequence, using it as a progressive painting course, or refer to one section or page at a time to find out about a specific technique, term, or artistic principle. If, for example, you want to learn how to paint portraits and figures, you can delve into the chapter devoted to that subject, as well as glance through any of the other chapters to find figural subjects that are used to teach particular oil painting techniques.

As you read through *Everything You Ever Wanted to Know About Oil Painting* you'll discover that the various artists' approaches to the medium differ, and perhaps even conflict, but all of them are valuable. You will also naturally find yourself preferring some artists to others—but don't let that keep you from listening to and exploring what each of them has to say. The only "right" way to do something is to try the various options until you discover what works for you.

Everything You Ever Wanted to Know About Oil Painting is an invaluable reference designed to help you gain a deeper understanding of a timeless medium. With your knowledge of oil painting bolstered, you'll find the painting process immensely more satisfying—and will be well on the way to producing better, more purposeful, more expressive work.

—Marian Appellof

CONTRIBUTORS

Excerpts have been taken from the following books, listed here alphabetically by author.

Julia Ayres, *Monotype: Mediums and Methods for Painterly Printmaking.*

An award-winning artist, Julia Ayres has contributed a number of articles to *American Artist* magazine and is also the author of *Printmaking Techniques* (Watson-Guptill, 1993). She lives in Chouteau, Oklahoma. Included in the material excerpted from *Monotype* is work by Ray Ciarrochi, a New York City artist with many awards and exhibitions to his credit, and by Betty Sellars, a Tulsa, Oklahoma, printmaker.

Linda Cateura and **David A. Leffel,** *Oil Painting Secrets from a Master.*

Linda Cateura, a Brooklyn, New York, resident, is a professional writer and editor whose interest in drawing and painting led her to study at the Art Students League, where she attended classes taught by David A. Leffel. It was there that she wrote the notes that form the basis of *Oil Painting Secrets from a Master.* David A. Leffel is a prominent artist and teacher whose award-winning work has appeared in numerous exhibitions and hangs in many public and private collections. A New York City native, Leffel now lives in El Prado, New Mexico.

Alfred C. Chadbourn, *Painting with a Fresh Eye.*

Alfred C. (Chip) Chadbourn was born in Turkey and studied art in Los Angeles and Paris. His paintings are included in many museums nationwide, as well as in numerous corporate and private collections. Chadbourn has won many prizes throughout his painting career. His home and studio are located in Yarmouth, Maine.

Michael Crespo, *How to Make an Oil Painting.*

A native of New Orleans, Michael Crespo studied art in Louisiana and New York City. He is a member of the faculty at Louisiana State University, where he teaches oil and watercolor painting. He is also the author of *Watercolor Day by Day* and *Experiments in Watercolor,* both published by Watson-Guptill.

Joseph and **Gloria Dawley,** *Seeing and Painting the Colors of Nature.*

Joseph Dawley was born in Arkansas and graduated with a degree in art from Southern Methodist University. He is a successful painter whose work appears in numerous private and public collections. Gloria Dawley, a native of Dallas, Texas, attended Lake Forest University in Evanston, Illinois. The Dawleys coauthored four previous books for Watson-Guptill. They reside in Cranford, New Jersey.

M. Stephen Doherty, *Developing Ideas in Artwork.*

M. Stephen Doherty is the editor-in-chief of *American Artist* magazine. He frequently lectures on contemporary artists, judges exhibitions, writes magazine articles, and conducts workshops. He has written or contributed to several other art books, and is most recently the author of *Business Letters for Artists* (Watson-Guptill, 1993). Doherty lives in a suburb of New York City.

Douglas R. Graves, *Figure Painting in Oil.*

Douglas R. Graves was born in Denver, Colorado, and studied art in Los Angeles and Chicago, concentrating on portrait and figure painting and drawing. He has been represented by several galleries and done commissioned portraits for Portraits, Inc., in New York. His work is included in many collections in the United States and abroad. Graves is also the author of *Drawing a Likeness* and *Drawing Portraits,* both published by Watson-Guptill. He resides in Burr Ridge, Illinois.

Albert Handell and **Leslie Trainor Handell,** *Oil Painting Workshop* and *Intuitive Composition.*

Albert Handell paints in both oil and pastel and has won numerous awards for his work. His paintings are included in many museums and public and private collections, and he has had more than thirty solo shows. His work has also been featured in various publications, including *American Artist* magazine. Handell exhibits regularly and conducts well-attended painting workshops nationwide and abroad. Leslie Trainor Handell holds degrees in history and Spanish and has devoted much of her time to writing and art. The Handells live in Santa Fe, New Mexico.

Margaret Kessler, *Painting Better Landscapes*.

Margaret Kessler specializes in painting the landscape in oil and has taught painting for more than twenty years, conducting demonstrations and workshops nationwide. She has won major awards for her work, which has been featured in such publications as *Southwest Art* and *The Artist's Magazine*. Originally from Indiana, Kessler lives in Dallas, Texas.

Gregg Kreutz, *Problem Solving for Oil Painters*.

Gregg Kreutz began his art studies at the Art Students League in New York City, where he himself subsequently taught painting. His work has won numerous honors, and has been featured in many juried exhibitions and gallery shows. Kreutz lives in New York.

Charles Le Clair, *Color in Contemporary Painting*.

Charles Le Clair's work has been the focus of more than forty one-man shows in the United States and abroad, and has been included in group shows in several major museums. He has taught at the University of Alabama, the Albright Art School in Buffalo, Chatham College in Pittsburgh, and Temple University's Tyler School of Art in Philadelphia, where he served as dean from 1960 to 1974. Le Clair is also the author of *The Art of Watercolor: Styles and Techniques*, now in its second edition, and several of his paintings are featured in *Painting Flowers* by Elizabeth Leonard; both books are published by Watson-Guptill. He resides in Philadelphia.

Elizabeth Leonard, *Painting Flowers*.

Elizabeth Leonard is an art historian who lives in New York City. She has written and edited numerous articles, essays, and books.

Peter Poskas and **J. J. Smith,** *The Illuminated Landscape*.

Peter Poskas was born in Waterbury, Connecticut, and studied at the Paier School of Art in New Haven and the University of Hartford. His paintings have been featured in numerous solo and group exhibitions at such venues as the Schmidt-Bingham and David Findlay galleries in New York City and at the William Benton Museum of Art in Storrs, Connecticut. Currently, Poskas lives and paints in Connecticut's Litchfield County. J. J. Smith, who resides in New Haven, has lectured on American art at Yale University and is the author of numerous museum publications and magazine articles on that subject. He has served as director of the Silvermine Guild in New Canaan, Connecticut, and the New Haven Historical Society, and has taught art at the university level.

Charles Reid, *Painting What You Want to See; Pulling Your Paintings Together;* and *Painting by Design*.

Charles Reid's popularity as an artist and workshop teacher is well known in the United States and abroad. He is also a best-selling author. His other books published by Watson-Guptill are *Figure Painting in Watercolor; Flower Painting in Watercolor; Portrait Painting in Watercolor;* and *Portraits and Figures in Watercolor* (in The Artist's Painting Library series). Reid lives in Connecticut.

MATERIALS & PREPARATION

Michael Crespo
Choosing Materials

The smorgasbord of oil painting supplies is vast. Racks of paint, brushes, and prestretched canvases are now available even in the local drugstore. It's a good sign that the craft is flourishing. It also signals fierce competition in the art materials business, so it pays to spend some time shopping for the best prices as you collect the various supplies you need. Despite the competition for your business from various suppliers, art materials are expensive.

Usually the best prices appear to be found in the catalogs of large mail-order establishments. The main problems—unless you live near one of these dealers—are that you must wait three weeks to a month for shipment, and you usually have to pay for that shipment. Supplies, especially pigments, can be quite heavy. It's a good idea to shop at your local art supply stores, seeking the best price for the best material. You'll find bargains from time to time, and (more importantly) you'll have a consultant who can answer your questions now and in the future, and be your spirit guide through the massive inventory of available art goods.

Brushes
One can never have too many brushes. Although you really need only a few, you won't be able to resist occasionally buying one of a new shape, size, or bristle. And as the years flow by, you'll end up with cans stuffed with well-worn veterans of countless paintings. Even the most ancient brushes, worn to the ferrule, can still carry out some task in painting.

Oil painting is best carried out with brushes of hog hair, sable, or synthetic sable. Unequivocally avoid the nylon-bristle brushes designated for acrylic painting. Also avoid cheap bargain brushes. They do not hold a suitable shape and will shed their hairs as quickly as your cat. Better brushes will make better marks and service you for many years. Spend the little extra here.

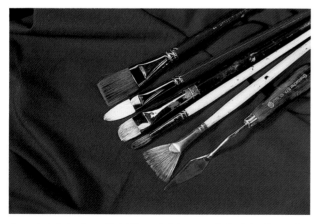

From top to bottom: flat, filbert, bright, round, fan blender, and palette knife.

Hog-bristle brushes are available in a multitude of sizes, and five basic shapes: flats, brights, rounds, filberts, and fan-shaped blenders. They have fairly stiff bristles and are the workhorses of painting. Sables, both natural and synthetic, are much softer and perform more specific tasks, such as glazing transparent colors and subtle modeling. They also come in many sizes and shapes. The synthetic sables are very popular now, and considerably less expensive than the natural sables. They are highly recommended.

The life span of a brush depends on how well you care for it. Clean your brushes after each painting session. Wipe excess paint and turpentine from the bristles and clean them with dishwashing liquid, working lather into the bristles on the palm of your hand. Rinse them in cool water, shape them, and store them bristles up in a can or jar. When transporting brushes, never carry them in a position in which the hairs could be bent and smashed. Try a bamboo place mat as a carrier; just roll your brushes up in it for protection.

Paint
There are many fine brands of paint in the marketplace; Winsor & Newton, Grumbacher, Rembrandt, and Maimeri are just a few. Most companies offer two grades: professional or artist's grade, and student grade. The less expensive student paints are diluted with more filler. This does not harm the tone or quality of the paint, just limits its tinting strength. Artist's grades are about three times stronger. Purchase what you can afford. You will have no problems down the road if you stay with a permanent palette, as suggested in the basic supply list. There are a number of fugitive colors that fade quickly, or cause cracking. You'll find lists of all colors and their behavior in any of the many books on artist's materials.

Oil paint is packaged in either tubes or jars. For convenience, tubes are recommended, either studio size (1.25 ounces) or the more economical large size (5.07 ounces).

Supports
A support is the surface on which you paint, usually canvas or a panel of wood or Masonite. Canvas, either linen or cotton, is usually stretched over a wooden frame or mounted on wood or heavy cardboard. Popular sizes of prestretched canvas are readily available, as are canvas boards, which are much less expensive. Or you may choose to stretch your own, as illustrated on page 15. Prestretched canvases and canvas boards already have a white ground of oil or acrylic gesso on them. If you decide to stretch your own, you can purchase unstretched canvas by the yard, either commercially prepared or raw. The raw canvas is easier to stretch, and afterward you can apply a ground of two coats of acrylic gesso. It will adhere best if you lightly sand between coats.

Untempered Masonite makes a permanent, inexpensive painting surface. It can be found at any lumberyard, and usually, for a small fee, someone there will cut a sheet into as many pieces and sizes as you wish. Before painting on Masonite, apply one coat of acrylic gesso to both sides to prevent the panel from warping, and an extra coat to the side you will paint on. It's up to you whether to paint on the rough or smooth side.

Paper also makes a fine, permanent support, provided it is all-rag content and primed. Tape and tack it to a board while applying two coats of acrylic gesso, so that it won't wrinkle when drying.

Palette

A palette is simply a flat, nonporous surface on which to lay out and mix your colors. Your personal working habits will determine what kind of palette suits you best. Michael Crespo recommends that your palette be white; other artists recommend a neutral, middle-value gray or brown surface. In any case, your palette should be of a tone that lets you accurately gauge your color and value mixtures. Crespo engages a number of different palettes for different activities. For his primary studio palette he uses a large sheet of glass painted white on the back side, which remains stationary on his painting table. When he's working on a very large painting and moving from one end to the other, or when he's mixing a specific group of colors that he needs to keep isolated (like the subtle flesh tones of a portrait), he uses a wooden hand-held palette and a number of old china plates that work nicely. He sometimes uses a pad of the disposable peel-off palettes of smooth paper. There are also airtight plastic boxes to accommodate these pads, which are especially good for going out to paint in the landscape.

Palette Knives

Palette knives not only make good tools for mixing paint on the palette, but also may serve as trowels for applying it to canvas. They are varied in shape and size. Purchase those that look and feel useful to you. Actual painting will dictate future needs.

Mediums

Artists seldom use oil pigment straight from the tube, but ease its handling and effect by adding one of many different mediums. Since oil pigments contain substantial amounts of oil, gum turpentine alone is an acceptable medium. Crespo recommends using Winsor & Newton's Liquin in addition to turpentine, because it speeds up the drying time of oils. He suggests a small dab, about what you can pick up on the end of your brush, mixed with each puddle of color. When a painting is worked over in different sessions, the medium should be added in increasing amounts with each layer. This is in keeping with the "fat over lean" rule for permanence: In a painting with different layers, the oiliest should always be on top, the thin turpentine wash on the bottom.

You can mix your own medium—a standard one that many painters use—by combining one-third gum turpentine, one-third stand oil, and one-third damar varnish. Liquin may also be added to it to speed the drying time. Use about a teaspoon of Liquin per 4 ounces of medium.

Drawing Materials

You will need vine charcoal and drawing pencils to make initial drawings on canvas. Purchase the thin sticks of soft vine charcoal. Unlike compressed charcoal, vine charcoal is easily corrected by wiping. Charcoal drawings can also be blown from the surface, leaving a faint residue to guide your painting. Drawing pencils should be soft; a 2B, 4B, or 6B grade is recommended.

Jars, Cans, and Rags

You will need at least three jars, cans, or other containers to hold turpentine, mediums, and dirty brushes. They should be glass or metal, because turpentine will disintegrate many kinds of plastic and paper. Depending on how you work, you may find it convenient to use palette cups, or dippers, which are small cups for holding turpentine and medium that clip onto your palette.

An abundant supply of rags or paper towels should be on hand for cleanup. They are also useful for applying paint to and removing it from your canvas.

Easel and Table

Avoid the small table easels and select instead a standing easel—either a folding easel, which is easy to store and excellent for toting into the landscape, or one of the more stable and more expensive studio easels. There is also the French landscape easel, which is a folding paint box, palette, and easel all in one. You'll also need a small table for your palette, brushes, and mediums. One or two TV trays will suffice and are easy to store.

Sketchbook

Purchase a small sketchbook for use as a journal. In it, make thumbnail sketches of your subject before each painting. Record in words and images anything pertinent to your work as a painter—a favorite color mixture, future subject matter, a line from a poem, the latest perfect medium. Over the years a well-kept personal journal will surpass any book ever written on oil painting.

Caution

Many of the various mediums and pigments are toxic. Care should be taken in their use. Be certain to read any warning labels on the materials before working with them. Michael Crespo strongly recommends wearing examination gloves while painting. They are inexpensive, comfortable, and available at any drugstore or science supply house.

Basic Supplies

Here is a list of the basic supplies you will need to get started in oil painting. Although the number of items has been kept to a minimum, you will no doubt supplement them over time, eventually gathering an ample cache of materials while being perhaps less aware of the cash outlay.

Brushes

#2 flat hog-bristle

#3 flat hog-bristle

#6 flat hog-bristle

#3 hog-bristle fan blender

Small round synthetic sable for detail work

1-inch flat synthetic sable

Oil Colors

Michael Crespo recommends studio-size (1.25-ounce) tubes of all colors except titanium white. Because you'll be using a lot of that, buy a large (5.07-ounce) tube of it. These are the colors you will need to get started:

Grumbacher red (or cadmium red medium)

Alizarin crimson

Ultramarine blue

Phthalocyanine blue

Cadmium yellow medium

Hansa yellow or lemon yellow

Cadmium orange

Phthalocyanine green

Burnt sienna

Raw umber

Yellow ochre

Ivory black

Payne's gray

Titanium white

Miscellaneous

Wood, glass, or other permanent palette, or disposable paper palette pad (large size, glossy surface)

Palette knife

Vine charcoal and drawing pencil

Gum turpentine

Winsor & Newton Liquin medium

Damar varnish (small bottle)

Stand oil (small bottle)

Jars and rags

Sketchbook

Examination gloves

Supports

Choose from among the following, determining which type of surface and what size you wish to work on:

Canvas board

Stretched canvas

Primed Masonite

Primed paper

Michael Crespo
Stretching Your Own Canvas

You can stretch your own canvas, either primed or unprimed. (If it is raw, prime it with two coats of acrylic gesso after you have stretched it.)

Artists stretch canvas by stapling it over wooden stretcher bars, which come in pairs and are fitted together. Many sizes are available.

Most of your staples will fasten the canvas to the outside edge (not the front or back) of the stretcher bars. After stapling once in the center of one side, use the canvas pliers to stretch the canvas over the opposite side and staple once more, as illustrated. Repeat with one staple on the remaining two sides. The center of the canvas should now be stretched taut in all four directions.

Now add one or two staples to one side, an inch or so apart, gradually working out in one direction from the center toward the corner. Then repeat on the opposite side so that the canvas is pulled tight directly across the stretcher bars. Continue this, constantly rotating to the opposite side, until you've stapled all but one inch from the corner on all four sides. Be certain to pull tight with the canvas pliers for each staple.

Fold the corners over neatly, and staple them to the back of the stretcher bars. It's a good idea to also secure the excess canvas to the back of the bar, rather than cut it off. Having the extra few inches will facilitate tightening or restretching your painting.

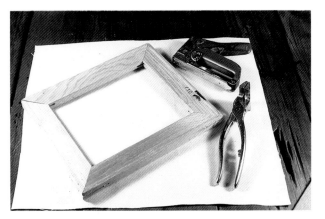

Tools you will need for stretching canvas: the canvas, a light-duty staple gun, a pair of canvas pliers, and wooden stretcher bars.

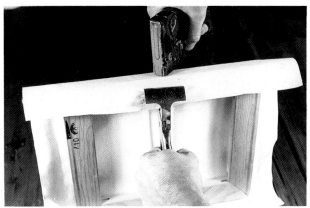

Before you insert each staple, pull the canvas taut with the canvas pliers. Keep turning the canvas to the opposite side as you add staples. This keeps the canvas stretched tight and evenly.

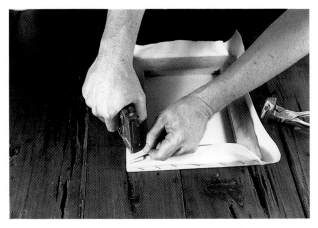

The corners are stapled last. Fasten them to the back, not the outside edge, of the stretcher bars.

Gregg Kreutz
Organizing Your Palette

Painters' palettes invariably look like their paintings. A palette with globs of dried paint, colors squeezed out wherever there's room, and only a little gooey area to mix on, can only result in a messy picture. Likewise, a sheet of white paper with tiny drops of paint squeezed around the rim couldn't ever produce a painterly painting. Palettes have to be well enough organized so that the artist can move fluidly from thinking to mixing to painting. Making pictures is hard enough without the material and craft side of it holding you back. Organizing your palette is good for your painting because it makes a statement about your intentions. It says, "This is serious." The alternative, having the craft side of your efforts be inefficient, is tempting because it lets you off the hook. If your tools are meager or sloppy, you, the artist, can't be held responsible if the painting doesn't work out. To actually take control of the situation and make your material more functional can be difficult.

Also hurting the craft side of painting is the suspicion that there's something unartistic about keeping things too tidy. The artist looks most artistlike when he or she is covered in paint and squeezing colors out onto any surface that's handy. But art is not being served when red is wanted, can't be found, and brown used instead. Or when a big juicy stroke would look good, but because of low paint outlay a tinting dab has to suffice.

When you plan a day of painting, it's a good idea to spend about forty-five minutes setting up your palette. That means cutting the skin off the dried paint and removing the wet from inside. Then add some new paint to the little puddle of just-excavated stuff, and put it back on its pile. After you've done that to all the paint piles that need it, take some alcohol and clean off the mixing area. A glass palette is especially easy to clean.

By the time you are finished with these preparations, you will be ready to paint. Because you've been fooling around with the paint for all that time, you will feel warmed up to it, and in a more painterly frame of mind than if you'd just started off cold.

As you paint throughout the day, keep your palette organized and looking coherent, scraping it clean with a razor blade every so often.

As this illustration shows, Gregg Kreutz has organized his palette in a general light-to-dark sequence. Also, he has assembled the hues into color groups: the blues are together, the browns are together, the cadmiums are together.

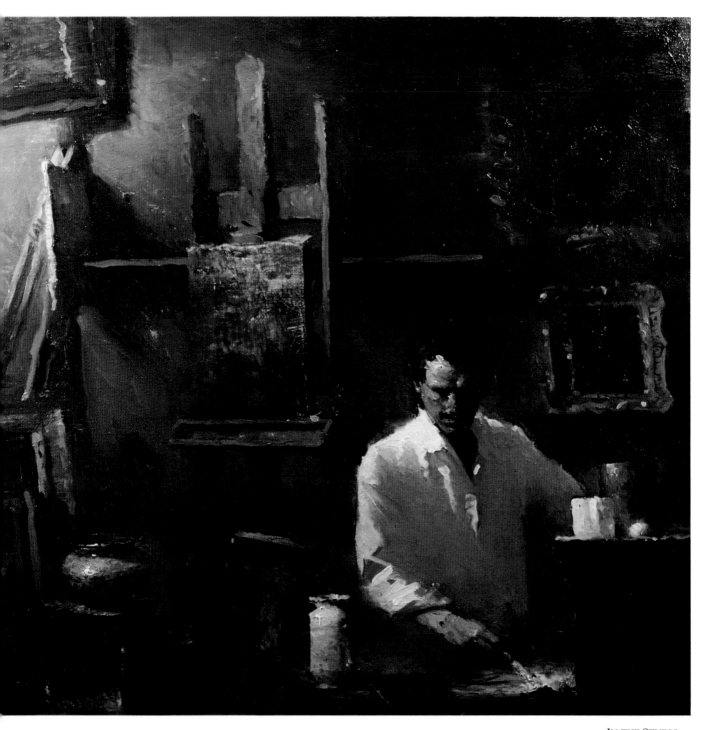

IN THE STUDIO
*Oil on canvas, 12 x 20" (30.5 x 50.8 cm),
collection of Andrew Bell.*

COLOR

Charles Le Clair

Understanding Color Theory

On a summer day at the beach, we are bombarded by electromagnetic radiation. We hasten to ward off invisible ultraviolet rays with a protective sunscreen cream or umbrella. But we welcome the friendly visible rays of the solar spectrum, because the sunnier the day, the more fun we shall have in watching the passing parade of colorful robes, T-shirts, and bikinis.

In short, the solar spectrum makes the artist's world of color possible. This is a band of radiation shining upon us as white light reflected back to our eyes by certain objects—a towel, seashell, or bathing cap—which we then perceive as "white." Most things appear to us as "colored," however, because they contain pigments that absorb certain rays while reflecting others. Such substances, whether natural or applied with dyes or paints, may be thought of as another kind of sunblock. But instead of screening invisible ultraviolet rays, they screen out part of the visible spectrum. Thus, one dye or artist's pigment will block out everything but blue wavelengths, another will absorb everything except yellow rays, and so on.

Sir Isaac Newton laid the foundation for our modern understanding of these principles in a series of experiments begun in 1666. Working in a darkened room with one small hole in his window shutter, he was able to direct a thread of white sunlight through a glass prism in such a way that it broke into the multicolored solar spectrum, a rainbow of progressive frequencies ranging from red (a band of the longest wavelengths) through orange, yellow, green, blue, and violet (at the short end of the scale).

This much had been known before. But Newton was the first to recombine the separated rays into white light again by means of lenses and a second prism. He discovered that objects appear colored in white light because they reflect only a segment of the spectrum. And he designed a prototype of the modern color wheel.

Since Newton's time, various color "systems" have been put forward with two- and three-dimensional charts. The best-known American system was designed by Albert Munsell. His plan features a color wheel of ten hues modified by a vertical scale of variations according to lightness or darkness and a horizontal scale of brilliance or dullness, the whole collection of color chips assembled as a dimensional tree.

Anatomy of the Color Wheel

The concept of a rigorous, mathematical logic of color relationships is an exciting prospect for certain artists. Such a theoretical approach, however, is of little interest to most studio people, who tend to work with an idiosyncratic selection of pigments and to mix them spontaneously rather than by formula. Nevertheless, the practicing painter has a great deal to learn from color theory. The trick is to translate technical terms into a studio vocabulary, seek out key concepts, and discover how they may be utilized in the creative process.

The basic color wheel is our inevitable starting point. You will recall that it diagrams the following elements:

1. Hues. _Hue_ is the attribute of color associated with a dominant spectrum wavelength. Thus, hue is a family name for all the different reds—or different greens or blues—on your palette. A vivid lipstick red, a deep maroon, and a light shocking pink, for example, are all variations of the same red hue.

When used in this sense, to describe one of the properties of a color in contrast to another, the word _hue_ has a specialized scientific meaning. We must remember, however, that hue also has a more general everyday meaning in which it is virtually synonymous with _color_. In most art discussions, unless there is a technical point to be made, the words are used interchangeably.

2. Analogous Colors. The basic color wheel arranges six segments of solar radiation in order of their wavelengths— red, orange, yellow, green, blue, violet—with the long- and short-wave ends of the spectrum (red and violet) connected up to form a circular continuum. Obviously, the spectrum can be divided more elaborately, as in the ten-hue Munsell Wheel used in industry. The six-color wheel is generally preferred by artists, however, as a simpler, more easily remembered diagram of basic relationships.

In any case, _analogous colors_ are those close to each other on the wheel. They are generally harmonious—as in the yellows, oranges, and reds of autumn foliage—and they are often used to describe shifts from warm to cool tones created by sunlight and shadow. For example, you might use warm orange on the light side of a red apple and a cool violet on the dark side.

3. Primary and Secondary Colors. The _primary colors_—red, yellow, and blue—are those that can be combined in various mixtures to create all other colors. Or, to reverse the definition, these are the unique hues that cannot be produced from anything else.

Secondary colors are derived from a mixture of primaries: orange (from red and yellow), green (from yellow and blue), and violet (from blue and red).

Tertiary colors aren't shown on the basic color wheel, but they are implied by the fact that the spectrum can be divided and subdivided ad infinitum into narrower and narrower bands of radiation. Thus, the circle of six colors may be extended to twelve by in-between mixtures: yellow-green, blue-green, blue-violet, red-violet, red-orange, and yellow-orange.

4. Complementary Colors. The dictionary defines *complement* as either of two things needed to complete each other. Accordingly, the perfect marriage is one in which the qualities of husband and wife complement each other. By the same token, *complementary colors* are those that, when combined, incorporate all the rays of the spectrum.

On the color wheel, complementary hues are shown as opposites: red versus green, blue versus orange, and yellow versus violet. They are also opposites psychologically and in their references to nature: fire and ice (orange/blue), sun and shadow (yellow/violet), flower and foliage (red/green), and so on. Unlike analogous hues, these are colors of extreme contrast. When used together, they create brilliant, vibrating, or even clashing effects.

After looking at a brightly illuminated object, doubtless you have sometimes observed an afterimage, in an opposite color, upon closing your eyes or looking suddenly at a white wall. This visual phenomenon is an interesting proof of the complementary principle. Try this experiment. Put a red apple on a black cloth in bright light. Stare at it for a minute or two, then turn to a blank sheet of white paper, where a green afterimage should appear. Oranges, lemons, and limes will produce similar effects in their respective complementary hues.

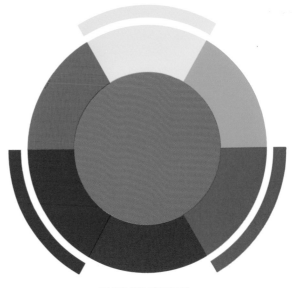

BASIC COLOR WHEEL

Additive and Subtractive Mixtures

The Munsell and similar color systems have one thing in common: They offer a rationale for the interaction, not of pure color in the form of *light*, but of colored *pigments*. In short, this is color theory for painters and designers. And a crucial consideration for any studio person is a fact that is seldom emphasized or fully understood: namely, that mixing colored pigments is a *subtractive* process.

By subtractive we mean that any given pigment absorbs, or "subtracts," a segment of white light in order to reflect back its distinctive hue. Hence, a combination of two such pigments is, by definition, the sum of their subtractions—or to put it in practical terms, a derivative color of diminished brilliance. Thus, a green mixed from blue and yellow is less vivid than the colors you start with—or for that matter, than a tube of unmixed green paint made from a substance that was bright to start with.

Follow this principle to the bitter end and you will see that, at least theoretically, a mixture of all pigmented colors should result in total blackness, or absence of color. In practice, however, stirring up all the paints on your palette will produce not a dead black but the dark gray shown at the center of the color wheel. You will find that the only way to make a true black out of other colors is to start with very dark pigments like umber, alizarin, and Prussian blue.

Meanwhile, on Broadway, Hollywood, and TV stages there is another kind of artist: the lighting designer with batteries of spotlights and a computerized keyboard, who

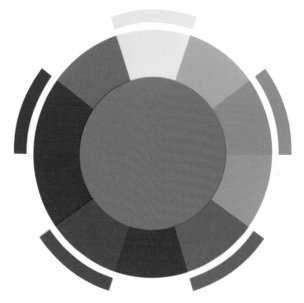

MUNSELL COLOR WHEEL

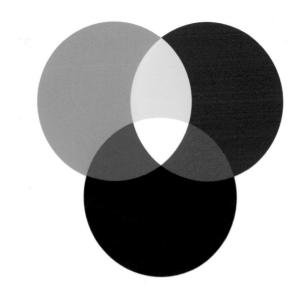

LIGHT MIXTURE CHART

speaks an entirely different color language. This is the language of *additive light mixtures*, best visualized not as a wheel or triangle but as three interlocking spotlights. These circles of green, red, and blue-violet light overlap in pairs to produce three other hues—yellow, greenish blue (or cyan), and red-violet (or magenta). Most significant, of course, is the fact that all colors overlap in the center to produce not blackness, as in the pigment system, but white light.

At first glance, relationships in the light mixture chart strike anyone who works with paints as utterly bizarre. It is hard to imagine creating blue from green plus violet or mixing yellow from red plus green! Nor do we find familiar primary and secondary relationships here. Since any of the colors can be produced by a blend of its neighbors, none is "unique" and "unmixable" like the pigment primaries. Instead, in this purely additive system, combining colors strengthens rather than weakens them—the opposite of what happens in pigment mixing. The effect is like that of turning on a series of lights in a dark house. Each newly switched-on lamp—the green-shaded desk lamp, the red Tiffany chandelier, and then the yellow floor lamp— increases the overall level of brightness in the room.

Brightness is by no means the ultimate artistic achievement. For centuries painters veiled their colors in Rembrandtesque shadows. And in today's galleries you will find a great deal of art, ranging from Andrew Wyeth's weather-beaten realism to Anselm Kiefer's metallic expressionism, that capitalizes on muted harmonies. Nevertheless, the main thrust of modernism has been toward increasingly dynamic color relationships. For most artists, the problem of keeping color fresh and alive—of making the painted rose as red as the real one, even as it wilts on the studio table—is an ongoing, never-ending challenge.

Practical Guidelines

If you are a painter interested in achieving the most vibrant color relationships, our review of additive and subtractive color systems suggests at least two practical guidelines.

First, for maximum brilliance, work with a generously stocked palette of at least ten or twelve spectrum hues (not counting earth colors and neutrals). Because pigment intensity can only be diminished by mixing, you must start at the top of the scale. Some artists prefer the subtleties of a limited palette, but for sheer brilliance the broadest possible spectrum is required. In short, your palette should look something like the ten-hue Munsell Wheel.

Unfortunately, the popular interpretation of the color wheel as a guide to mixing up a storm from three little tubes of red, yellow, and blue paint is simplistic and, from the professional artist's standpoint, downright misleading. Red, yellow, and blue can indeed beget the secondary hues, but their offspring, though not unlovely, will be muted rather than brilliant. The same principle applies to

secondary and tertiary mixtures down the line. That is why the basic wheel's six hues alone won't do. You need three reds (warm orange-red, true red, cool violet-red), three greens of similar warm/cool variation, at least two yellows, and so on.

A second helpful hint is to make the most of transparent passages wherever you can. Watercolorists quickly learn that a pink created by a thin red wash on white paper is more vivid than the same pink made by mixing red with opaque white. The reason is that, instead of being blocked by heavy pigment, light penetrates to the paper in watercolor. It is then reflected back *through* the transparent wash, which becomes, in effect, a film of color lighted from behind like a bit of stained glass.

The "stain painting" of abstract artists like Helen Frankenthaler and Morris Louis may be seen as an extension of this watercolor wash principle, as liquid acrylics are poured out like multicolored dyes onto unsized canvases. Transparent colors are even more luminous when used as glazes over built-up opaque pigments in oil painting. This was the technique of Flemish masters like the van Eycks, who worked out details on a white-highlighted underpainting and then finished off their pictures with enamel-like varnish-and-oil glazes. Many of today's realists still use this approach.

A third way of intensifying color should also be mentioned here, even though it is more intriguing as a concept than as a practical suggestion. This is the notion put forward by the nineteenth-century French scientist Chevreul that tiny dots of color will merge in the beholder's eye to produce intermediate tints more luminous than those mixed on the palette. His argument, of course, was that such optical mixtures are a blend of additive light rays rather than subtractive pigments.

Monet and the impressionists were thus encouraged to work with spontaneous touches of unmixed color, and Seurat subsequently refined their approach with a more formalized system of measured dots, or "points," of color. In a few short years, Seurat produced a remarkable body of highly personal images, and a masterwork, *Sunday on the Grande Jatte*. Although Seurat's pointillism has had few imitators, his idea—that in a picture you can see "ghost" colors that aren't actually there—has enormous popular appeal. Most critics agree, however, that his paintings, though beautiful as art, do not conform to his theory. The difficulty is that at a comfortable viewing distance of ten or fifteen feet, Seurat's color dots don't really dissolve and melt into one another. They remain stubbornly visible because they simply aren't small enough.

Value and Intensity Scales

When describing a color, our first thought is of its hue. We identify someone as wearing a "red" dress or "blue" suit. Then, if further information is needed, we add phrases like "dark dull red" or "vivid light blue" to suggest how the basic hue has been modified by other elements. These modifiers are most commonly known as *value* and *intensity*.

Value refers to a color's lightness or darkness. Pale colors with everyday names like pink or aqua are identified, technically, as reds and blues of high value, while dark colors like maroon and navy are defined as reds and blues of low value. In value/intensity chart #1, the vertical columns show four different hues (red, green, yellow, violet) in value scales shading from light to dark. They have been made by lightening each basic hue with white to form "tints" and adding black to create darker "shades."

Intensity, on the other hand, measures a color's brightness or "saturation." To put it another way, intensity refers to a color's purity and freedom from dilution by other colors. Thus, the crosswise bands in this chart show how colors become dulled by complementary mixtures. Here, red moves toward brownish gray when mixed with green, and yellow is similarly neutralized by violet. The contrast of H and N shapes also helps to explain the difference between value and intensity. As you see, each hue has a

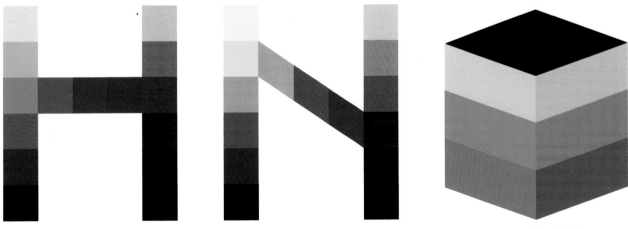

VALUE/INTENSITY CHART #1 VALUE/INTENSITY CHART #2

particular value when it is at full intensity. Thus, the green-to-red crossband is horizontal because both hues are in the same mid-value range, whereas the yellow-to-violet band is diagonal because these colors are value opposites, yellow being an intrinsically light hue and violet a fairly dark one.

There is probably no more difficult color principle to grasp than this distinction between value and intensity, because words like *dark* and *light* (describing value) and *dull* and *bright* (describing intensity) sound so much alike. Nor is the difference always evident in looking at the actual colors. Value/intensity chart #2 (page 23), however, should make things a bit clearer. Here, the left, sunny side shows dark, medium, and light values of a bright (or high-intensity) color, while the shadow side shows dark, medium, and light values of a dull (or low-intensity) version of the same basic hue.

This diagram shows you how value and intensity function as independent variables. It also demonstrates that, of the two, value is the more measurable quality, and hence of greater importance for the artist. Whereas the eye makes an immediate assessment of these dark, medium, and light stripes, the precise hue and intensity of the colors is harder to assess. Accordingly, painters generally pay fairly systematic attention to dark and light patterns, while other aspects of color are approached more intuitively.

Working with Value Scales. House paint and textile manufacturers employ a minutely calibrated system of color measurement based on hue/value/intensity formulas that you have doubtless seen in decorator shops. For industrial use, just imagine chart #1 extended to ten vertical values and ten horizontal intensities. Then, with all the cross rows filled in like a checkerboard, each hue would require a hundred mixtures—or a grand total of a thousand for the ten-color Munsell system!

Art teachers also like to emphasize fine-tuned gradations, and painting an evenly modulated value scale is a classic freshman assignment. Such exercises help you develop control, but having to mix paints with an

eyedropper can also be hateful. And unless carefully taught, a precisionist approach to color can give the wrong message to a creative person. The best advice for the painter is to look for ways in which theoretical concepts can generate visual excitement and be absorbed into the basic rhythms of picture-making. Needless to say, this calls for simplification rather than elaboration. It means reducing complicated possibilities to a workable few.

Advantages of a Four-Value System. Values are the building blocks of a color composition. They determine whether your painting carries across the room or fades into the woodwork; whether it makes a snappy black-and-white publicity photo or one that lacks contrast. A painter's values must be shaped like the notes of a musician's scale—as evenly spaced intervals that can give the viewer a sense of sequence, rhythmic repetition, and structure.

In painting, however, the number of "notes" on a value scale a viewer can keep in mind, or that an artist can comfortably work with, is limited. A composition can sometimes be reduced to just two main light and dark values representing areas of sunlight and shadow. A traditional landscape format with foreground, middle ground, and distance calls for a three-value scheme (perhaps with subordinate dark and light scales in each of the three main zones). And watercolorists who paint with spontaneous brushmarks—Homer, Cézanne, Welliver, and Fairfield Porter come to mind—generally rely on a *four-value* technique. The reason: Three tones are insufficient, five too complicated, but working with four main values has the naturalness of a runner's jogging rhythm.

Achieving Color Excitement

The big question for artists is, What *is* "good"—or "interesting" or "exciting" or "dynamic"—color? And how can understanding color theory help the artist to achieve it?

The answer is quite simple. Color interest derives from movement between and among its three polarities: hue, value, and intensity. To have any kind of drama

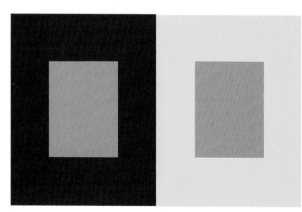

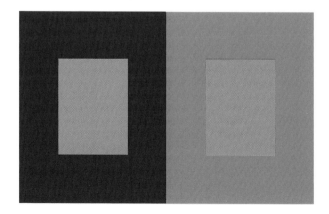

COLOR RELATIVITY STUDY

or excitement, you usually have to involve all three. Furthermore, the sequence has to have the logic of the charts we have been studying. Hence, a move from yellow to red needs an orange halfway step; a light-to-dark move requires a medium-value transition; and a shift from vividness to dullness calls for a neutral mixture in between.

Josef Albers and His Legacy

The name Josef Albers is as closely linked with the study of color as Freud's is with psychology. Albers focused on color as a self-sufficient, independent element. His Homage to the Square series, featuring designs in three or four flat colors, has been a continuing inspiration for color purists and artists of minimalist persuasion.

In Albers's view, color had been subservient throughout history to the representation either of images or abstract designs. He argued that color should be understood instead as the basic structure of a painting, and as an "autonomic" or self-governing esthetic element. To this end, he guided his students through a remarkable series of experiments that he summed up in *Interaction of Color*, a treatise published with a boxed set of more than two hundred color exercises.

The overall theme of these exercises is our changing perception of colors when they are seen in different combinations. In the color relativity study shown opposite, for example, identical swatches of the same neutral beige are shown against four distinctive backgrounds. Yet visually, the beige squares on the left don't seem to match the brown squares on the right at all! This is because a color's value is relative to its surroundings. It will appear dark against a light yellow or orange, and comparatively light against dark colors like blue and purple. Hold a manila envelope up to the window, then down against a dark rug, and you will see that this principle works in real life as well as in art. Thus, it is an important consideration for the figurative painter as well as for the abstractionist.

A color's hue is also modified by its environment, though so subtly that the change is less easily detected. Be assured, however, that spectrum hues, like yin and yang or male and female, attract their opposites (or complements) in any relationship. Accordingly, by staring at the four center squares, you should be able to make out a faint yellowish glow to the tan that is shown against purple, and a corresponding purplish cast to the brown shown on yellow. Orange and blue have a similar complementary interaction, and perhaps the clearest example of this principle is the distinct orange tonality of the tan square on the blue panel.

Albers is most famous for his Homage to the Square series, a body of more than two thousand paintings and prints that addressed the concerns of infinitely refined color relationships. Some of the Homages are untitled, but Albers often gives verbal clues to his thinking. The title *Saturated*, for instance, refers to purity of hue, which in technical language is called *saturation*. Thus, we infer a merely formal intent to give one color (in this case, red) its maximum potency. With a title like *Festive*, on the other hand, Albers reminds us of the power of colors to evoke distinctive moods. We speak of "feeling blue" or being "in the pink," and the blue-and-orange scheme of *Festive* has the cheerfulness of college colors at a football game.

Some of Albers's finest efforts explore still another color possibility: the illusion of light. As its title suggests, *Light-Soft* is one of numerous Homages devoted to luminosity and radiance. Some are very dark, some very dim, and others, like *Light-Soft*, so pale they draw you into a hypnotic twilight world. What is most remarkable, though, is the economy of means—three flat colors: yellow, gray, and a mixture halfway between—with which Albers creates the effect of a nimbus, or halation, around a squared-off sun.

A Lesson for Painters

Realist painters such as Philip Pearlstein and Janet Fish use color for both formal and representational purposes. But to understand color in terms of Albers's strategy, we must be aware of the difference between a "meaningful" color relationship and one that lacks "commitment." Casual painters may achieve charming effects, but serious artists aim for color relationships that are more dynamic, complex, and, as Albers says, "interactive." This is a view of color as an equation in which the painter pits various forces against one another in order to create interesting movement, on the one hand, and equilibrium on the other.

Just what are these forces, and how does one balance them? Quite simply, color movement—or "push and pull," as the German émigré artist Hans Hofmann called it—is created in two ways: either by opposites tugging against each other, or by neighbors in a chain-reaction impulse.

The polarities are light versus dark *values*, bright versus dull *intensities*, and opposing (or complementary) *hues*, plus one additional factor—the backward or forward *spatial thrusts* of various colors. Sun-bright yellow, for instance, has an aggressiveness that makes it a perfect choice for traffic signs, whereas blues and violets—colors we associate with the sky—tend to be recessive.

These elements establish a painting's basic dynamics, but movement is also created by transitional sequences that lead the eye from one color to another.

Michael Crespo
Color and Value Mixing

As you begin to explore the possibilities of color and light in your work, it's helpful to make a nine-step value scale in black and white. Then, to gain experience with color mixing, create various grays by combining different versions of the primary colors red, yellow, and blue.

Making a Value Scale

Squeeze black and white paint onto your palette and have on hand a piece of heavy drawing paper or a scrap of mat board to serve as a painting surface. On your palette, make an ample puddle of black, thinning it with a little turpentine. Load one of your brushes and make a swatch of the black near one edge of the paper. With your palette knife, mix a little white into the black puddle to make a gray. Don't use too much white, because you will need to make six more graduated grays before arriving at pure white. Once you've finished, go back in and make adjustments by mixing either black or white into the swatches if needed. The intervals between these values should be as similar as possible. Tack this to your studio wall. It will serve well as a chart for mapping out value systems in your paintings, or just as a reminder of the vast potential of value as a harbinger of light in your work.

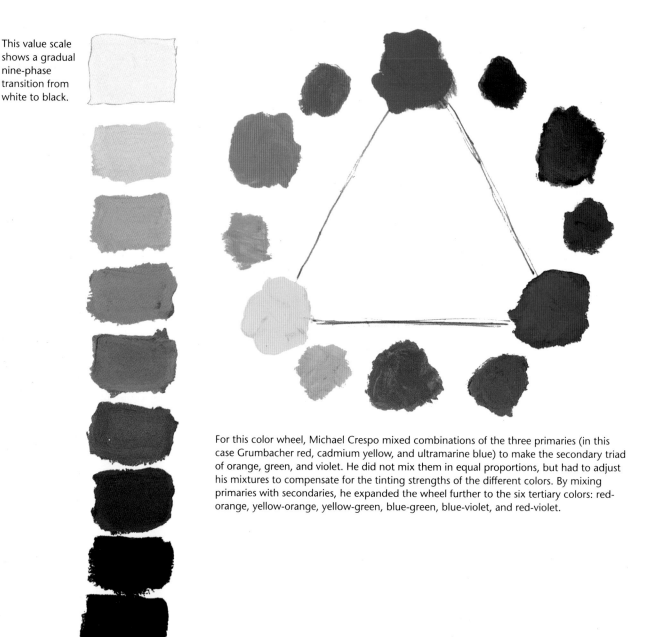

This value scale shows a gradual nine-phase transition from white to black.

For this color wheel, Michael Crespo mixed combinations of the three primaries (in this case Grumbacher red, cadmium yellow, and ultramarine blue) to make the secondary triad of orange, green, and violet. He did not mix them in equal proportions, but had to adjust his mixtures to compensate for the tinting strengths of the different colors. By mixing primaries with secondaries, he expanded the wheel further to the six tertiary colors: red-orange, yellow-orange, yellow-green, blue-green, blue-violet, and red-violet.

Mixing Primary Grays

Smearing blue and yellow crayons together to make green was probably your first exposure to the color wheel, which is composed of two basic triads: the primary triad, consisting of red, yellow, and blue; and the secondary triad, consisting of green (blue plus yellow), orange (red plus yellow), and violet (red plus blue). Let's expand it further to the tertiary colors: red-violet, blue-green, yellow-orange, and so on.

When red, blue, and yellow are mixed together in equal portions, the result is a primary gray. Mixing complementary colors such as blue and orange produces what some call complementary grays also; however, such grays are still based on the primary gray. For example, mixing yellow and violet is the same as mixing yellow and red and blue, since violet is a combination of red and blue.

This basic color theory is wonderfully expanded when we apply it to the various pigments we employ. "Blue" could refer to ultramarine, cobalt, Prussian, or cerulean blue, to name just a few. All have different properties and effects, so that you have an almost infinite array of choices in your paintings. It's important when you're mixing colors to be aware that some pigments are stronger than others so that you can gauge how much to use in any given combination.

To mix two sets of primary grays, on your palette lay out ivory black and titanium white, plus one primary group consisting of cadmium red, cadmium yellow, and ultramarine blue, and a second primary group consisting of alizarin crimson, lemon yellow, and phthalocyanine blue.

With a palette knife, mix each of the groups of primaries to get two different grays.

It's difficult to tell whether the dark color you are mixing is neutral or not, so pull a little aside and add a bit of white to determine its color. Equal amounts of red, yellow, and blue will not necessarily produce a neutral color, because the strengths of the pigments vary greatly.

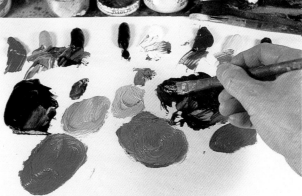

Now mix different values of the two grays. A little bit of turpentine added with your brush will make the paint flow more easily.

Charles Reid

Seeing Pure Color as Value

Sometimes people have trouble seeing certain colors as specific values, particularly the lighter and more intense colors such as red. For example, students asked to identify the values they see when looking at someone dressed in a bright red shirt and dark blue slacks will often say "dark" for the slacks, but "red" for the shirt!

When you're painting a scene, it's important to be able to identify each color you use as a specific value. Bright, strong colors often suggest a light value to people, while grayed, less intense color may suggest a darker value. But they are confusing value with intensity. Remember, each color has a specific hue, value, and intensity as it comes from the tube. Try to keep them separate.

To illustrate this point, Charles Reid created the value chart shown here with the colors he uses most frequently. Make a color-value chart of your own on a canvas panel

(8 x 10" or larger). Paint a black-and-white value scale across the top—five values plus white. Next, put the colors you normally use—you don't have to use the ones shown here—in their usual order around the edges of your palette. Then match each color with one of the black-and-white values. Don't adjust the tube color by mixing it with another color or with black and white, but use it just as it is when you squeeze it out of the tube. It might be hard to judge the values at first, and you may mess up several panels in the process, but in the long run the practice is worth it.

Notice that several colors on Reid's chart fall between two values. Cadmium yellow, for instance, seems to be between 4 and 5 on the scale, yellow ochre between 3 and 4, and viridian between 1 and 2. Obviously, on a value scale containing nine or more values plus black and white, these colors would have their own place.

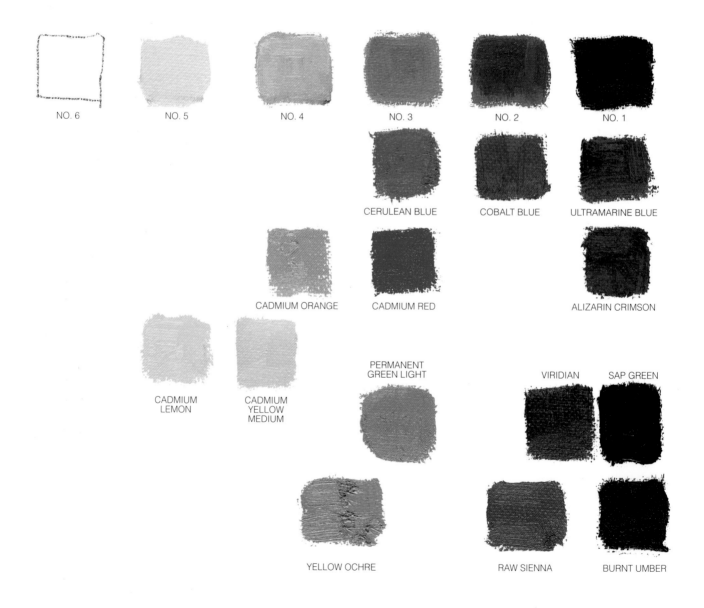

NO. 6 NO. 5 NO. 4 NO. 3 NO. 2 NO. 1

CERULEAN BLUE COBALT BLUE ULTRAMARINE BLUE

CADMIUM ORANGE CADMIUM RED ALIZARIN CRIMSON

PERMANENT GREEN LIGHT VIRIDIAN SAP GREEN

CADMIUM LEMON CADMIUM YELLOW MEDIUM

YELLOW OCHRE RAW SIENNA BURNT UMBER

Learning to Use Strong Color

One reason children's art has such a strong graphic quality is that they see objects in terms of color rather than value or form. In fact, children don't seem to be aware of light and shade or roundness until they're older.

Most older people are afraid of using strong colors. Also, in an effort to make something look "real," they muddle about with small details. The result is that they overmix their color so it gets gray where it shouldn't and the values become muddy and confused.

Try to see color freshly and directly. Force yourself to concentrate on getting the correct color value without having to worry about edges and details. To do this, paint a group of objects just as a child might, with a color that comes right out of the tube that matches the color value you see before you.

With the painting shown here, Charles Reid illustrates how to achieve value and color differences without letting them become muddy or confused. Each area is painted in a single color value, just as it comes from the tube. He allowed himself to add *one* highlight on some of the objects— but that was all. These are the colors he used:

Coffee can: cadmium yellow light, ivory black, cadmium red

Aspirin bottle: titanium white, cobalt blue

Orange: cadmium orange

Salt bottle: permanent green light, titanium white

Apple: alizarin crimson

Wall: raw sienna

Table: permanent green light

The color sketch doesn't match the black-and-white value sketch exactly; the intense greens and oranges look lighter in black and white. But the purpose of this exercise is not to match a color sketch to a black-and-white value sketch. It's intended to train you to match color and value to simple objects.

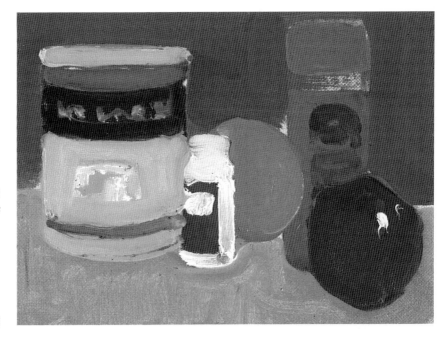

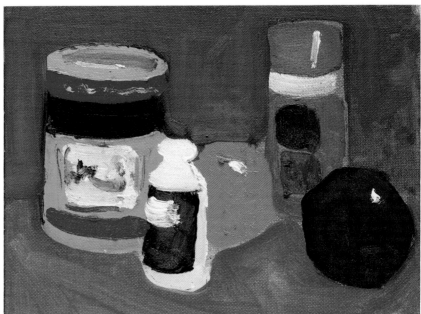

Try this exercise yourself. Set up a still life of four or five objects with an obvious color identity. Fruits and vegetables are a good choice, or flowers or objects you may find around your kitchen. You may also want to paint commercially packaged goods, since most typical containers use pure, strong colors. Stay with the primary and secondary colors, colors that correspond to tubes of paint you already have. Remember, you're not going to be mixing your colors.

Place these objects under a diffused light, one with no strong shadows. You're not going to be concerned with light and shade, just local color. Before you paint in color, make a value sketch of your setup using only ivory black and white (to make shades of gray). Concentrate on local value only, and paint the objects as flat shapes, working in a posterlike fashion. Come in close to your objects. Crowd them into the picture surface so you'll have almost no background to worry about.

When you have finished your value sketch, switch to color and paint the objects again with pure, flat color. Use your colors full-strength—straight from the tube.

Michael Crespo
Primary Value Systems

In paint, the manifestations of light are interpreted by merging value and color. Of course, mere black and white can produce an impression of light. And color has its own inherent light—its chroma, or intensity, which can illuminate without changes in value. However, only when the two are fused can their separate potentials to exude luminosity be fully exploited. Always keep color and value tightly attached in your thinking and mixing.

There are three primary systems of value/color: normal, high-key, and low-key. In the normal system the values range from white through the middle values to the darkest color you can make. Most of the colors used are clustered around the middle, with extreme lights and darks used primarily as accents.

In the high-key value system the range is restricted. White is still the lightest light, but the darkest dark is now the middle value of a normal range.

In the low-key value system the middle value of the normal range is the lightest light. All the other colors are darker, moving toward the darkest black.

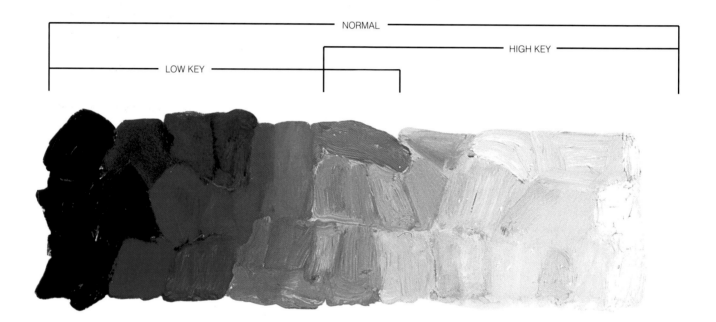

Low-key value system. The lightest light is the middle value of the normal system.

Normal value system. Dominant values are from the middle range, with extreme darks and lights used as punctuation.

High-key value system. The darkest dark is the middle value of the normal system.

The Temperature of Color

Color floods our eyes at every moment. Even in a room of darkness, we cannot escape the wash of obscure blues, greens, and purples that bestow on us faint recognitions of vague nocturnal forms.

Color preys on our senses both directly and symbolically. Red may muster excitement and happiness, yet symbolize violent death. Blue can signal the optimism of a lucid sky, or the doldrums of depression. (Compare the two songs "Blue Skies" and "Blue Monday"!)

The arena of color is complex, and one of our challenges as painters is to harness the intricacies into simple, seemingly uncontrived structures. The power of color can be used deliberately to beat the viewer over the head . . . or to perform a more unassuming seduction, subtly disclosing the intentions and mysteries of the artist's vision, both painful and delightful.

Scan the color wheel and decide which colors appear hot and which appear cool. Yellow may seem the hottest, with blue moving toward blue-green the coolest. Green and violet are the transitional areas for temperature. Green cools off as it moves toward blue and warms toward yellow. Likewise, violet does the same as it approaches blue and red respectively. However, none of this is absolute; the greatest lesson of color is that it is relative both to itself and to those using it. A particular orange might appear much more sizzling in a field of blue than it would in a field of yellow. And you may feel that red is hotter than yellow. But most artists agree about a general sense of warm and cool.

An important concept to understand is that warm colors advance in a painting, and cool colors recede. This allows you to create spatial depth in your paintings. Temperature contrasts also make for some exciting color stimulation.

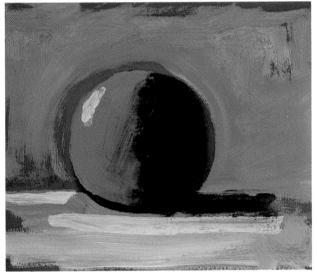

Here warm yellow and orange were scumbled over a cool blue-violet using a palette knife. The warm colors jump forward, pushing the remaining blue-violet shapes further into the painting for a sense of depth.

In this example, a cool blue was scumbled over yellow and orange with a brush. Notice how the scumbling process allows bits of the first color to show through. Even though the cool color was laid on top of the warm, it still sinks deep in the space with the warms leaping forward.

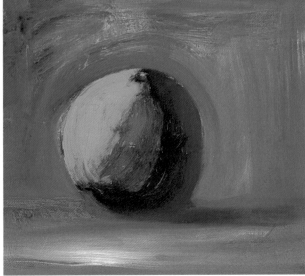

Margaret Kessler

Achieving Color Harmony

Are you aware that, when you enter an art gallery displaying similarly sized canvases, color is typically the factor that first draws your attention to a specific painting? Only after absorbing the emotional impact of the color do you view other elements—design, subject matter, linear movement, focal point, brushwork.

The problem is, we have preconceived ideas about color. We think the sky is blue, clouds are white, grass is green, and mountains are purple. When a task is too complex for us, we tend to paint it according to our preconceived ideas—only to discover that our painting lacks unity, atmosphere, and emotion. There is no magic because the picture lacks a feeling of light, illuminating, reflecting, and bouncing colors around within the scene and creating color harmony.

You must forget these preconceived notions and learn to observe subtle color relationships. Train your eye. Instead of seeing "things" like green bushes, analyze relationships—the green vine is orange-green when compared to the blue-green shrub and the yellow-green bush. Or compare temperatures—the vine is warmer than the shrub and cooler than the bush. Then, keeping in mind overall tonality, unify your color scheme by modifying these local colors with the color of the light. Remember: Local colors are influenced by the color of the primary light source (time of day and weather conditions), the environment (air pollution), and reflected lights (from nearby surfaces and the sky itself).

The key to establishing color harmony lies in maintaining a predominantly warm or predominantly cool picture. No half and half: Using two color schemes in one picture produces total chaos.

One way to maintain temperature dominance is to tone your canvas with one overall color and allow it to show through your finished painting. Almost any set of colors can be pulled together in this way. Another technique is to use a "base" color. Let this color—a warm or cold dark such as brown or purple—come into play from the very beginning stages, when you draw the scene on the canvas. Then allow traces of this color to appear here and there throughout your finished picture, thus harmoniously uniting the color scheme.

These techniques can, of course, be combined. You can also establish a dominant color temperature by deliberately exaggerating one color—preferably the color of the light—to create a "golden" picture or a "blue" picture.

Working with Traditional Color Schemes

The first step is to choose the overall color temperature—predominantly warm or cool. After you have selected a subject, visualize it in warm tones and then in cool tones. Since there are no right or wrong color schemes, trust your instincts. Make a decision based on the colors you see and the lighting effects of the moment.

Within the framework of your chosen temperature theme, explore one of the many conventional color schemes that have been passed on from generation to generation. Try a limited palette or use related colors, working with analogous, complementary, or triad color combinations, to name a few. Don't randomly choose colors when you're in the heat of battle.

To develop the color harmony in your painting, use thick paint and large brushes, blocking in large masses of color. Rhythmically orchestrate masses; don't dab spots. Adjust the masses as you work until you have an orderly arrangement of attractive colors. Using your underpainting as a value guide, concentrate on color temperature and intensity. Place your most intense colors at the center of interest. Balance your colors; even a predominantly warm painting needs a few cool accents, just as bright colors need a few neutrals for contrast. Avoid details until you have a compatible variety of colors on your canvas.

Using a Limited Palette

Restricting yourself to a limited number of colors simplifies the painting process. Color is downplayed, while design, subject matter, and execution are emphasized to communicate the mood of the scene. If you choose to use two tube colors, select one warm and one cool, so you can push and pull with color temperature to establish depth. For a three-color painting, select some form of red, yellow, and blue. *Alley Cat* was painted with Acra red, cadmium yellow medium, and ultramarine blue, as well as yellow ochre. To establish the effect of the light and thereby unify the colors in the painting, Margaret Kessler toned her canvas with yellow ochre and let this color show through the finished work. She chose a dark, cool theme to emphasize the spot of warm light enjoyed by the cat—the center of interest.

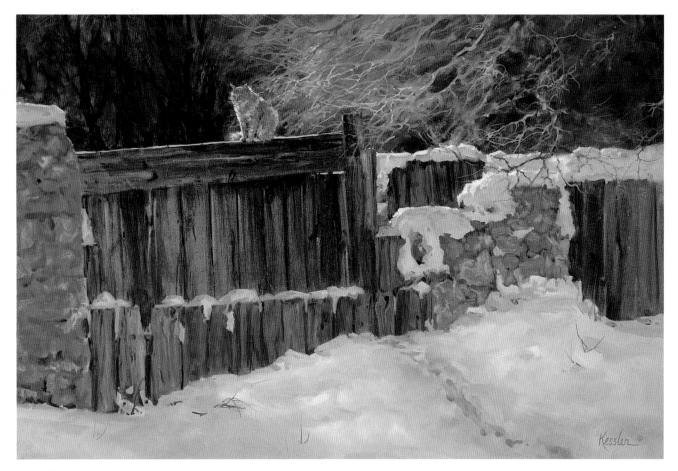

ALLEY CAT
Oil on canvas, 24 x 36" (61 x 91 cm), 1986,
collection of J. and S. Webb.

Margaret Kessler

Analogous and Complementary Color Schemes

Conveying an emotion while working within the context of a dominant color temperature is relatively easy when you use analogous colors (colors next to each other on the color wheel). For *Desert Canyon*, for example, Margaret Kessler chose a purple theme and then subtly stretched this color in both directions, toward red-purple and blue-purple. The golden green accents complement the warm purples, adding vitality to the scene. Overall, the magical quality of the evening light is captured through a warm undertone (yellow ochre, cooled with cadmium red deep), a purple base color, low-key values, analogous colors, and muted tones. Kessler deliberately avoided any spots of bright, intense color, which would have jumped out of context.

In *The Little Red Shed*, Kessler used complementary colors—red and green—to create visual excitement through contrast. When using complements like this, it is especially important to create a dominant warm or cool color theme.

Large masses of complementary colors, as seen here, are assertive, whereas small dots of complementary colors will mix together when viewed from a distance. If you make these dots the same value and distribute them equally, they will neutralize each other, appearing gray or brown. Also, a color is influenced by the colors around it and appears different when placed in a different setting. A spot of dull red, for example, looks warmer and brighter when surrounded by green than when placed beside a close relative such as purple. A cool gray looks blue when placed in an orange setting. Work with this principle to control your colors.

You can use the complement to reduce the brilliance of any color. But rather than mix pure red with true green to neutralize it, try using a neighboring color such as orange-red, thereby keeping the new color exciting, not static and dull.

In *The Little Red Shed*, Kessler did not paint a red building and green trees with blue sky and water—

preconceived ideas. Instead, she painted the effect of the hot, late afternoon sun on the scene, warming the greens with reds and thus relating them to the red shed. She also bounced some greens onto the red shed, especially on the shaded side,

and then reflected these colors into the water. By repeatedly bouncing the complementary colors through the painting and adjusting the local colors, she related the objects to their surroundings and unified the overall color scheme.

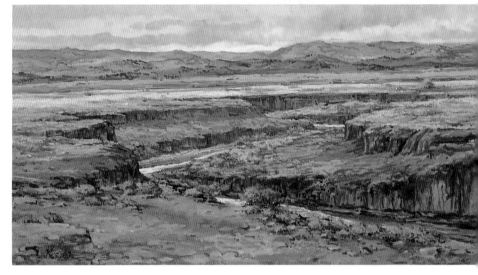

Desert Canyon
Oil on canvas, 18 x 36" (46 x 91 cm), 1985, collection of City National Bank.

The Little Red Shed
Oil on canvas, 18 x 24" (46 x 61 cm), 1983, collection of Texas Green Inc.

34

Triad Combinations

Increase the range of your color presentation by working with triad colors—three points, regularly spaced around the color wheel. Within a triad color scheme, you can handle the full rainbow of colors and still create a sense of order in your picture—just maintain that predominantly warm (or cool) theme. Remember: Warm or cool, blue, gray, green, or gold, the sky is very important in establishing color harmony in your picture, so reflect its color repeatedly throughout your painting.

A triad combination of orange, green, and violet is ready-made for landscapes—especially an autumn scene like *Foothill Cluster*. There are many other triad color schemes. Study a color wheel and experiment with all the combinations. See which ones will adapt readily to your chosen mood.

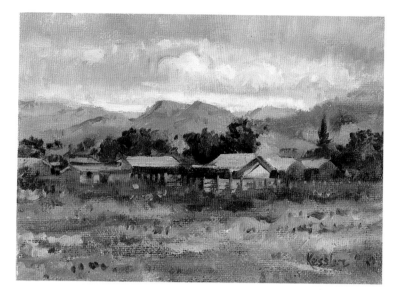

FOOTHILL CLUSTER—
A SKETCH
*Oil on canvas, 5 x 7"
(13 x 18 cm), 1984.*

Painting a small preliminary sketch like this gives you the opportunity to develop a workable color scheme without investing a great deal of time. Here, the sketch also helped solve the dilemma of what to emphasize—village, mountains, or sky. Depicting all three clearly would overwhelm the viewer.

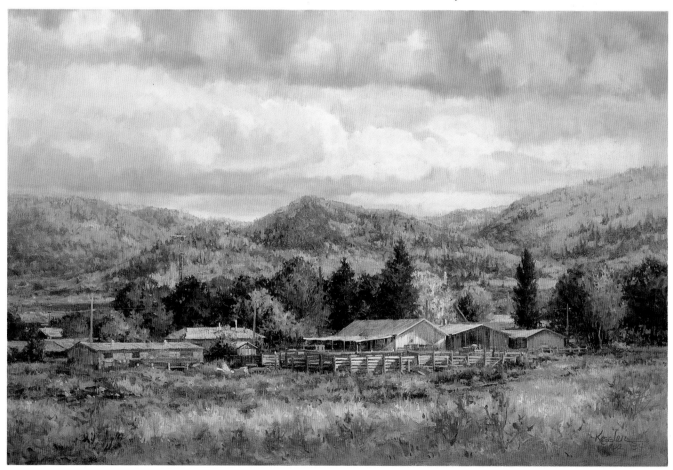

FOOTHILL CLUSTER
Oil on canvas, 24 x 36" (61 x 91 cm), 1984.

Charles Reid
Mixing Lights

Pure white or a cool white often appears less white than white paint with a touch of warmth. So if a white looks dead, a touch of cadmium orange will give it life. Even if the area is cool, if you really need a light light, add a touch of warmth to the white.

Look at the swatches shown here and note the large proportion of white pigment compared to the small amounts of strong colors like cadmium orange, cadmium red, and alizarin.

Mixing Warm Lights

To mix warm lights, always start with white, then add the smallest touch of color to it. If you add too much of a strong color like cadmium orange, you'll just end up wasting a lot of white paint to get the white you want. If this should happen, rather than try to add more white to the mixture, just start a fresh pile of color—but this time take less cadmium orange, or add a touch of the first mixture instead of the pure color to the white paint.

These swatches are just a few examples of the colors you can add to white and still have it read as "white." Interchange the colors in your own swatches and try adding other pigments that might work better for you. Here are the colors that were used to make the warm lights:

A. Titanium white, cadmium lemon, cadmium orange

B. Titanium white, cadmium yellow light, cadmium lemon, alizarin crimson

C. Titanium white, cadmium lemon, cadmium yellow light, cadmium red

D. Titanium white, cadmium lemon, alizarin crimson, cadmium orange, cerulean blue

Sometimes adding only one warm color to white is enough. You don't have to add several colors—it all depends on what you want. On the other hand, the last swatch is a nice combination of colors that suggests both warm and cool tones. Try this one without orange, too.

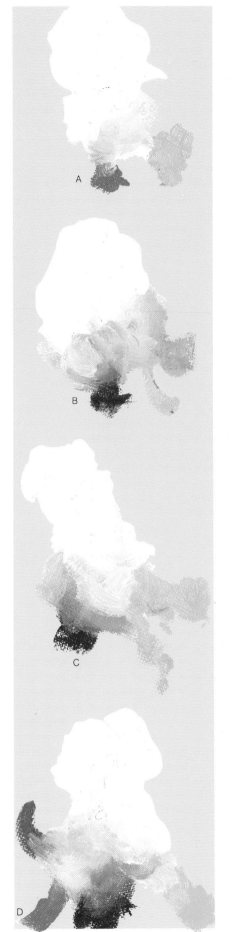

WARM LIGHTS

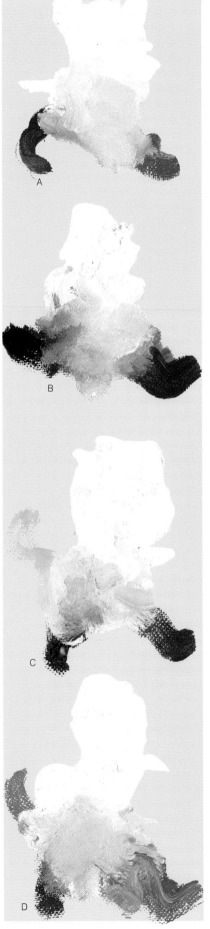

COOL LIGHTS

36

Mixing Cool Lights

Here are some ideas for mixing cool lights:

A. Titanium white, cerulean blue, alizarin crimson

B. Titanium white, ultramarine blue, alizarin crimson

C. Titanium white, phthalo blue, alizarin crimson, cadmium lemon

D. Titanium white, cerulean blue, alizarin crimson, cadmium orange

Also try the last two examples without the respective complements, yellow and orange. These colors add a nice mellow quality to the white, but they also neutralize the color. (For example, swatch A is the same as swatch D, but without the orange.)

In making your swatches, try not to overmix your colors. Keep the color identity of individual hues visible in some areas of the swatches, along with a small area of completely blended color.

Handling Lights in a Painting

Charles Reid established the color scheme of *Friends* early. Indian red, a dominant color, was tempered with raw sienna, yellow ochre, and viridian. He spent a long time deciding the color of the windows, and ultimately made them a cool white with alizarin, a little cadmium lemon, and cerulean blue to balance the young man's jacket. Although the jacket itself was basically cool, Reid added some yellow ochre to the cool gray mixture to tie it in with the rest of the surroundings, which were warm.

The young woman's trousers are a dark blue mixed with ultramarine blue and alizarin. Reid didn't want them too dark, so he added some cerulean or cobalt blue to the mixture to lighten it. He tries never to add white to very dark colors. Instead, he looks for a color in the same family that will lighten it at the same time. In the same vein, he lightened the shawl with yellow ochre (not white). But he did add white to lighten the gray jacket, because white was already in the gray and adding more wouldn't damage the color. In short, the main idea is to use a specific color (not white) to lighten any dark area that has a definite color idea. Since white tends to neutralize color, add it only to a neutral or gray area.

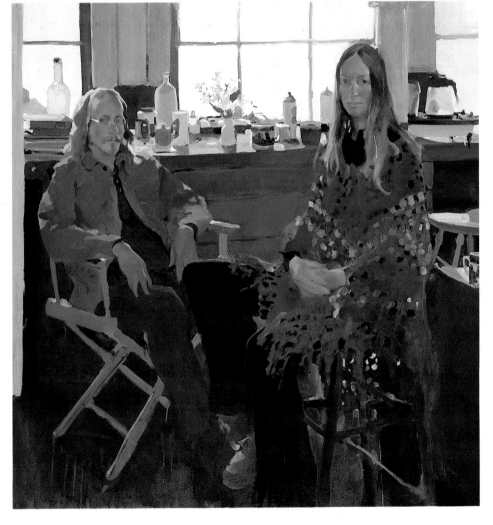

FRIENDS
*Oil on canvas, 50 x 50"
(127 x 127 cm), collection of
Smith College, Northampton,
Mass.*

Charles Reid

Mixing Darks and Grays

Charles Reid rarely uses black to darken a value. He likes black for its own sake. It can be a clean dark if your painting is too colorful and you need a foil. Manet used black to great advantage in his paintings, not as an additive but for contrast. Reid mixes black only with dark earth colors or with dark greens and blues. The only time he uses black with a light-value color is when he mixes it with a yellow or ochre to manage a green.

When you darken values, try to avoid mixing complements, because they can muddy a painting unless you're really skilled at using them. Keep your darks pure. Stay within a color family as best you can—but do experiment. You can get, for instance, some really nice darks by combining alizarin crimson and phthalo blue.

Mixing complements gives you what we call grays. They can be great for very rich darks if you don't overdo it; think of these mixtures as dessert. A good combination is alizarin crimson with viridian.

Avoid cadmium red as a mixer—it and some other reds can be too pasty. Reid uses cadmium red only when he needs to quiet a green, or when he is painting flesh tones; otherwise, he uses alizarin crimson as his mixing red.

The examples you see here are just a few of the possibilities. (A touch of white has been added to each swatch to show a slightly lighter value.) Note that there are cool and warm variations in these mixtures, something you should aim for as you experiment with different color combinations. Note, too, that nothing is homogenized: Darks and grays should have the life of the individual colors from which you mix them.

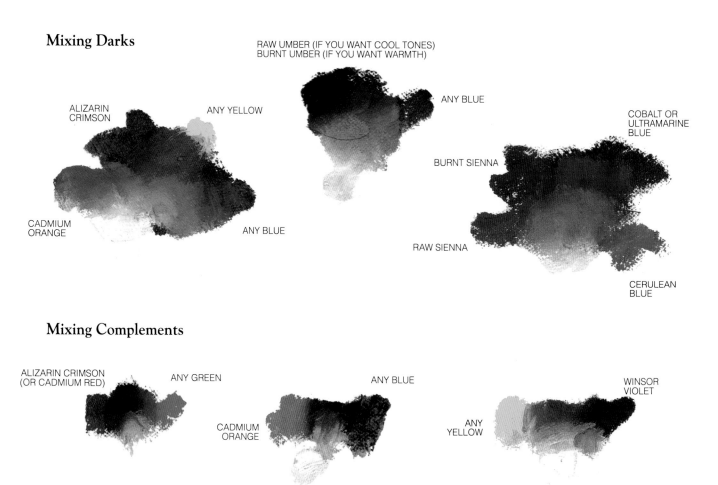

Mixing Darks

RAW UMBER (IF YOU WANT COOL TONES)
BURNT UMBER (IF YOU WANT WARMTH)

ALIZARIN CRIMSON

ANY YELLOW

ANY BLUE

COBALT OR ULTRAMARINE BLUE

BURNT SIENNA

CADMIUM ORANGE

ANY BLUE

RAW SIENNA

CERULEAN BLUE

Mixing Complements

ALIZARIN CRIMSON (OR CADMIUM RED)

ANY GREEN

ANY BLUE

WINSOR VIOLET

CADMIUM ORANGE

ANY YELLOW

Mixing Flesh Tones

Everyone always wants to know what colors to use for flesh tones. Unfortunately, it's not just a matter of mixing the correct colors. The colors you use really have very little to do with getting a good skin color. What does matter is the quantity and proportions of the colors in the mixture and where you place them on the figure, and how you mix and relate them to the rest of the picture.

The colors Charles Reid mixes for flesh are very simple. He uses a red (cadmium red) and a yellow (cadmium yellow or cadmium yellow light or yellow ochre or raw sienna) for the warm areas. Then, to cool them, he uses cerulean blue for the light areas and viridian green for the darks.

Reid has no set proportions, though he tends to use more cadmium red in the mixture than cadmium yellow because the yellow is a stronger color. He uses the same colors in both the light and shadow areas. The only difference might be substituting raw sienna for yellow ochre in the shadow.

There are no unique colors for painting the flesh of blacks, Hispanics, or any other racial group. The colors Reid uses are always the same. The difference is in the proportions of certain colors and how dark he makes his "light" wash. For example, he uses the same colors for the *shadow* of a white person that he would use in the *light* areas of a black person. It's true that on a dark-skinned person the colors would generally be darker and certain hues may seem more apparent—we might, for example, be more aware of the blues. But blue tones are on white skin, too. In fact, the mixture for a person with fair skin would have more blue and less red-yellow than, say, a person with olive skin. That's why there are no set formulas for painting flesh tones—because the proportions of the colors are as varied as the colors of each individual.

The proportion of warm to cool color also depends on the clothing the person is wearing, since the clothing reflects its colors onto the skin. It is also influenced by the colors of the surroundings and the color idea of the painting. You can never separate the flesh tones from the rest of the picture. You must harmonize and relate all your colors. Thus, a warm complexion surrounded by cool color might look "off" unless both areas are integrated.

Here are the basic flesh tone mixtures Charles Reid uses, as illustrated by the swatches at right:

A. Titanium white, cadmium red, cadmium yellow. Try this basic combination first before adding a complement like blue or green.

B. Titanium white, cadmium red light, cadmium yellow pale (or cadmium lemon, cadmium yellow, or any other yellow you'd like to try), cerulean blue or permanent green light. This is the basic light flesh tone Charles Reid uses. He might mix all of the above as a single complexion color, or he might use only the red and one of the yellows with a complementary color. Don't look for a formula. You must experiment!

C. Titanium white, yellow ochre, cadmium red, any one of the cadmium yellows, cerulean blue or permanent green light. This makes a subtler flesh tone. It's less vibrant than the others because the yellow ochre is so quiet, but is included here because some students have trouble with yellow. They tend to add too much and their mixtures get too orange.

D. Titanium white, raw sienna or yellow ochre, cadmium yellow, viridian or cobalt blue or ultramarine blue. This is a darker mixture than the others, and is useful for shadows or darker complexions.

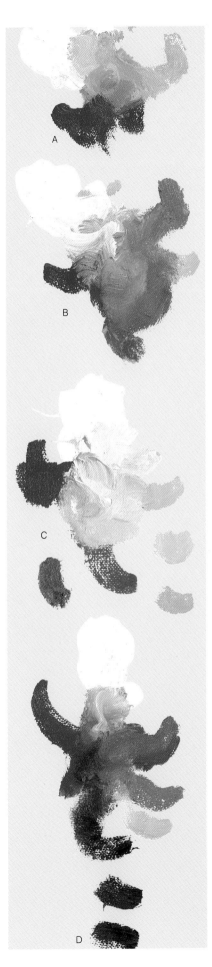

Charles Reid
Mixing Greens

If you were to look at a single leaf on a large bush, green is the initial color you'd see. But if you wanted to capture that scene on canvas, painting the entire bush "green" wouldn't be the answer. If you were to look at the scene more closely, you'd probably see other colors—purple-blue grays in the distant trees and cool, milky grays and yellows in the bush itself—that you'd want to include in your painting. But unless you have done a good deal of landscape work, you may find that green is the hardest color to mix.

The swatches shown here range from the obvious green-yellow blends through blue-yellow mixtures to more complicated combinations involving the addition of a complement with white. When you make your own swatches, experiment by substituting several yellows for the one suggested here. Don't worry too much about what they're called. Just notice whether they're warm or cool, and whether they appear to blend well or dominate a mixture. Naturally, this applies to all colors, not only yellow. Every manufacturer has different formulas for their colors, so one

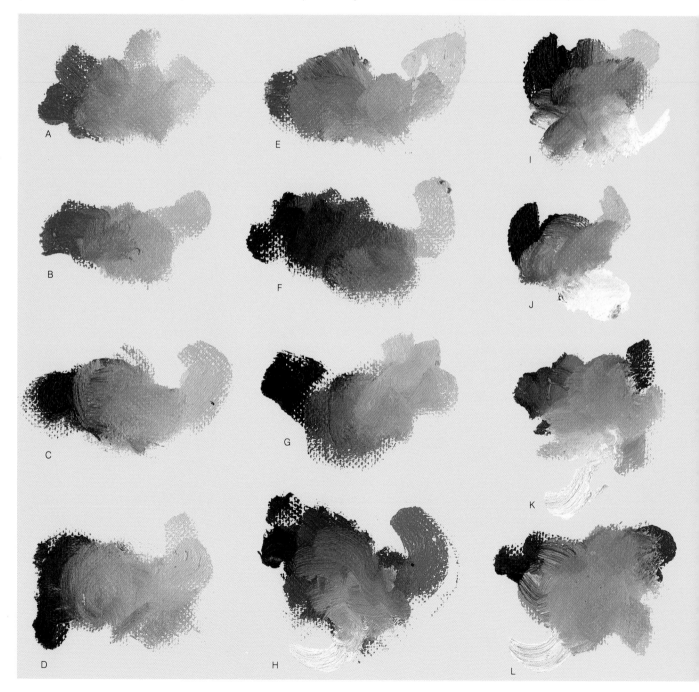

cadmium red might look almost like an orange, while another might look like a cool vermilion red. Yellows especially seem to vary a lot. As for blues, Grumbacher's cerulean blue is very opaque, while Winsor & Newton's cerulean is much more transparent.

Warm and Cool Greens
When you mix greens, you must be aware of which of your tube colors are warm and which ones are cool.

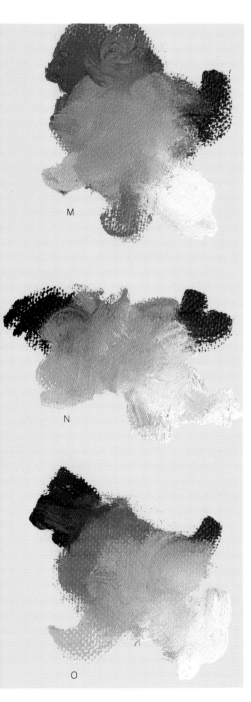

Naturally, it would make sense in mixing warm greens, for example, to start with a set of warm yellows and warm greens, and in mixing cool greens, to start with cool colors. To see how this works, have a look at the swatches.

Swatches A through D were mixed only from warm and cool versions of green and yellow. Swatches E through H were mixed from warm and cool blues and yellows. (Of course, all blues are cool, but some are relatively warmer than others.) Swatches I and J were mixed from ivory black and yellow. White was deliberately omitted from all these mixtures, since it cuts the intensity of the color. Also, it's helpful to see first how the mixtures look with pure color before lightening or otherwise changing the mixture.

The rest of the swatches, K through O, consist of three colors plus white. These mixtures are the most interesting color combinations. Notice that within each of the three-color mixtures there are possibilities for both warm and cool greens, depending on the amount of yellow. The white both lightens the mixture and makes it more neutral. Of course, these mixtures represent only a few of the possibilities. You can find many more by interchanging the colors or trying other colors and combinations that might work even better for you. So don't look at these swatches as "rules for painting greens." See them as tools to help you start experimenting. Never feel you must always use a certain yellow or a certain green or blue.

As in any mixing situation, you must get to know which colors dominate in a mixture and which colors are weak. A little bit of cadmium yellow, for instance, goes a long way. And since cerulean blue is a comparatively weak color, when you mix the two, you'll need to add more cerulean blue and only a little bit of the cadmium yellow to make a green.

Gregg Kreutz
Devising a Color Strategy

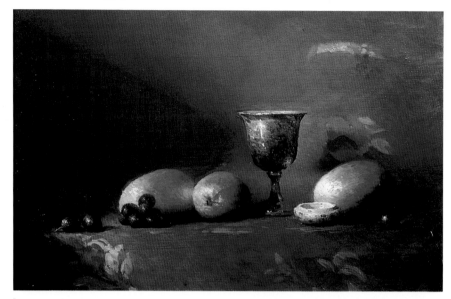

Arbitrarily putting a lot of bright colors on the canvas can create a vivid look, but not necessarily a harmonious one. To achieve harmony, you must have a color idea for your painting. A good painting is a unification of opposing elements, or polarities: big and small, sharp and soft, dark and light, and so on. A painting looks "in color" when some sort of color polarity is presented. For example, yellow and purple are opposite each other on the color wheel, and consequently there's a tension between them. The artist can exploit that tension to create energy in a painting by directing it toward the interplay of those two colors. One of them should be what we might call the focus color—the color of the center of interest—and the other should be the surrounding color. In general, the focus color should be the warmer of the two. A green/red painting, then, would describe a red center of interest surrounded by a green environment. The colors needn't be exact opposites for this concept to work. Green and orange or green and purple also create a dynamic. But the colors have to be fairly different; blue and purple or red and orange can look nice together but are too close to work as an opposite-color concept.

Another idea is to juxtapose noncolor with color. Noncolor doesn't necessarily mean gray (gray is maybe a little too assertively cold to be neutral); it means a hue that's almost unidentifiable—something like a dull umber or a pale olive. In a picture, the effect would be a lot of dull color surrounding a colorful object.

In the still life at top, the color concept is orange and green. The mangoes look vivid because they're set against the cool green of the background. In the still life at bottom, color against noncolor is the strategy: the pink of the carnations set against the dull brown of the background.

Keeping Color Pure

Colors dull as they're mixed together. It's commonly said that you shouldn't use more than three colors in a mix. In the first place, more than three colors is redundant; if you're mixing a brown, and you've used red and yellow and blue, and you then add orange, you're repeating what the red and yellow have already achieved. The second reason to limit your choices is that you want the mixtures to solve problems rather than create them. In other words, the components of the color you want shouldn't be so numerous that you have to spend a lot of time refiguring out what they were and how much of them you used. The process should be: "This flesh color could be approximated with orange and white and blue." From that point on the only decisions to make are ones of proportion. That's the ideal, though the reality is often sloppier and less well thought out.

If you're painting something with a lot of color in it, try to match that chroma with pure color. If someone's wearing a brightly colored shirt, or a flower has some bright petals, that's the opportunity to use some straight-out-of-the-tube vividness. Sometimes you can get so used to modifying and toning down the colors on your palette that you're reluctant to use the unmixed color that's there. But it's a terrific effect to have some vibrant hue shining out against muted surroundings. In Rembrandt's time colors were expensive, and bright colors were the most expensive of all, so artists would build their whole pictures around a small bit of these beautiful, costly hues. They showcased the color the way a jeweler showcases a diamond. Today, when oil paints are so much more accessible and affordable, it's easy to lose that reverence and either put bright color everywhere or dull it everywhere.

In the still life at top, the nectarines are painted with a low chroma; the color fits into the color world of the painting almost too well, and there's no color excitement being generated. In the still life at bottom, however, bright cadmium reds and oranges were applied directly to the nectarines. Getting some strong color into the picture gives it flair and presence.

Gregg Kreutz
Painting the Colors of White

Things that are white—clouds, tablecloths, snowbanks, refrigerators—can't be painted with straight-out-of-the-tube white. A false white needs to be mixed up that looks the way white does in the picture's color world. Why doesn't straight white work? Because there's always some part of a white subject that's brighter than another part. A refrigerator, for example, consists of a series of planes that go from dark shadow to middle tone to light, with a highlight along the edge of the object facing the light. Each of these transitions represents an increase in brightness. Yet none of the different facets of this one "white" object is really white.

The problem of what color to use for dark white isn't usually solved with gray. Gray looks like gray, not white.

If you're painting white sheets and you use a flat gray to depict them, they'll look like gray, which is to say dirty, sheets.

The best approach is to use the color world of the painting as a guide. White in a greenish environment would have a green cast to it, white in a blue environment would have a blue cast, and so on. If your painting is built around an orange/blue color strategy, orange and blue and white mixed together should create the right kind of neutral "dark" white you need. Complements mixed together neutralize each other, and if you add white to such a mixture, you'll get a nice dark neutral that will fit into the color scheme.

In this still life the white cloth was created by mixing white into the burnt sienna and cobalt blue components of the background color.

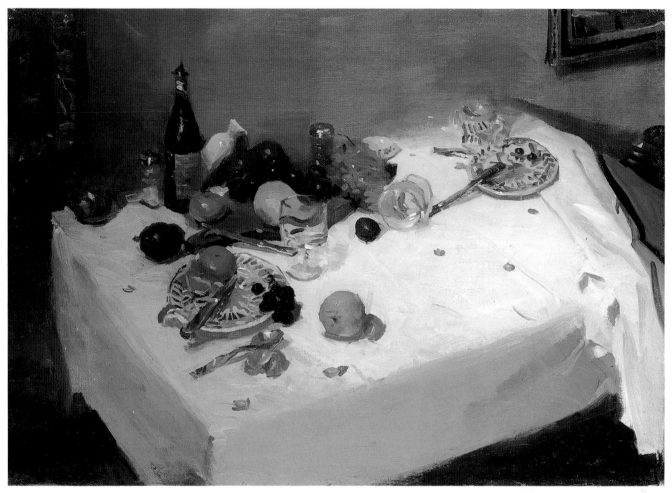

DESSERT COURSE
Oil, 16 x 23" (40.6 x 58.5 cm), collection of Keith and Bernadette Keenan.

The tablecloth here was a bluish white, so Kreutz used a mixture of cobalt blue, orange, and white to depict it. There was a partial cast shadow on the left-hand side of the table, so he used less white in that area.

MRS. LUNNING'S BATHROOM
Oil, 18 x 32" (45.7 x 81.2 cm), private collection.

There's a lot of white to deal with here. The only relief from it are the washcloths, the mug, and the shower curtain. Yellow ochre, green, and white are what Kreutz used to simulate the white of the walls, and for the towels he added a little blue to the mix. What the artist liked about this bathroom, and what he wanted to capture, was the flow of light from the high window.

Alfred C. Chadbourn

Finding the Color of Light

Chip Chadbourn's first impression of this scene was of the play of late sunlight on the simple white building in the foreground, accentuated by the strong cast shadows in the grass. In his initial sketches (not shown), he suggested a building on the right, which cast the shadow, but in the end he left it out, as he thought it would be more interesting to make an L-shaped composition, using the vertical shape of the white building against the horizontal of the cast shadow. The other buildings then fell into place, forming a jumble of geometric shapes against the calm water.

Having decided on the general composition, Chadbourn faced the problem of transforming light into color. First, he pushed the dark greens and exaggerated the cool shadows on the buildings. This gave him the chance to build up some rich, thick pigment in the lights, which helped to establish a strong feeling of late afternoon light. He had to paint the grass several times until he caught the effect he was after. This is important: Don't settle for the first colors you put down. Keep trying to push color to its fullest possibilities.

The numbers in the following list of color mixtures correspond to those in the illustration.

1. The dark greens are burnt sienna, yellow ochre, and Grumbacher's Thalo green (phthalocyanine green). As you can see in the color swatches, when burnt sienna and Thalo green are mixed together, the result is a dense, almost black color. Adding some yellow ochre to this mixture gives it a little more luminosity, so you can see into the shadow.

2. The shadows of the buildings are done with a simple mixture of yellow ochre, ultramarine blue, and white. The amount of blue added to this mixture determines how cool the shadow appears.

3. Then, on the light side of the building, a small amount of yellow ochre is added, along with white, to make the lights more luminous.

4. The light-struck part of the grass is a thick mixture of cadmium yellow, white, and Thalo green. Sometimes, if too much white is used, this mixture looks vile, so be judicious.

5. The small green house and the green roofs are painted with Thalo green, yellow ochre, and white—a mixture that is just a bit cooler than the light grass.

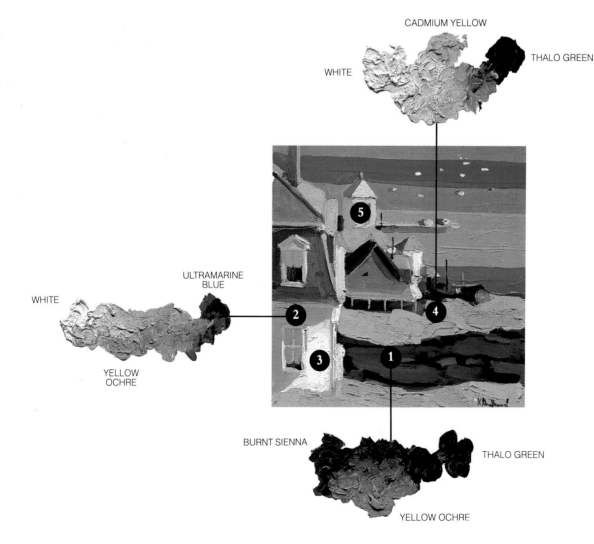

CADMIUM YELLOW

THALO GREEN

WHITE

ULTRAMARINE BLUE

WHITE

YELLOW OCHRE

BURNT SIENNA

THALO GREEN

YELLOW OCHRE

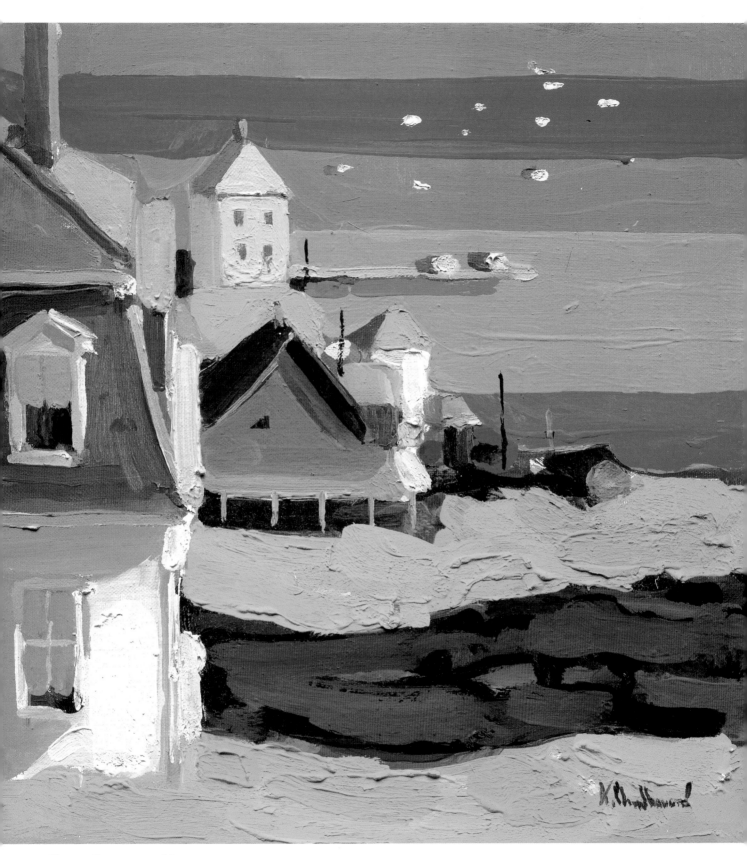

VIEW OF STONINGTON, MAINE
Oil, 14 x 14" (36 x 36 cm), collection of Dr. and Mrs. Daniel Miller.

Charles Le Clair
Integrating Color and Image

Developing a color scheme that is both true to your subject and optically effective is a major hurdle for beginners, who must learn to leave out certain hues and heighten others for a unified color impact. And for an experienced painter, the problem of finding just the right color harmony never quite goes away. Charles Le Clair's struggle with *Banana Grove*—a canvas that underwent four color-change operations before things fell into place—is a case in point.

The problem was to find the right ground color for a rather complicated positive image. As you see, the foreground is dense, with only small, shardlike openings in a jungle thicket. Yet the color of the sky is crucial and Le Clair found that his initial choice of cadmium yellow proved dead wrong. Yellow's bright aggressiveness failed to provide either spatial depth or the lush tropical mood he sought. He tried two more equally unsuccessful experiments—a blue that proved much too shrill and a Venetian red that looked like shadows in the foliage rather than sky.

A Disney animator might have resolved matters quickly by putting the image on transparent film and testing various skies behind it. With oils, however, Le Clair was stuck with the tedium of painting each new color into countless disconnected small openings before an overall effect could be judged. Fortunately, his fourth choice—a deep red sky shading to ochre at the horizon—finally worked. Here, the value is at last deep enough to set off the dramatic lighting of the banana trees. More important, the red background establishes a clarifying red-versus-green polarity for the many colors in the jungle. There isn't a lot of red here, or much true green. Yet once the dominant notes in a "chord" are struck, other colors are perceived in relation to them. Thus the colors in this final version of *Banana Grove* move in a rhythmic arc: in the foreground, from green to yellow-green to beige; then, upward in the sky, from ochre to orange to the opposite polarity, red.

In contrast to the subtle red/green polarity in *Banana Grove*, *Green Dahlia* is based on a more straightforward complementary format. Though the drawing of interlaced leaves and branches is elaborate, the color plan is simplicity itself: a circle of green on a shallow red ground, with a triangle of dark purple in one corner to suggest deeper space beyond.

BANANA GROVE
Oil on canvas, 50 x 72" (127 x 182.9 cm), 1986, courtesy More Gallery, Philadelphia.

The image is unusual in one respect, however, since it is based on an experiment with color reversals. If you have ever looked at a photographic negative, you will recall that the blacks of the positive print show up as white, while white objects are black, and vivid colors appear as their complements. *Green Dahlia* is one in a series of paintings Le Clair based on the abstract effects of such chromatic opposites. Accordingly, here an ordinary red flower on a green bush becomes an exotic jade blossom in an autumnal setting.

As you can see, the experiment also demonstrates how evenly balanced the red/green partnership is. Despite the reversal, a sense of natural growth and sunshine is maintained. And red, which is normally the more aggressive hue, slips comfortably into the role of ground color while green takes over as the positive image.

GREEN DAHLIA
Oil on linen, 58 x 40"
(147.3 x 101.6 cm), 1989,
courtesy More Gallery,
Philadelphia.

Charles Reid
Putting Color to Work in Design

This rough pencil sketch is a compositional study for the painting shown below. In the drawing, the lobster seems too centered and isolated; it just looks like a dark stuck in the middle of the composition. Now look at the painting.

Charles Reid has stressed color in this painting: The lobster was painted with reds right out of the tube, but he used a middle value, not one that's too dark. He applied pure color in other areas too—in the lemons and the apple. But the colors don't seem garish, because he cut the intensity by using complements in several places—purple flowers adjacent to the lemon at center, a green pepper next to the red apple, and so on. There are definite grays as well, both warm and cool—the shading on the lobster's right claw, some of the cast shadows, the bit of wall you see in the background. In a color-oriented painting such as this, the placement of objects isn't as critical as it is in value-oriented paintings. Whereas in the pencil sketch the lobster reads as too dark a shape to work well in an overall design, in the painting, even though the lobster is still the dominant shape, its red color is a middle value that doesn't overpower the composition but is echoed elsewhere and offset by other colors to form a pleasing pattern.

LOBSTER AND MACKEREL
Oil on canvas, 20 x 20" (50.8 x 50.8 cm).

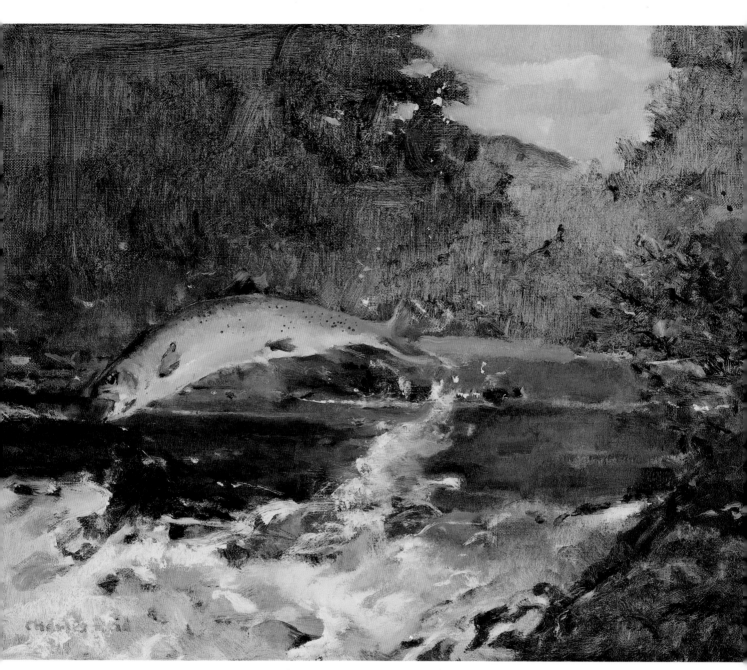

CUTTHROAT TROUT
Oil on canvas, 18 x 24" (45.7 x 61 cm),
courtesy Sports Afield.

Here, Reid used just a spot of red for the fisherman (toward the right in the middle ground) and a speck on the left of the composition as relief from the fish, but these touches also reflect the spots of red in the trout's jaw and fin and help keep the viewer's eye from getting stuck in any one area for too long. The water splash in the foreground helps direct your attention off to the right toward the fisherman. When you have a center of interest that's as obvious as this trout, introduce shapes, colors, and values as diversions that will make the eye move throughout the rest of the painting.

Peter Poskas

Handling the Saturated Colors of a Winter Sunset

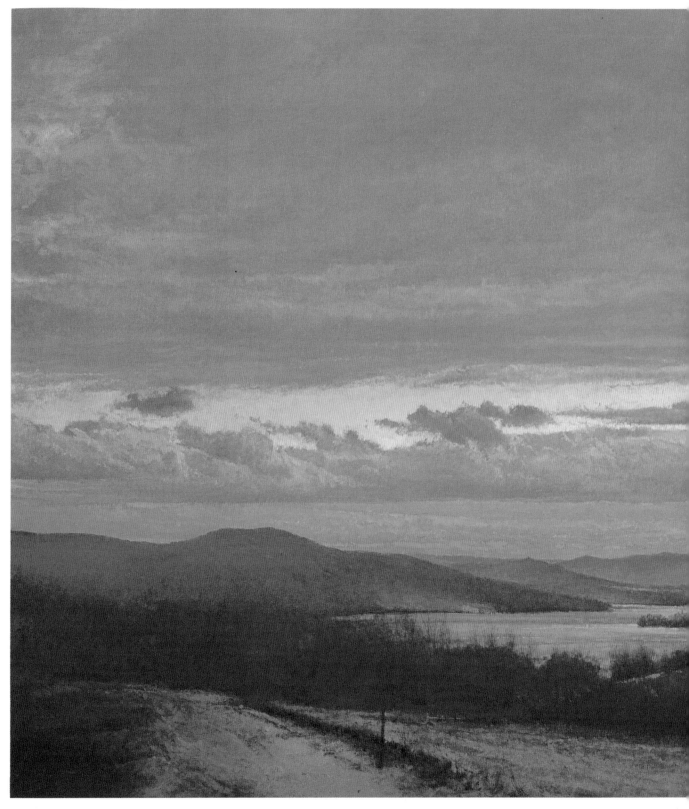

DECEMBER, LAKE WARAMAUG SERIES
Oil on canvas, 26 x 40" (66 x 101.6 cm), collection of National Health Insurance Company.

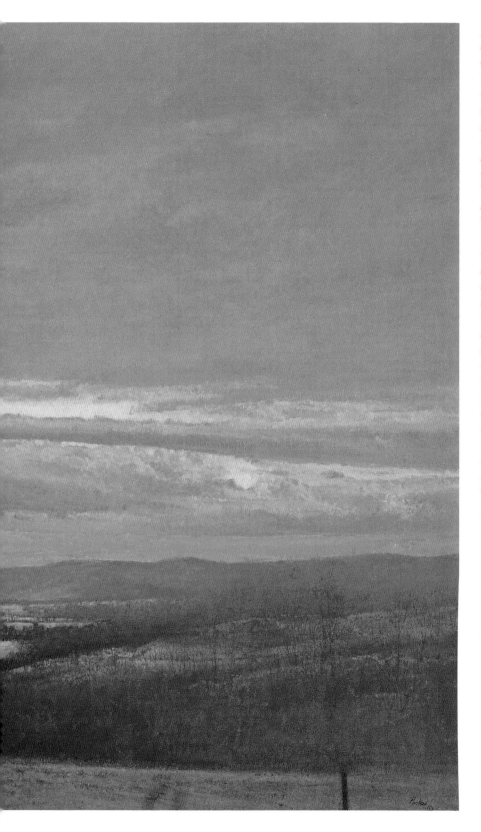

A December storm has left a light covering of snow on the hills, but Connecticut's Lake Waramaug is still liquid at this time of year. The winter wind is riffling the water, breaking up any direct mirror image of the sky into streaks and dots of color. Depending upon the wind's strength and direction, each wave catches color from various parts of the sky. The bands of color are not just yellow, orange, or the color of cloud cover, but a combination of all three.

There is a clarity to the forms here, which is helped not only by the contrast of snow but by the snow's capacity to reflect the warm and cool colors of the sky. In this painting, note the beautiful saturation of warm and cool color found at the horizon line, and particularly the intensity of the violet-purple snow-covered hills bathed in various degrees of the sky's reflecting warm light. The expression of space is suggested here by two concurrent sweeps of land masses: the darker, tree-studded forms of the middle ground and the lighter, more open snowfields of the foreground. The darker tones form a consistent gradation that ranges from lighter/cooler in the distance to darker/warmer in the foreground, but the lighter snow-covered area is in three bands: slightly darker and warmer in the distance; lighter, cooler in the middle reaches; and once again lighter and warmer in the foreground. This variation is caused by the surface geometry of the landscape and also by what these different planes are reflecting. Because of this painting's broken and contrasted surface, there is a dynamic interaction between land, sky, and lake. The sky is brought down into the land through the reflecting snow and water; land patterns are brought upward into sky through the contrasting bands of cloud surfaces.

TECHNIQUES

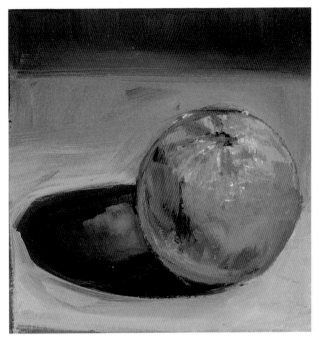

Pursuing the idea of working on a colored ground, M. Stephen Doherty filled a square area of his painting surface with a uniform application of Acra red, then added a circular form on top of it with cadmium orange. His intention was to establish a bright, vibrant ground on which he could create a very expressive presentation of the subject.

Here, using a flat bristle brush, Doherty applied fairly thick strokes of oil color on top of the red ground, exaggerating both the color of the orange and the shadow areas. For example, a stroke of blue marks the edge of the shadow directly under the orange.

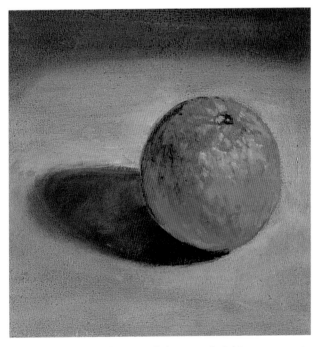

This demonstration aims to show how both underpainting and overglazing can affect the presentation of a subject. A solid square of burnt umber was first painted and allowed to dry, and then the orange and background were painted.

After the surface was dry again, Doherty applied thin, transparent mixtures of the same burnt umber. The result was a softer, more atmospheric presentation of the subject.

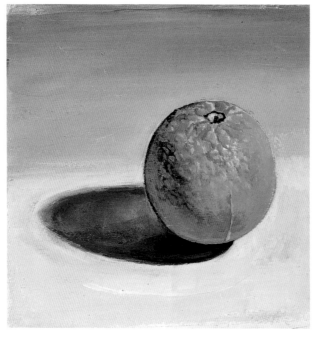

This grisaille painting was done with a series of graduated mixtures of Mars black and titanium white. Once the grisaille underpainting was thoroughly dry, thin, transparent glazes of color were applied over it, causing an immediate transformation of the picture even though very little pigment was used. In this case, Liquin was the medium used to prepare the glazes.

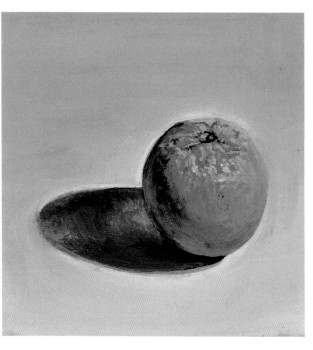

Here, a cold gray color—one that matched the mid-range value of the backdrop—was applied over the entire area to be painted. As reproduced here, the finished painting of the orange looks very much like the one executed in the grisaille technique shown above. If you could see the actual paintings, however, you would note an obvious difference between the two. The grisaille example has a smooth, detailed surface, while the example painted on a toned ground has a coarse, generalized appearance, because the colors had to be built up over the gray underpainting.

M. Stephen Doherty

Some Basic Techniques for Applying Oil Paints

For centuries the most influential works of art have been created with oil paints. Among the great advantages of the medium are the variety of ways in which it can be applied, the luminous colors, and the ease of application on large-scale surfaces. On the next few pages M. Stephen Doherty demonstrates a range of approaches to working with oil colors by painting the same subject six different ways, following practices employed by many artists. All six demonstrations were done on a sheet of 100 percent rag paper covered with two coats of acrylic gesso.

Creating a Grisaille Underpainting

One of the most academic and traditional approaches to oil painting is to begin with a grisaille underpainting, a monochrome painting executed in shades of gray. Thin glazes of color are then applied over this gray tonal painting to create the actual appearance of the subject. The idea is to first establish a solid value composition (especially when the aim is to produce a three-dimensional effect) before introducing color in the picture. In the French academies of the nineteenth century, students would spend years perfecting their skills in making charcoal drawings and grisaille paintings before ever being allowed to mix and apply color to a canvas.

The simplest way to do a grisaille painting is to use mixtures of black and white paint. Another approach is to use combinations of warmer or cooler grays to make the underpainting; these could be mixed from burnt umber, sap green, ultramarine blue, and white.

Several different mediums, either those available in a premixed form or ones prepared in the studio, can be used to thin oil paints in preparing the transparent colored glazes. A combination of turpentine, stand oil, and copal varnish is one of the most common glazing mediums, as is Winsor & Newton's fast-drying alkyd medium called Liquin.

Working on a Toned Ground

Another fairly traditional approach to oil painting is to work on a canvas that has a ground, or uniform covering, of a medium-tone color. One advantage of this method is that it makes judging value and compositional relationships easier. Typically, an artist working on a toned ground will quickly lay in the brightest highlights and the darkest dark masses of the subject; this allows him or her to make a preliminary evaluation of the composition and then adjust the elements. A second advantage of working on toned grounds is that the underlying color will show through the semitransparent layers of oil color, thus establishing a uniformity in the composition. A landscape painter might like a burnt umber or a burnt sienna glowing underneath the greens and blues of the painting, while a portrait painter might want a rosy red ground to enrich the subject's flesh tones.

Next time you are in a museum, look at the older portrait paintings and you will likely see very thin, dark passages and heavily painted highlights. You can tell from seeing one of these portraits what kind of result you might achieve by working on a toned ground.

Glazing

Painting several glazes over a canvas helps to unify the colors within the picture and soften the overall presentation. The technique is particularly useful for achieving subtle transitions of flesh tones in a portrait or a misty hillside set in the deep space of a landscape painting. The glazes can be selectively applied to certain areas, changing the color or opacity as each part of the picture is developed, or brushed uniformly across the canvas.

Starting with an Underdrawing

It is very common to begin an oil painting by first making a rough drawing of the subject on the canvas with either thinned, dark oil color or sticks of charcoal. Soft charcoal is preferred to pencil or ink because it does not scratch the gessoed surface; it also gives a clear definition to the subject, and can be obscured with subsequent applications of oil color.

Applying Oils in a Painterly Fashion

The term *painterly* indicates a fairly thick application of paint, with the marks of the brush bristles remaining apparent. To achieve this quality, artists tend to generalize the appearance of the subject, allowing the viewer to freely interpret what he or she observes.

Oil Sticks

Among the newer art products that have attracted the attention of oil painters are oil sticks, which work like fat, soft crayons. Oil sticks can be used to sketch in the subject with lines of color that are then thinned with strokes of turpentine or built up to create a thick layer of paint.

You should be aware that when exposed to air, oil sticks "skin over," meaning that they dry out enough to develop a hard outer crust (typically on the edges and tip of the stick). The hardened paint must be cut or scraped off before you use the oil stick.

As a guide for the subsequent application of paint, Doherty first drew the orange on his gessoed surface with a stick of vine charcoal, then lightly sprayed it with fixative.

He then applied oil paints over his drawing in a fairly loose, free manner that is often referred to as a "painterly" style.

For this demonstration Doherty first sketched in the subject with Shiva's Artists Paintstik and allowed the rough drawing to dry completely.

He then applied moist oil color with a flexible palette knife. All of this could be described as an impasto painting technique, one of several that result in thick, highly textured painting surfaces.

Michael Crespo
Working with Thin Paint

If you've ever painted in watercolor, you know the delicacy of thin, watery washes gushing across the surface of the paper, finally settling in, staining, but never completely masking the whiteness of the ground. Oil paint can be approached similarly, with flowing, diluted colors and the textured white of canvas playing major roles in the finished painting.

In the most common process of constructing an oil painting, the initial drawing is made on the canvas, and then colors heavily diluted with turpentine (known as turp washes) are applied. These washes can be manipulated easily and the white of the canvas can be quickly reexposed with the swipe of a rag. Highlights can be added this way without using white paint. Charcoal and pencil corrections can also be redrawn into the washes. This procedure is referred to as laying in a painting. Normally it is an exploratory period of trying out colors, values, and placements that will form the matrix on which thicker, more refined, more opaque colors will be applied, establishing the denser surface of a finished work.

When you apply thin paint on stretched canvas, the fabric absorbs more of the color as stain, and the weave provides textural dimension. On Masonite or canvas board, the paint tends to stay on the surface, exposing more brushwork. You may have to work with your support flat on a table to keep the paint from running.

Washes made by diluting paint with turpentine alone tend to dry chalky; to give a little sheen to the color, add a small amount of medium (such as Liquin). Do not make your mixtures so liquid that they run to the bottom of the canvas, dissolving the forms. Experiment to find a consistency of paint that sticks where it's brushed.

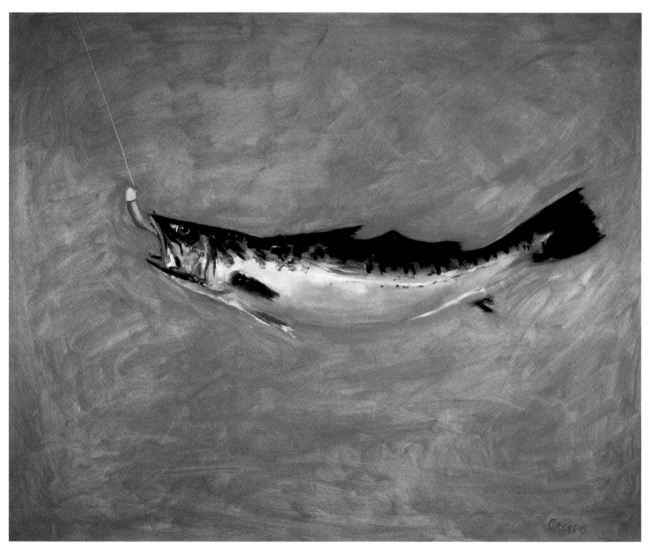

HOOKED SPECKLED TROUT
Oil on canvas, 24 x 29" (61 x 74 cm), 1984.

Michael Crespo intended to build up heavy layers of paint in this painting, but as he swished on an underpainting of blue-green he became infatuated with his brush movements and continued to push the wash around. He let it dry and decided that the white of the canvas yielded an excellent version of underwater illumination, and the bustling brushwork signaled agitated water. He then painted the fish in thin yet opaque colors.

Highlights can be achieved by applying white pigment, or by rubbing back into the white of the canvas with a soft rag.

Here, a highlight is being applied with a sable brush. Use a light, quick touch, and thin the paint with turpentine or other medium so that it won't disturb the wet paint beneath it.

This time the highlight is being rubbed out with a clean rag moistened with turpentine. This technique does not work as well over thick layers of paint.

A cotton swab moistened with turpentine makes an ideal tool for rubbing out detailed highlights in thin paint.

Michael Crespo
Impasto

Impasto, the Italian word literally defined as bread dough or paste, came to describe a style of painting in which brushstrokes are deliberately rendered in thick, luscious slabs of paint. Peruse a few art books or visit a local museum and look for those works in which the paint surface no longer simply amplifies the tooth of the canvas, but buries it beneath layers of sculptural relief. To cite but a few examples: Vincent van Gogh's short, caked strokes are plastered across his canvases in tight-knit patterns, marching in multitudinous directions. Rembrandt's self-portraits map the fleshy planes of his face in dense, spackled colors. It would seem that to run your fingers across one of these paintings would surely reveal the actual contour of the master's countenance. The modern genius Hans Hofmann trowels great silent slabs on top of juicy, swirling fields in his powerful abstractions.

Impasto can imply weight. Not only is the reality of the physically heavier surface immediately recognized, but even the most sprightly colors and values appear graver and more leaden. Light striking an impasto surface reveals the exaggerated terrain, with actual cast shadows becoming part of the visual dialogue—painting nudging the boundaries of sculpture.

To build an impasto surface, begin by laying in washes of paint thinned only with turpentine, in observance of the "fat over lean" dictum. Use slightly thicker paint as you move along. Eventually, proceed to paint using thick globs applied with brushes and palette knives. The consistency of the colors as they come from the tube is often ideal for impasto painting. If needed, you may introduce a little medium into your mixtures, but be careful not to make the paint too runny. Should you need to lay another color on top of a wet stroke, do it with a delicate touch, just depositing it onto the surface without disturbing the color beneath. A brush with long, soft bristles (such as a synthetic sable) is the ideal instrument for this technique, which may take a little practice but is necessary for laying highlights onto a contour.

Impasto paint can be applied with a palette knife, in a fashion similar to buttering toast.

Or drag it across the canvas with a brush.

The paint can also be deposited in short strokes with either a knife or a brush, even right on top of thick underpainting.

Interesting textures can be formed by stippling a knife rapidly across the wet paint. Should mistakes occur, use your knife to scrape away the globs of paint and begin again.

Thick, oily impasto is illustrated here. The blue shape was textured with bits of dried paint scraped from the palette and mixed with the wet color. The yellow and white marks at center were deposited on the thick paint with a soft sable brush.

In this example, thick paint was scraped with a knife across a contrasting surface of already dry washes. The contrast between impasto and wash can create a strong spatial illusion.

Diatomaceous earth was added to this drier-looking impasto applied with a stiff brush. The values and colors are close, placing more emphasis on the texture.

Michael Crespo

The Painted Line

Vary the value, width, and color of your lines to create interesting contrasts in a painting and to evoke different emotions.

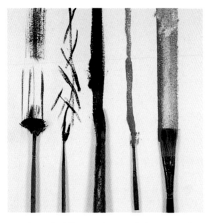

Brushes of different sizes and shapes will produce different lines. From left: marks produced by dragging a blending brush on both its flat and narrow sides; crosshatching rendered with a #1 round synthetic; and the paths of a #12 round hog bristle, a #3 round sable, and #12 flat camel-hair.

A palette knife can also be used to paint lines. Load its edge with paint and make a slicing motion across the surface.

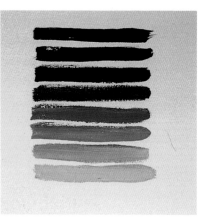

Lines of different values will appear to be at different locations in space. Dark lines come forward, while paler lines recede.

The fluctuations in these lines were produced by varying the pressure on the brush while moving it across the canvas. Thinner lines appear to be farther back in space; thicker lines seem closer.

The color of a line is also important; warm, intense lines appear closer to the viewer than cooler ones. Also notice the varying emotional character of the lines shown here.

Very distinct lines can also be produced by etching with a palette knife through wet paint to expose the color below. In this example the white of the canvas is exposed through a layer of black paint.

Shape

Pay close attention to the edges of your shapes. Make some of them hard and others soft.

Hard edges can be achieved by either painting one wet color alongside another, or painting over a previously painted dry color.

Masking tape can also be laid down over dry paint, painted over, and then peeled off to expose a hard, straight edge.

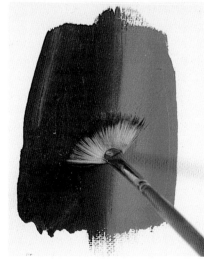

Hard edges can be softened by gently brushing over them with a dry brush or your finger. If the paint is stiff, dip your brush in a little turpentine.

Michael Crespo
Modeling Form

Paint plays two essential roles in the hands of the artist. It can be a substance of description, with which we illustrate the people, places, and things of our physical and cerebral environments. Or it can be the subject of itself, a purely visual twinkle of energy, suspended on a surface, existing solely as a gesture of the painter who deposited it there. In the process of painting we cannot escape constantly juggling the two, seeking some balance between the portrayal of subject, whether that portrayal is figurative or abstract, and the actual physical presence of the paint. This balance need not be equal. Our quest for personal expression demands great leniency in how and where we direct the paint.

Using paint as an illustrator of form rather than as a form itself calls for subtle blending techniques, with which you model form by virtually eliminating brushstrokes. A basic drapery fold makes an ideal subject for practicing with a blending brush. Study the illustrations on fold structure on the facing page and attempt some similar examples on paper using black, white, and one additional color.

One basic approach is to first lay down your dark, medium, and light values in simple planar shapes. Then, using a blending brush, lightly stroke back and forth across the boundaries of the values until a smooth transition is achieved. It may be necessary to add more black and white from time to time to recapture lights and darks. Another method is to lay down only the dark color and add white with a brush, mixing the middle values on the surface as you move across the form.

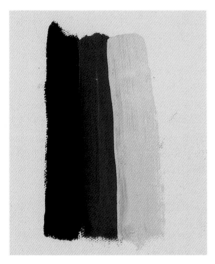
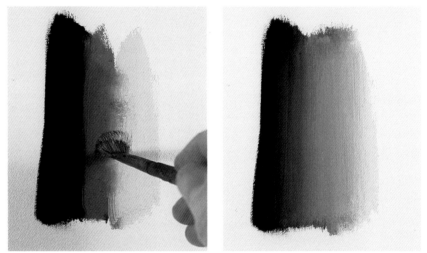

Three separate values are painted on the canvas.

They are blended together with back-and-forth motions of a dry blending brush.

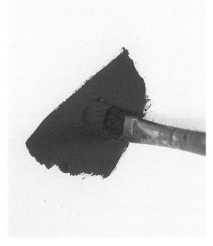
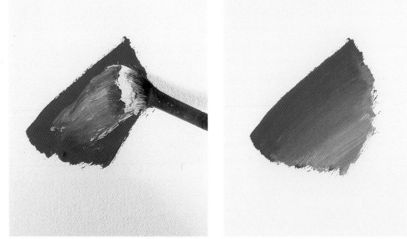

A dark-value color is brushed on the canvas.

A brushload of white paint is brushed back and forth across the shape. It may be necessary to go back in with some of the dark color if the value becomes too light.

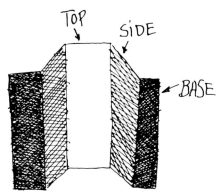

In a basic drapery fold, both sides of the protrusion are visible. The top is the lightest value, the sides middle gray, and the base dark. In the study at left a blending brush was used to mix alizarin crimson, black, and white.

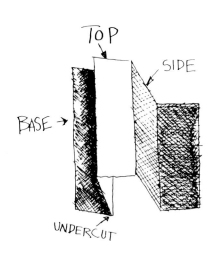

An undercut fold flops over, obscuring one side. The dark base appears right next to the light top of the fold. On the other side, the value darkens gradually. Stroke your blending brush in the direction of the fold.

Michael Crespo
Defining Planes

When flat shapes relate to one another in such a way as to give the illusion of a third dimension, they become planes. Planes direct the eye through space and give volume to forms. We copy them directly from nature, or we invent them to help clarify the space in our paintings. There are planes in any landscape, on your face, and on an apple. The planes of a craggy mountainside are easily discernible; the planes of an egg are not. However, they can be interpreted by noting the changes in direction of the surface; imagine constructing a three-dimensional model of an egg by folding a piece of paper.

To better understand how planes work, spend some time looking at works by the French painter Paul Cézanne. His still lifes, landscapes, and figures all reveal a powerful continuum of geometry that erupts from within a form, punching out the surface and leaving it mottled with planes of color. In his paintings peaches, mountains, bodies, sky, and water all have the same planar structure.

When you draw, try to see objects as planes of color and value. Imagine a color for every plane you record as your eye moves across the surface of what you see. You may find that eventually painting, say, a hand is no longer difficult, that it is the same as painting a pear—just planes in a different order.

Here is an exercise to help you interpret planes. Set up a still life with multiples of an object whose surface at least suggests planes—a pile of potatoes, apples, seashells, or rocks. Light your subject well to aid in exposing potential planes. It will help if you paint your objects larger than life, so don't skimp on the size of your painting surface.

Mix a fairly diluted solution of ultramarine blue and turpentine. Load a small round brush with this wash and begin drawing directly on the canvas with lines of blue paint. If you err, simply wipe out with a rag dipped in turpentine, or just correct the line with a stronger blue line. An advantage of this process is that you can leave some, or all, of these colored lines in your finished painting.

Scrutinize the surfaces of your subject and draw the planes that are implied. Invent if you need more. Exaggerate what you see! Break up the surface of each object as much as possible. You may refine more when you paint. As you begin to paint, pay close attention to the light as it illuminates the surfaces. These lights and darks must be translated into the planes you've drawn. Well-placed values will greatly aid the three-dimensional illusion. Make color changes, either drastic or inconspicuous, as you move from plane to plane, remembering the theory that warmer, lighter, or more intense colors tend to come forward, while cooler, darker, or grayer colors seem to recede. This can be very helpful in trying to locate planes in space relative to one another.

Remember also that brushstrokes are planes and can be applied with great spontaneity and flourish at any point in the process. Paint on until volumes emerge and space is delineated, preferably over the course of more than one session. Layering the paint will help build the illusion of depth.

Michael Crespo began this painting of two animal skulls by drawing with a brush loaded with ultramarine blue thinned in turpentine. Corrections in the drawing can be made by wiping out with a rag, using heavier, darker value lines, or, as in the case of the foreground skull, by covering lines with a little white paint. The thin wash will dry quickly, so you need not wait to begin painting.

The harsh light that was cast on the two forms helped greatly in simplifying the complicated contour of the skulls. Crespo painted clearly defined planes of light, middle, and dark values of colors that were significantly grayed. You should be able to visualize climbing through this painting as if walking up stairs.

David Leffel and Linda Cateura

Brushstroke Techniques

An important lesson in painting is to learn the feel of the paint on the brush, to know how much paint is needed for a thick or thin application of color. The thicker the paint, the richer the darks and the lighter the lights. Learn to hold a brush loaded with paint and still make a sensitive stroke so almost no paint comes off. If you aren't in total command of your brush and paint, you are not a painter. This is primary; trying to learn value and color is otherwise impossible.

Practice, while painting, to control the amount of paint that comes off the end of your brush. *This is the heart and soul of painting.*

Make each brushstroke describe your intention. Think before you use the brush. Load your brush with thick paint and let the brushstroke follow the form of the object you're painting, or stroke it on in the direction of the gesture, the body's movement. You might use the brush in a chiseling fashion, in short staccato movements, or as a conductor uses a baton. Always use the stroke that best describes the surface you're painting. And finish your brushstroke on the canvas. Don't lift the brush until the stroke is finished. Then lift it off for the next brushstroke to begin and end.

Start to paint seriously the moment you pick up a brush. If you begin by painting carelessly, with slapdash strokes, you'll find it difficult to move into more careful painting.

Use more impasto, that is, thickly applied paint, where the center of interest lies. Impasto breaks the surface of the canvas and gives it more thrust. You can't get thrust without the impasto. It can also bring life to a dull color or area in your painting.

As you paint, don't scrub the paint into the canvas. Be sure your brush has plenty of paint, apply it, and *let it stay.* If necessary, you may push the paint around a bit, moving it up or in a curve, gently. There should be a layer of paint between the brush and the canvas. You might say the bristles never touch the surface.

You can mix colors on your canvas as well as on your palette.

When you paint, the brush should make no noise. Pick up enough paint so that it works silently. In other words, keep a layer of paint between the brush and the canvas. If you paint thinly, use enough medium to attain a silent brush.

With each paint application, with each stroke, do the "finished" picture. Otherwise, all those brushstrokes you weren't paying attention to will come back and haunt you.

Nothing delights a student more than to draw with a brush—the more minute the detail, the better. Avoid doing this. Instead, *paint* with your brush; think in terms of dimension. Instead of drawing individual hairs, for example, paint hair thickness or dimension; paint the light on the hair.

If too much canvas texture is visible through your paint, you will have a colored canvas, not a painting.

Have the best materials available, especially brushes. You want a brush that will do exactly what you want, instantly.

A "mistake" done with a crisp, confident brushstroke will look better than something correct done with a flaccid brushstroke.

There are two essential types of brushstrokes, one to create form, the other, direction. The stroke that goes along the form gives action and direction. The stroke that traverses or is painted across the form gives instant dimension. The choice of brushstroke should be part of the painting process.

A juicy brushstroke (one with lots of paint on it) makes an enormous difference in adding a dimensional quality to your painting.

Never do more than three strokes with the paint on your brush. Two strokes are better. Then pick up another batch of paint for each new series of brushstrokes.

Respond to the tactile surface quality of what you're painting with your brushstrokes. For example, different fruit has different textures; oranges differ from apples. What you paint dictates how you paint it.

Whatever brushstrokes you apply to your picture, make them describe something. A stroke may describe space, dimension, movement, light, color. Try to get as much of this descriptive material as possible into your picture.

Paint broadly with heavy paint. Keep yourself from merely dabbing. Be more painterly.

You can get rid of choppy brushstrokes in the background by taking a big brush and painting in one direction, horizontally. After you finish, take a dry brush, lay the flat side parallel to the canvas, and brush lightly downward.

SELF PORTRAIT
Oil, 16 x 14" (40.6 x 35.5 cm), 1984,
private collection.

Margaret Kessler

Calligraphy and Broken Color

Calligraphy adds a personal touch. For variety, try adapting this watercolor technique to your work in oils. Use a rigger—a long, red sable script brush. Dilute the paint with turpentine to a watery consistency, load your brush, and gracefully scribe some details, such as twigs and a few individual blades of grass, into your painting.

Also experiment with broken color, using spots of partially mixed colors, as a way of achieving a vibrant lighting effect. You can make shadows and sunlit areas dance with excitement by letting the viewer finish mixing the colors in his or her mind's eye. This technique adapts itself especially well to foggy or overcast skies.

After establishing the underpainting, subtly glide the tip of your rigger brush across the surface, allowing the texture to work for you as much as possible. As a way to stop thinking "limbs and twigs" and instead concentrate on design elements, experiment with turning the canvas upside down to paint the skeletal form. Pull the paint down rather than up; then return your canvas to its proper position to refine your drawing. As you drag the fluid paint away from the base, slowly lift the brush off the surface, thereby gradually tapering the line.

From the very beginning, be patient; don't develop details too soon. If you were building a house, you would not hang wallpaper before you put on the roof. Start thin and build to thick paint as you define the details. To add complexity and character, smudge and restate lines. If you lose control and must begin again, scrape down the canvas with your knife and work over the stain. For variety, but without overdoing it, scratch out a few delicate lines with the handle of your brush. When necessary, use a small, flat sable brush to add a few busy little marks symbolizing individual leaves. With color, indicate the full span of lighting conditions, passing from highlights through the local color to the shadows.

To entertain with variety and complexity, you can paint light over dark and dark over light, lifting off as well as building up paint, as shown here. As you taper from limb to twig, the line becomes cooler and lighter. You cannot duplicate reality, so develop a large vocabulary of visual symbols to tell your story. Use gestural marks to symbolize energy, as well as objects.

When working with broken color, be sure to use thick paint, mixing the patches of color on the canvas, not on the palette. You can interlock the colors using controlled brushstrokes as seen here, or you can use bold, flip-flop marks with a large, flat bristle brush.

All four demonstrations within this illustration are made up of the same three colors: lemon yellow, cadmium red deep, and phthalo blue. By using colors of similar value and varying the quantity of each pigment, you can create, from left to right, a golden color, green, lavender, and gray.

Joseph Dawley
Using Large Brushstrokes to Animate the Surface

Joseph Dawley usually paints with small, carefully placed brushstrokes, but once in a while a subject comes along that lends itself to large, gestural strokes. This was one such subject. He wanted to capture the overall flavor of the scene rather than render details of architecture and tree branches, so he used loose brushstrokes to summarize the forms.

The facades of the buildings are defined by patches of light and color; sometimes the brush drags one color into or over another. In other places, such as the fence, the brushstroke makes a very simple statement—it becomes the object. Each post of the fence was painted with one stroke.

One key to successful handling of the large brushstroke is moderation—too much looseness can make your painting simply chaotic. Here, the relatively smooth surfaces of the grass and the concrete walls of the canal provide a respite for the eye.

Dawley wanted to capture the flowing motion of the water, so he concentrated on the little waterfall and on the movement of the water at the foot of the falls. He used a smaller brush here than in the rest of the painting, but the strokes are longer than usual. The technique he used was to drag a brush loaded with white over a still-wet area of dark paint. He didn't go over the brushstrokes, as that would blur them and diminish the crispness and the bristle marks.

CANAL IN WASHINGTON
Oil on Masonite, 20 x 24"
(50.8 x 61 cm).

Gregg Kreutz
Avoiding Overblending

Blending is one way to effect a transition between two areas but is not always a satisfactory solution to the problem, since it doesn't contribute to the logical structure of the picture. In creating transitions, you should always consider the whole color and tonal world of the painting. Simply to blur that tricky area between two planes or objects dodges the issue. If you do this, the picture may look alright, but you haven't learned anything about how to apply wet pigment onto the canvas in such a way that abstractions and illusions occur.

A problem with blending is that it's not clear where to stop. Once you start feathering little passages here and there, you want to do it everywhere, and the picture gets softer and softer. Reworking areas then becomes difficult because the perimeters are so vague that you can't tell where one passage ends and another begins. Gradually the picture starts sliding into the mud.

To avoid overblending, try mixing up a color that will provide a bridge between two areas. If you are painting a face and feel that the edge where light and shadow meet seems too sharp, rather than blend it to soften it, mix some dark halftone (maybe background color) and put it along the edge of the light side. Remember: The shadow doesn't get lighter as it nears the light; the light gets darker. The closer in value that middle tone gets to the shadow value, the softer looking the transition will appear.

The pear at left was painted with a lot of soft strokes that were then feathered together. It's all transition. In the second pear (below), each stroke stands by itself. The transition from light to shadow has been expressed by mixing and applying a distinct color to each of the three main areas of light, halftone, and shadow. There's very little blending. As a result, this second pear has more substance and more personality. When too much blending occurs, the character of the object and the character of the painter start to disappear.

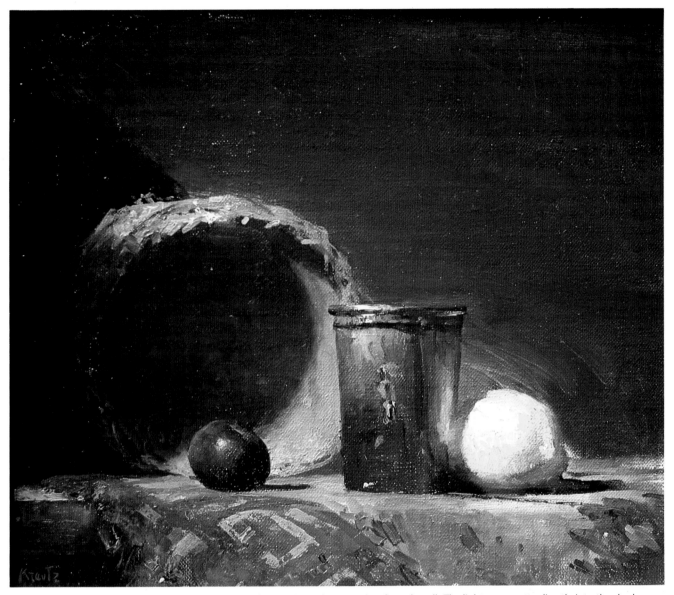

STILL LIFE WITH LEMON
*Oil, 13 x 16" (33.1 x 40.6 cm), private
collection.*

The transitions here aren't softened at all. The light goes pretty directly into the shadows.
But because the light is so bright, you don't notice how abrupt the transition is. It's hard to
focus on an edge if the light within the edge is made too compelling.

PERCY'S SHED, CHATEAU DE ROCHE
Oil, 14 x 17" (35.6 x 43.2 cm), private collection.

Here's some direct painting: The trees, leaves, tiles, and stonework are all painted in directly with hardly any blending. Gregg Kreutz painted this picture on a salmon-colored ground that corresponded nicely to the color of the shed wall, which is the middle tone of the composition. With that color taken care of, he moved into the darks (the underplane of the roof, the doors, and the trees) and then into the lights. The effect he was trying to re-create was the way the light almost slid off the roof and landed on the grass and pathway.

SoHo Stoop
Oil, 16 x 13" (40.6 x 33.1 cm), collection of Dale and Lynn Rhyan.

This picture was painted in a direct, stroke-by-stroke approach. The scene didn't need any blended transitions; Gregg Kreutz wanted an immediate, gritty effect, and smoothing things out would have softened it too much. The only exception to that was the underplanes. Since this is a top-lit situation, Kreutz needed to make sure that the areas facing away from the light were in shadow—and shadow, to look like shadow, needs be fairly dark and smooth.

Charles Reid
Finishing One Section at a Time

Most artists don't ever feel content with their work. We all worry about going stale, about getting into a rut, and often wonder if we're better or worse than we were a year ago. But this is one of the things that keeps painting interesting.

One way to keep fresh is to try something different. We all have certain safety nets, painting clichés and techniques we've come to rely on to make a decent painting. Now, there's no reason you should dump these safety nets, particularly if your painting is an important source of income. And you shouldn't necessarily change the look of your paintings, or your subject matter, either. Instead, try to change your *method* of painting, your approach, so that your paintings will still look like they're yours, but you'll have an adventure painting them.

Many students think that the big difference between oil and watercolor is that you can't rework a watercolor but you can rework an oil to your heart's content. This just isn't so. An experienced watercolorist like Winslow Homer could overpaint and scrub out and still have a fine picture. On the other hand, an inexperienced oil painter will come up with a greasy-looking painting with a clogged, slippery surface and dull, muddy colors, particularly when working on cotton duck or canvas board. Using oil is not an excuse to be careless in your color and value choices. You can't think, "I can always overpaint later; now I'm just trying to get the general idea." You can't just let the paint build up; you must make every decision count, or your paintings will go sour.

This is what gave Charles Reid the idea for the approach described here. In fact, he often changes the colors and values he sees in order to improve a painting, and you should do the same. Get into the habit of referring to your painting for answers instead of trying to copy your subject.

Sketch and Initial Color

To begin, Reid sketches in the general idea with charcoal. Nothing is set in stone. Since the positions of objects are not as important as the placement of colors and values, making a complicated line drawing on the canvas won't help. At this stage only a starting point is needed. Reid starts with the bowl from Portugal, paints a yellow shape inside it, then puts in a green pepper and works them to a finish. These objects now act as a reference for everything else he'll be adding. In general, remember this advice: Establish something you know and work from it, using it as your reference for proportions, values, and color.

Adding and Relating Subsequent Colors

Reid adds some tomatoes, onions, and scallions, then works a little on the windowsill and adds a gray jar in the foreground. He worries that perhaps the jar doesn't work with the gray behind the bowl with the peppers. At this point it's the part of the painting he doesn't like. Instead of taking it out, though, he works on some other areas. A single color or value isn't wrong in itself. It's only right or wrong in relation to other parts of the painting.

Working on a Cloudy Day

With each painting session, sometimes there's a strong light coming in the window and other times it's cloudy and the table looks dark. This stage was painted on one of those dark days. The white tablecloth has become a gray, with no color suggestions. So, Reid is careful not to touch any colors in the painting that will be changed when the sun is shining. He works on some color values below the windowsill using rather dry paint. Then he works a bit on the books, then tries the black window casing. The window is indeed black, but should it be painted as black as it seems? Reid checks the values and colors on the canvas rather than trying to match the setup in front of him. Then he adds some cast shadows under the postcards on the wall and puts in their predominant colors. He judges whether or not these spots of color go with the color spots already on the canvas. Reid likes to have things working together nicely at whatever stage he stops for the day.

Background and Final Adjustments

A lot has happened in this last stage. Reid painted the scene through the window in one three-hour sitting. Technically, he should have worked back and forth between the outside scene and the tabletop. But because of the changing light and his fear of cloudy days, he decided it would be safest to do the scene through the window immediately. On the other hand, he wanted the background to relate to the still life, so he constantly looked at the tabletop in his painting as he worked on the outdoor scene. (Remember, your painting has as much information as your setup.)

Reid tried to simplify values by choosing just one for the light area and one for the shadows. Of course the tree shadow value was darker than the grass shadows, and you can let some minor variations like this creep in. But you can't start out by seeing a dozen value changes in your shadows and then try to paint them all.

When he had finished the outdoor scene, Reid turned to the still life, adding a few objects and painting the tablecloth. Notice that all the objects added in the final stage are light in value. Reid wanted to get rid of the empty feeling on the table without creating clutter. He also added warm and cool tones to the tablecloth—a touch of cadmium orange and cadmium yellow medium to the titanium white he used for the fabric—but only a bit of each, as the cloth must still look like a white tablecloth.

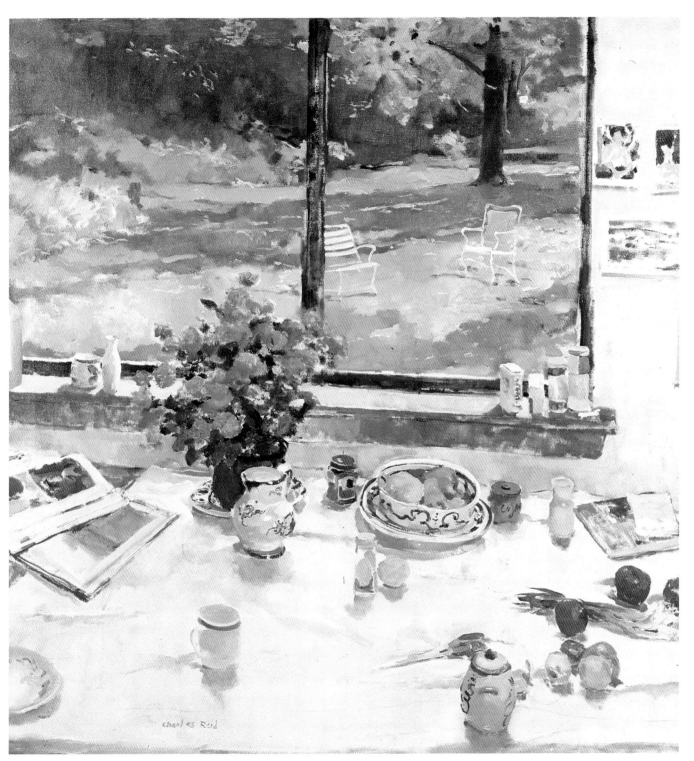

WHITE TABLECLOTH
Oil on canvas, 50 x 50" (127 x 127 cm), courtesy Griffin-Haller Gallery.

Margaret Kessler
Creating a Center of Interest

As you compose a painting, you must create a center of interest—the one focal point that will ultimately command the viewer's attention. Decide which object in the scene is the most important—the one you want to emphasize to carry the theme aesthetically. Then judge the relative importance of the other objects: very important, rather important, not too important. Using rhythm and balance, emphasize the objects in that order.

A good way to direct attention to the center of interest is by dramatically contrasting the various elements of design—light against dark, warm against cool, bright against dull, large against small. Of all the contrasting elements, the play of light against dark is the most effective, as it is human nature to seek light. Use the light-dark patterns to set up linear movement leading to the center of interest and to lay the foundation for other design elements, such as color and texture.

With controlled contrast, you can regulate the force of the emphasis at the focal point, making it shout or whisper for attention. The more dramatic the interplay of the contrasting elements, the more quickly the eye responds to the call for attention. A lonely little petunia in an onion patch demands that you look at it! Because of the strength of contrasting elements, the viewer will inspect the onion tops only after studying the petunia.

A generally quiet mood, of course, calls for a reserved

A light tone appears lighter when placed next to a dark, and vice versa. Without dark accents, a high-key painting looks anemic. Similarly, a bright painting doesn't vibrate unless there are a few neutral notes. Experiment with different kinds of contrast, as in the examples shown here.

WARM/COOL

BRIGHT/NEUTRAL

LIGHT/DARK

COMPLEMENTARY COLORS
(VIBRATING)

OPAQUE/TRANSPARENT

LARGE/SMALL

THICK/THIN

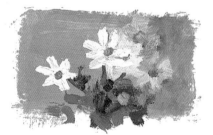

SHARP FOCUS/LOST EDGES

degree of contrast at the focal point. Even then, all other elements within the painting must remain subservient to the focal point, as it is disruptive to divide and separate the visual interest. You may have secondary points of interest, but if they compete for attention with the principal point, you will create confusion and lose your audience.

Everything must be in harmonious relationship with the one dominant feature; therefore, in a landscape, after blocking in the sky, it's best to immediately establish the power of your focal point. Once this degree of excitement is established, you can use it as a "home key" and pitch the rest of the painting in tune with this key. If your center of interest becomes too overpowering, tone it down or create areas of fairly strong contrast elsewhere in the picture, indirectly diluting the strength of the primary focal point.

VERTICAL/HORIZONTAL

BROAD/DELICATE BRUSHMARKS

PERPENDICULAR/DIAGONAL

SIMPLE/COMPLEX

CONTINUOUS/BROKEN

ARCHITECTURAL/ORGANIC

Julia Ayres and Betty Sellars

Making Monotypes

Monotype is a unique process in which you combine painting and printmaking techniques to create a one-of-a-kind print. The image is developed on a flat plate (made of metal, glass, Plexiglas, frosted Mylar, or another material) with oil- or water-based mediums, and then transferred to another surface, usually paper. The transfer can be made either by hand or with a press. For a hand transfer, essentially you place a sheet of dampened or dry paper over your plate and rub the back of it with a tool such as the bowl of a spoon, a baren, or a pot scrubber. In a press transfer, the plate and paper are placed on the press bed and mechanically moved under rollers (in an etching press) or scrapers (in a lithography press) to produce a print. After the transfer is completed, there is often some medium left on the plate, which is called the *ghost*. It is possible to use the ghost of a former work to develop a new monotype.

If you have painted with oils on canvas, you will feel comfortable using them in the monotype process, since most painting techniques can be used on the plate. You can thin oil paints with a solvent such as turpentine or mineral spirits and use them as you would watercolors, or apply them in an opaque manner. You can lay down expressive strokes of color with a brush or palette knife, as well as achieve detailed linear work by scraping away and drawing lines into the paint with the knife.

When you use oil paints on paper, it is desirable to speed up their drying time to protect the paper as well as to permit further work on the same sheet. You can accomplish this by thinning your paints with mineral spirits or refined turpentine. If you want to add oil extenders to paints from the tube, you should use printmaking mediums such as stand oil and burnt plate oil, which when dry will protect the paper fibers. Do not mix your paints with linseed oil, which can have a detrimental effect on untreated paper fibers.

Transferring the Image from Plate to Paper

Before transferring an image from plate to paper, it's best to cover the back of your paper with a protective sheet of either Mylar or newsprint to keep the back of the monotype free of abrasions from the rubbing.

Small, hard implements such as tracing tools, blunt-ended points, or even dull-pointed pencils can be used to make linear textures—crosshatching, circles, and so on. In fact, you may want to use a combination of tools to complete your transfer. You can use your fingers when you want shading in certain areas, or a variety of sharper tools to trace more defined details for transfer.

Here, artist Betty Sellars demonstrates how she executes a monotype using a single transfer by hand. First, she makes a drawing and places it underneath her Plexiglas plate as a guide, then she randomly rolls oil colors on the plate with a brayer. Next, she lays a sheet of mulberry paper on top of the inked plate. Sellars removes her guide drawing from under the plate and places it on top of the mulberry paper. With the pointed end of her palette knife handle, she traces over the drawing. She rubs parts of the drawing with her fingers, pressing the paper against the inked plate to pick up shading.

With a drawing under the Plexiglas plate to guide her, Betty Sellars rolls oil paints randomly over the plate.

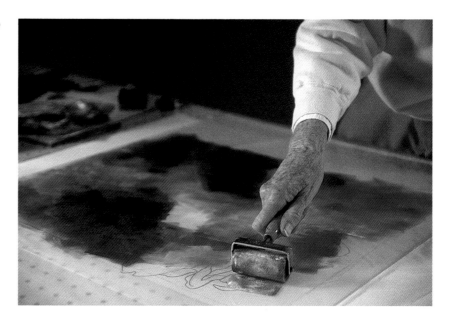

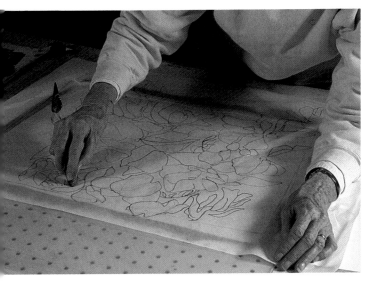

After gently laying a piece of mulberry paper on top of the inked plate, Sellars removes her guide drawing from underneath the plate and places it on top of the support paper. She then traces the lines of the drawing with the pointed wooden end of her palette knife. In areas where she wants shading, Sellars simply presses the paper with her fingers.

Here, she pulls the transfer from the plate.

WISTERIA
By Betty Sellars. Oil monotype on mulberry paper, 20 x 24" (50.8 x 61 cm).

Julia Ayres and Ray Ciarrochi

Multiple-Transfer Monotype Techniques

In monotype, more complex images are possible when you transfer one step on top of another. Multiple transfers necessitate some kind of registration system so that the image on the plate will print neatly and in correct alignment on the paper.

Ray Ciarrochi takes full advantage of multiple transfers. His overlays of transparent pigment create greater color variation, producing strong spatial depths and atmospheric effects for his landscapes. He prefers Fabriano Rosaspina and Tiepolo papers and Arches Johannot for his monotypes because they are strong enough to withstand the multiple printings his work requires. He also likes them for their distinctive textures, which lend interesting effects to his prints.

Ciarrochi begins by taping a guide drawing to his worktable and covering it with his glass plate. To ensure accurate registration during multiple transfers, he places two wooden right angles at the top corners of the plate, onto which he tacks his support paper with push pins. Since he usually makes up to fifty impressions to complete a work,

Ciarrochi reinforces the back of the paper with strips of masking tape at the edges where the push pins are used. He then lifts the bottom edge of the paper off the plate and tacks it against the wall behind his worktable.

Next, the artist begins developing the image on his plate. He usually starts by applying a ground color that is highly diluted with turpentine. With this color in place on the plate, Ciarrochi untacks the support paper from the wall and lowers it onto the plate, then rubs the back of the paper with a wooden spoon to transfer the color. After the ground color is transferred, he tends to work in individual areas, sometimes completing one before proceeding to the next. He uses the oils in both thick and fluid consistencies and, when transferring the plate work to paper, varies the pressure he applies with the spoon to manipulate color densities and image details. If the paint is very liquid, he simply rubs the back of the paper with his hand. At all times, he strives to maintain the grain of the paper and allows successive layers of color to show through one another as he builds the image.

Ray Ciarrochi tapes a guideline drawing to his worktable and covers it with a glass plate. Wooden right angles are used on the top corners of the plate to secure the paper and ensure correct registration. He lays his support paper face down over the plate and reinforces the top edges and center bottom edge with masking tape. The top edges of the paper are attached with push pins to the wooden corners; the bottom edge of the paper is lifted off the plate and tacked to the wall behind his worktable.

Ciarrochi's palette of oil paints can be seen on the enameled tabletop at left. Here, he begins to paint the first of many layers of color on his plate.

PHOTOGRAPHS BY RUTH KLEIN

Here, Ciarrochi has flipped the paper over the painted plate to transfer the first layer of pigment. He rubs the back of the paper with the bowl of a well-worn wooden spoon to effect the transfer.

Ciarrochi pulls the paper away from the plate and applies additional color.

After a second transfer, he repeats the paint and transfer steps.

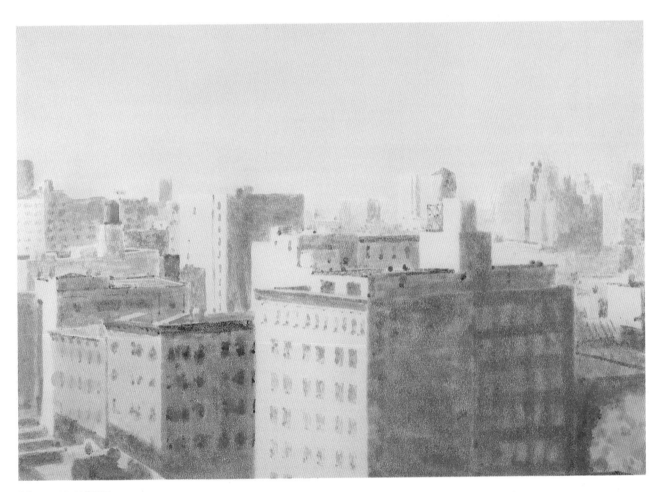

MANHATTAN JUNE
By Ray Ciarrochi. Oil monotype, 19 x 27" (48.3 x 68.6 cm), courtesy Katharina Rich Perlow Gallery, New York.

LIGHT & SHADOW

David Leffel and Linda Cateura

Painting the Lights

Physiologically the viewer will always look at light areas.

The center of interest is always in the light.

Avoid dabbing your lights on. If your subject is a portrait, for example, in painting the light on the model's hair, you must know what you're doing. Try to create a light or a pattern related to the form. Take your time to do it. See what happens as you work. You want a direction, a light, a focus. Do everything in a utilitarian, functional way. Paint what the light expresses, form or movement.

Does the light go across the model's hair? If not, can you paint it to go across the hair?

Don't lose the original design of your shapes of light and shadow, and value.

Highlights occur at corners or where a plane changes direction. They can indicate the separation of two planes. The temple, for example, is where the side plane of the head changes to the frontal plane of the forehead. Find out where the highlight breaks in this area. A highlight on the lip shows where the lip turns.

The color of the highlight should be different from the surface it's highlighting. A cool surface takes a warm highlight; a warm surface takes a cool highlight.

On the face and figure in your painting, decide where your light will travel and paint it. Think how the light might do certain things and paint that picture.

In observing an area of light, the eye prefers the warmer colors (the yellow-orange-red spectrum), not the cooler colors.

Where the shadow meets the light in your portrait, find areas where you can add just touches of color.

A shadow should follow a plane. A shadow along the neck may start at a slant, but then it straightens and runs down, following the form of the neck.

Since light is used to express what the artist wants to appear to come forward, try to arrange your subject matter so you are facing the part of it that is lighter, rather than facing into its shadow.

All great artists painted their sitters with the light facing the viewer. This is also true of objects that are the center of interest in still life painting.

Light is also the foreground material, such as the center of interest in the painting.

SYLVIA
Oil, 19 x 16" (48.3 x 40.6 cm), collection of Sylvia Maynard Knox.

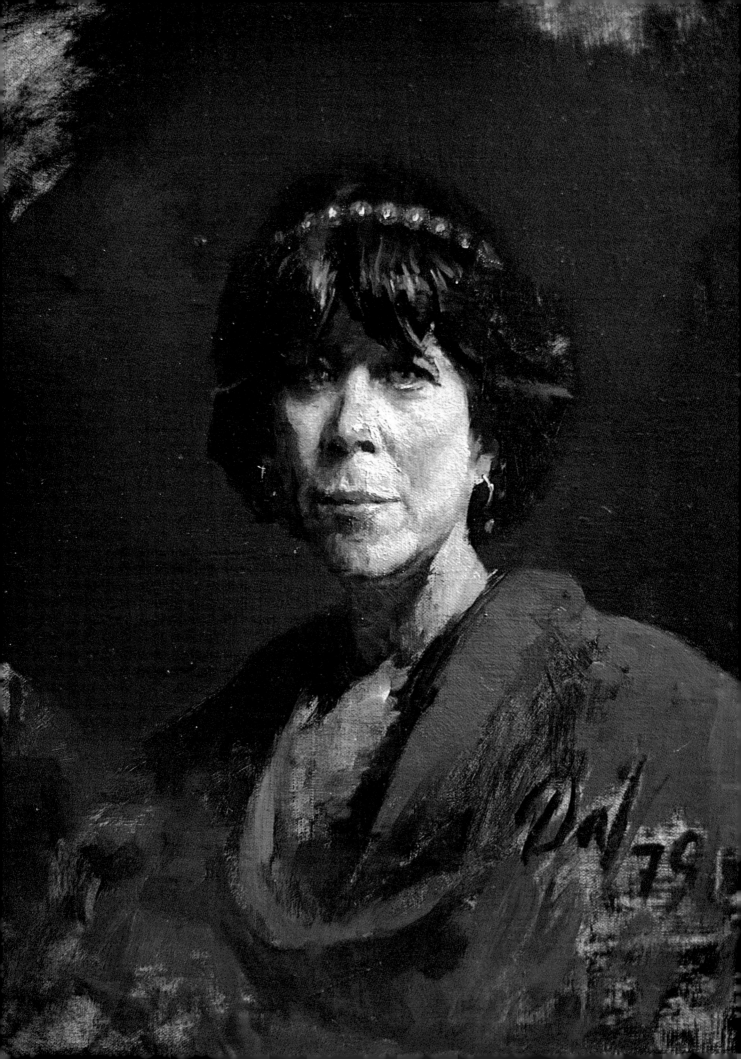

There are only two ways to make something look *lighter:* Either make it lighter or make something next to it look darker. To make something look *darker,* make the light next to it look lighter. Try to avoid adding darker color.

On the canvas, light should be nearest to the viewer.

Highlights have a crisp edge for brilliance and a tail that melts into the form. In painting a highlight's tail, try to get it to follow the direction in which you want the eye to travel. Highlights may cover a short or long distance.

Over the years paint gets thinner and loses its body. So right now add more and more light, and well into the next century your painting will still look light.

You can never paint your lights too light the first time you lay them in. Make them bright. You can always tone down the light if necessary, but it is rarely necessary.

Avoid putting light only in the middle of an object. Light hits the edge, moves across the object, and continues onto another object. You must arrange its path according to your concept, the way you want the viewer's eye to move around the painting. Make your treatment of the light consistent, too. If one area has a high-contrast light, don't paint a nearby area with a weak central light. Keep the quality of the light cohesive.

HARVEY DINNERSTEIN
Oil, 30 x 25" (76.2 x 63.5 cm),
collection of Daniel Dietrich.

David Leffel and Linda Cateura

Getting Depth in Shadows

Keep shadows thin, so that no brushstrokes can be seen in the shadows. Impasto destroys the illusion of shadowiness. If necessary, use more medium to thin the paint.

Some lights look darker than the shadow. This is a result of transmitted light in the shadow—in grapes and eyes, for example.

Avoid making your light and shadow too close in value. The eye should look at the light. The shadow must not, therefore, compete with the light. Make your light strong so the viewer doesn't look at the shadow.

Do the shadow and let it go. Don't try to do any modeling in the shadow. Describing form is not a function of shadow.

You can make a shadow lighter by adding a little white, Naples yellow, or more cadmium color to it.

Make the shadows on your objects more vivid. See how a shadow gives an object dimension, whether it's fruit, a bowl, or an arm. Without the shadow, nothing is going to look solid.

The darkest dark in the shadow is closest to the light.

Build up your light so that the viewer looks at it, not the shadow. Paint your shadows in such a way that you don't call attention to them. They should look mysterious, vague, shadowy.

If you have a lot of light, take out some of the color. Don't have both light and color competing for your attention. In other words, in a light area, paint color *or* light.

Think before you put in reflected light. It should be added for a specific pictorial purpose. Don't just put it in automatically.

Think of shadows in terms of depth and transparency.

In shadows where shapes are contiguous, you don't have hard edges or crispness.

You have to establish the shadow as a phenomenon different from the light. Light is cool and refracts off a surface. Opacity is the look of light. Shadow is more transparent. Add warmer colors to your shadows.

Light is the melody. It moves, it rises and falls in intensity.

Don't worry about the color of the shadow matching the color of the light. They do not have to match. A blue smock does not necessarily have dark blue shadows.

COFFEE BREAK
*Oil, 18 x 24" (46 x 61 cm),
private collection.*

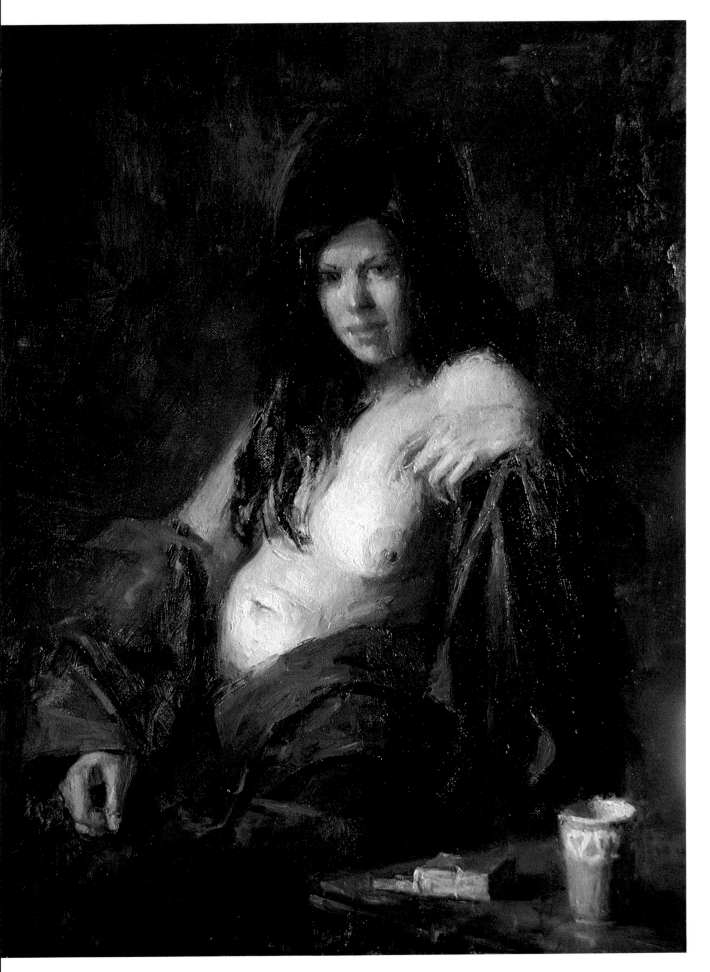

1

David Leffel and Linda Cateura

Chiaroscuro

Chiaroscuro literally means "light/dark." In chiaroscuro painting, your eye follows the light. The light gives the picture its flow—it takes the eye from one place to another, and the shadows structure the painting.

In a still life, there are two basic views an artist can work from. One is the shallow picture plane, where objects are placed across the canvas from left to right or right to left. The other is the tipped picture plane, where objects go *into* the picture at a variety of angles or curves, portraying depth.

When the picture plane is at eye level or close to it, the most important element, or center of interest, is placed at the right. With the artist working from dark at the left to light at the right, the picture culminates at the right. Seeing thus, from left to right, is the universal human way.

As you begin, first place the center of interest, which lies at the right. Everything will lead up to this. Paint this focal point clearly, with enough tone and mass to be seen precisely, be it a jar, orange, or other object. To be worthy of interest, the focal point must have enough light, color, texture, and substance to excite and capture attention. To keep the eye—which has followed the light to the right—from going *beyond* the edge, use a stopper. The stopper may be a shadow on a fruit peel, or a lone grape. It will hold the eye and keep it from traveling further.

In setting up a still life, you'll create more interest if all the objects do not have light on them. It also helps to have an object darker than the background.

If something looks dark and you want to lighten it, see how much light you can put in an adjacent area.

A Chiaroscuro Still Life

Imagine a typical still life setting: an amber glass at the left, five nectarines in a group, and a small blue and white Mexican pitcher as the center of interest on the right. The light comes in gradually from the left to focus on the pitcher at the right. The background is dark; the light on the objects becomes gradually brighter as it goes toward the right, where it bursts into full intensity.

1. Begin with the darkest dark first: the amber glass. Use a lighter shadow color for the background.

2. Next, place the shadow on the nectarines. Make the shadow here a bit lighter than the shadow on the glass. Then paint the shadow on the pitcher at right. Use the same shadow value as on the nectarines. Up to now, only darks have been painted.

3. Keep the background soft and shadowy. Use a cadmium color to provide transparency. The glass in the shadow area should be somewhat soft-edged.

4. On the first nectarine (working from left to right), paint a little bit of light, with the edge in shadow, to create the illusion of form. On the second fruit, paint a bit more light than you did on the first one; and on the next, paint more light still and make it brighter than its predecessor. In other words, you are painting a progression of values. In chiaroscuro painting, one way to make an object light is to paint the surrounding area in a lighter tone, not darker. It's like placing a little halo around the object.

Out of the darkness at the left, the light travels across the picture plane. This light, striking the pitcher, also hits the surface before it. As each item gets closer to the pitcher, it should be more luminous.

STILL LIFE WITH NECTARINES
Oil, 12 x 16" (30.5 x 41 cm), collection of Dr. and Mrs. William Horowitz.

4

2

3

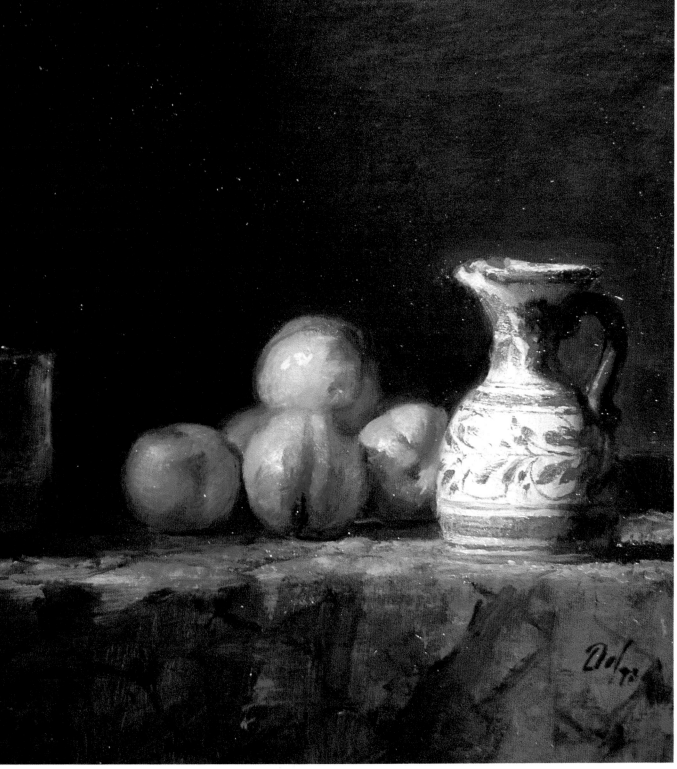

Charles Reid
Combining Chiaroscuro and Local Color

A common fault of student painters is overdoing light and shade, forgetting to put in local color values when working with a strong light source. The result is a spotty painting. No matter how strong the light, we always need local color value to give our pictures pattern and substance.

You can see how this works by looking at the three oil sketches shown here, which Charles Reid did of his family many years ago on a Nantucket beach. Note where he stressed local color and where he stressed light and shade. Now try to envision the real scenes.

Sketch 1. Think of how the water must have looked. Was it really as simple as Reid painted it?

Sketch 2. Why did Reid paint his wife Judith's back with the local color of her skin in mind, while he painted his son Peter's skin much lighter out in the light? Peter is painted much more in terms of light and shade. Notice the blue bag and red pail. Wasn't strong sunlight shining on them, too?

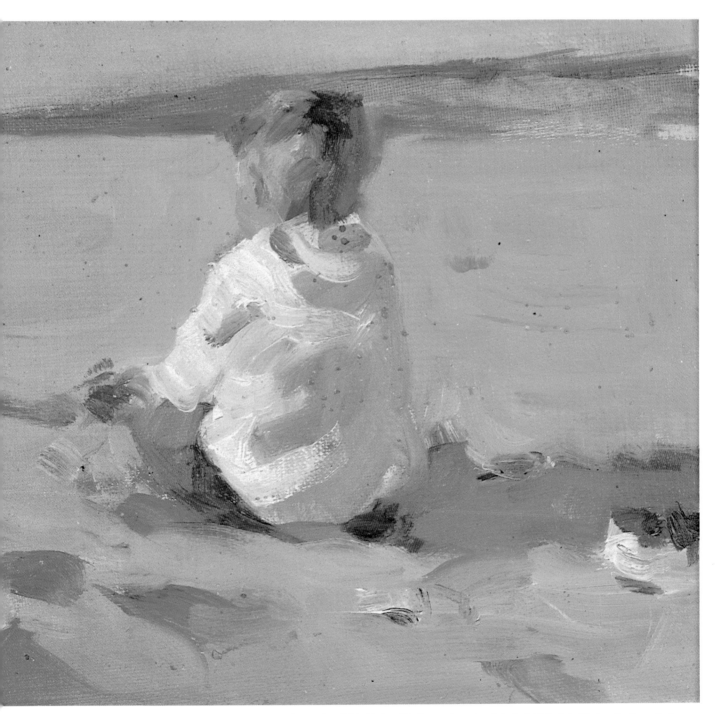

Sketch 3. Why did Reid simplify the sand next to Peter's shirt (painted in local color value) but use more small forms in the foreground sand (painted in terms of light and shade)? Why are Peter's pants more of a local color idea (though there's some light and shade), while his shirt is *all* light and shade?

Charles Reid
Shadows, Depth, and Design

Compare the still life watercolor sketch at left with the oil painting of the same subject below. In the watercolor, Charles Reid left out the cast shadows. Note how isolated the objects look, and how flat and bereft of life the picture seems. In the finished painting the shadows and cast shadows are definite compositional forms and are as significant as the objects themselves. If you squint at the painting you'll see double images. Think of objects and cast shadows as single, combined shapes.

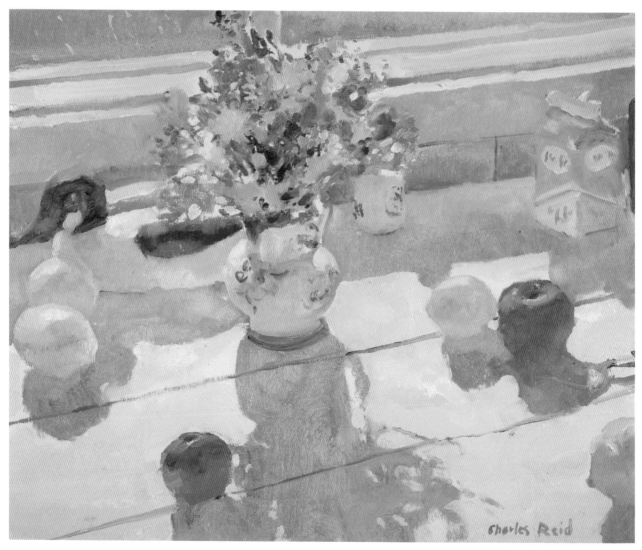

FIELD FLOWERS WITH APPLES
Oil on plywood panel, 18 x 22" (45.7 x 55.9 cm), courtesy Munson Gallery.

JUDITH'S GOLDEN EYE
Oil on plywood panel, 18 x 22"
(45.7 x 55.9 cm), courtesy
Munson Gallery.

It's easy to see the shadows and cast shadows as unified shapes in this painting. The subject was lit from behind and above, so shadows form on the front of the objects and merge with the cast shadows. Starting from the left, note how the shadow that begins under the soufflé dish forms a continuum with the shadow of the window frame, the decoy, the vase, the dish of fruit, and the red casserole at right. In spite of the fact that shadows can suggest depth, here Charles Reid was not really trying to do that—he was concerned with abstract pattern.

According to an oft-repeated rule, using warmer colors and darker values in the foreground and cooler colors and lighter values in the distance can suggest depth in a painting. There's truth in this, but usually distinctions between picture planes— foreground, middle ground, and distant background—don't concern Reid.

In *Judith's Golden Eye*, distant and closer darks are equal in value. Darks are used to weave the background and foreground together as if they were on the same picture plane. You'll see the trees melding into the flower darks and on to the accents of the decoy. Bright color—the reds in the tomato and the casserole dish—does bring the table forward, but Reid wasn't really interested in creating perspective with it; he was after a strong two-dimensional design.

Gregg Kreutz
Lighting Your Subject Effectively

For a painter's purpose, most indoor situations have too many light sources. Windows, lamps, doors, and so on combine to create multiple highlights and shadows, and that makes form difficult to render convincingly. With a single light source, on the other hand, the object being painted can be reduced to three planes: The side facing the light is the *light plane*, the side at a slightly oblique angle is the *middle-tone plane*, and the side away from the light is the *shadow plane*. Having these three simple planes clearly delineated by the light makes it easier to paint the picture, and makes for a visually powerful image. Putting an additional light source on the subject confuses the structure. Light can no longer go through the light-darker-darkest progression; it gets interrupted by some other light going the other way.

It is possible to paint a multiple light-source setup with good results, but somehow it's not as powerful as a scene illuminated by a single strong light. Certain Rembrandt and Vermeer paintings are so vivid that you can close your eyes and see them clearly. The one factor of the light coming into the darkness and revealing the subject gives these pictures a strong imagistic quality. It communicates an intense, purposeful search for the significant. It reduces visual reality to its essence.

An ideal painting situation can be created by blocking off all the light sources except for one high window facing north. North light is good because it's constant. If the window faces east, west, or south, at some point in the day sunlight comes into the room. That's usually not too good, because it's not constant; it moves around the studio as the day progresses.

Putting one light source on the setup is just the beginning. You must still resolve the problem of how much of each form is in the light and how much is in shadow.

The angle of the light is another important consideration. Whether it comes from below, the side, or above, you need to figure out how it moves across the form. Ask yourself if the top planes are brighter or darker than the side planes. If the subject is lit from above, the top planes will be brighter; if the light comes from a lower angle, they'll be darker.

Here, in the picture at the top of the page, the light is coming from both sides of the setup, thus creating a slightly unsettling effect. The still life on the bottom is lit from only one side, and consequently the picture takes on a quieter look.

JAMES IN A YELLOW SHIRT
Oil, 35 x 24" (88.9 x 61 cm),
collection of Gina Kreutz.

This painting was set up to exploit the possibilities of strong top lighting.
The model was asked to sit directly under the skylight so that only the top
planes are lit; everything else is thrown into dark halftone or shadow.

Gregg Kreutz

Conveying the Brightness of the Light Source

In *Farmhouse Bedroom* the window is the focal point as well as the light source. To make it look as light-filled as possible, Gregg Kreutz lightened all the darks within and around it and painted a hazy glow into the surrounding atmosphere.

Windows are also the light source in the painting *In the Coffeeshop*, shown on the facing page. To convey their brightness, Kreutz mixed two complements—here, Venetian red and cobalt blue—and added a lot of white. To make the windows look especially bright, he put in some pedestrians that appear to be washed out by the light. Except for the ketchup bottle and newspaper, the whole painting was done from pencil sketches the artist did in a local coffee shop.

FARMHOUSE BEDROOM
Oil, 14 x 18" (35.6 x 45.7 cm), courtesy Fanny Garver Gallery.

IN THE COFFEESHOP
Oil, 32 x 24" (81.2 x 61 cm), collection of Frederick H. Miller.

Alfred C. Chadbourn
Capturing Hot Summer Light

In this beach scene, the colors are the complete opposite of the snow scene on the previous page. To portray the warmth of the beach and the crowded atmosphere, Chip Chadbourn played hot, feverish colors against deep, rich darks. It's worth noting, however, that he used his normal palette for both the summer and the winter scenes. What's involved here is not so much a change in the colors on the palette as a change in one's thinking in interpreting the different seasonal impressions of nature.

Although the water isn't shown in the beach scene, the idea of high tide is expressed by the way the figures jam themselves like sardines against the snow fence at the top, escaping the incoming tide. Many of the figures are taken from quick sketches done on the spot, but others are pure figments of the imagination. Chadbourn wasn't concerned with literal accuracy in the bodies; he was striving more for an impression of a mass of bathers sprawled on colorful beach towels against the hot, pink sand.

As he began adding clusters of figures in small patches, a certain rhythm began to evolve, moving from the lower left in an S-curve, weaving through the painting, and finally culminating in the dark band of evergreens against the horizontal snow fence. As with most paintings without a predetermined composition, a lot of decisions were made instinctively during the painting process, with scraping out and repainting of areas until the whole pattern began to gel.

Note that Chadbourn used a lot of high-key blues and deep violets as complements to the warm pinks on the bathers and the sand. This color contrast is important—if he had just used warm colors throughout, the painting wouldn't have had the same vitality or dramatic impact.

It's also worth pointing out that the paint handling is somewhat brittle. There are no soft edges, nor was any attempt made to reproduce a realistic light source. To quote Degas, "The fun is not always in showing the source of light, but rather the effect of light."

HIGH TIDE, SCARBOROUGH BEACH, MAINE
Oil, 18 x 18" (46 x 46 cm), collection of Mr. John Holt.

109

Alfred C. Chadbourn
Interpreting Cold Winter Light

Interpreting the quality of light and discovering which colors best capture its various effects are important challenges for artists. Early morning light, evening light, seasonal light, backlighting—all these conditions affect a painting. If you have done a lot of outdoor landscape painting, you know that a painting started at nine in the morning won't look the same by five in the evening. A less obvious but still important consideration with light is the painter's geographical location. What this all boils down to is the need for a constant awareness of nature and of how you are responding to what you see. In any case, real light, the light we're all struggling toward, is the light that comes from the painting itself. That, in a nutshell, is what painting is all about.

Seasonal light strongly affects the mood of a painting, as can be seen by comparing this painting with the summer scene on the following two pages. *Hillside, Yarmouth, Maine— Winter* was done in January, based on a small sketch Chip Chadbourn did from a hill overlooking his hometown of Yarmouth. This artist is particularly fond of New England villages in winter because their underlying structure is revealed, with the gleaming white clapboards forming geometric patterns against the snow.

The key to the color in this painting is violet, although when Chadbourn started he didn't have a purple painting in mind. He did, however, tone the canvas first with a coat of ultramarine blue thinned with turpentine, which helps to control the value and color relationships, particularly in a snow scene. Then, in developing the painting, he used his normal range of colors, which allowed him to obtain a variety of colors while letting violet predominate.

Note that the lights on the houses—made by adding varying amounts of yellow ochre and lemon yellow to white—are relatively warm, in contrast to the deep blue-white tones of the snow. The violets on the road, rooftops, and trees are different mixtures of alizarin crimson and ultramarine blue, with white added for the violets in the distant hills and sky. The brick red on the chimneys and deep violet-reds on some of the buildings help complement the cool violet harmonies in the rest of the painting. Chadbourn kept these reds muted, however, as a bright red might have jumped out of the picture.

Overall, the effect of snow was accomplished by letting cool colors predominate. It would, however, be too easy to make a rule suggesting that cool shadows are the only way to make a snow scene look convincing. In the unforgettable painting *Hunters in the Snow* by the Flemish master Pieter Bruegel the Elder (c. 1520-1569), there isn't a cool shadow to be seen, yet one almost shivers in front of it due to the dramatic use of rich, dark patterns dancing against austere whites. The same can be said of Andrew Wyeth's snow scenes, in which the effect of snow is achieved through a judicious use of dark and light patterns, limited colors, and an incredible ability to leave everything unimportant out of the painting. One advantage of painting snow scenes is that the patterns and shapes of objects are easier to see because the snow has covered all the unnecessary details.

HILLSIDE, YARMOUTH, MAINE—WINTER
Oil, 30 x 40" (76 x 102 cm), collection of Mr. and Mrs. William H. Adkins.

It would have been easiest to paint the hillside, with all the buildings, and then paint the trees on top with a lot of dark color. But instead, Chadbourn started with the overall pattern of the buildings, adjusting their colors against the softer snow tones and gradually building up areas, adding trees more or less at will.

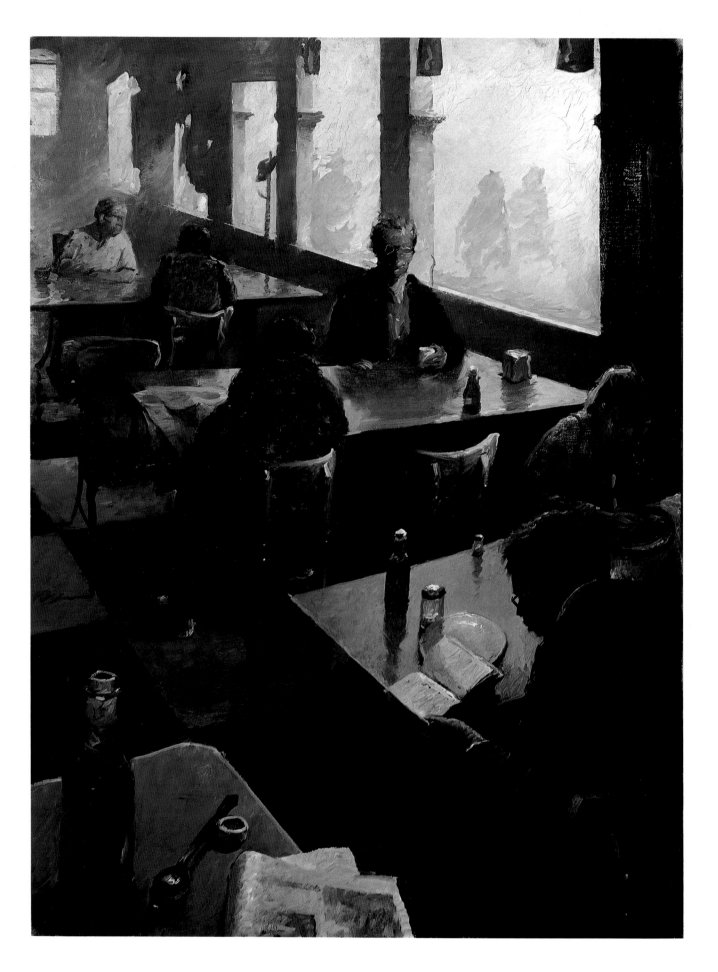

Alfred C. Chadbourn

Painting Dappled Sunlight

The biggest challenge with this painting was interpreting the sun-splashed pattern of light and shade on the old houses, trying to capture the essence of a summer day on a typical New England street. To depict the dappled light, Chip Chadbourn used warm lights and cool shadows throughout the painting, which is basically an impressionist approach.

Unlike the impressionists, however, Chadbourn used very few soft edges in the shadows. Had he softened the edges on the dark green grass or on the shadows of the buildings, it would have taken away from the brittle, sharp quality of light he was trying to convey. Each subject demands its own set of choices, which must be determined before you start your painting.

While Chadbourn was painting, the scene changed constantly. Had he come back an hour later, all the shadow patterns would have changed drastically, forming an entirely different composition. That's why he had to draw the buildings in first and then add the shadow patterns on top. This process was more complicated than it sounds, because the cast

shadows were so strong that they tended to destroy the three-dimensional form of the buildings. Look, for example, at the upper right corner of the picture. There, the whites of the sidewalk and the buildings are basically all on one flat plane. The only things that determine the form of the buildings are their diminishing size and the small diagonal shadows of the sloping roofs.

Color Mixtures

The numbers in this list correspond to those in the illustration shown below.

1. The long, horizontal strokes of grass are a mixture of Thalo (phthalocyanine) green and burnt sienna in the darks and Thalo green, cadmium yellow, yellow ochre, and white in the lights. To accentuate the long cast shadows, here and there Chadbourn spattered the paint on with a loaded brush.

2. The deep bottle green of the barbershop is again Thalo green and burnt sienna, with a little ultramarine blue to cool it down.

3. The light areas of the white clapboard houses are a mixture of alizarin crimson, yellow ochre, and white, with ultramarine blue added in the shadows. Basically, then, the shadows are a cool violet, contrasted with pinker lights in the thicker, white areas.

4. The tree trunk is painted with burnt sienna, ultramarine blue, yellow ochre, and white in patches that suggest both its texture and the play of light on its surface.

5. The red trim, the windows, the barber pole, and other details were not just added at the very end. Instead, Chadbourn worked on them during various stages of the painting, until they became an integral part of the overall design.

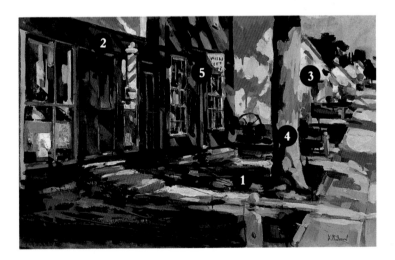

MAIN STREET, YARMOUTH, MAINE
Oil, 24 x 40" (61 x 102 cm), courtesy Barridoff Gallery, Portland, Maine.

LANDSCAPE PAINTING

Margaret Kessler

Conveying Depth with Linear Perspective

Landscape paintings need a sense of depth—an illusion of space and distance that stirs viewers' curiosity and fascinates their imagination. As you compose your painting, design some degree of depth into it. You may choose to settle everything snugly into a short visual range or to stretch the scene to infinity. Whatever the span, you, the artist, must be able to fool the eye into believing some parts of the picture are closer than other parts.

One way to indicate depth in a painting is through linear perspective, according to which you progressively reduce the size of objects as they recede toward the horizon. This principle must be applied to cast shadows and contour shapes, too.

Notice that the foreground shadows cast across the road in the black-and-white illustration shown here are wider and farther apart near the front edge and become narrower and closer together as they step into the distance. As you compose, make your cast shadows describe the contour and texture of the terrain—running down the grassy slope and gliding across the smooth pavement. Don't be careless with cast shadows—they're important.

Also notice that contour shapes on the mountain are widest at the point nearest you. Linear perspective reduces their size, shape, and proximity to each other as they move away from you and taper upward. Incidentally, contouring helps you convey the shape of an object without the need for sharp, well-defined edges or harsh outlines. Use contour shaping to push upward the inner thrust of natural forms such as mountains and trees. Save concave, sagging forms for man-made objects like ruts in roads, power lines, and roof edges. Echo, from foreground to background, these radiating patterns.

Extreme differences in scale also create a dramatic sense of depth, as you can see in the oil sketch *Copper Mountain*, with the large pine trees and the small mountain. Even the length of your brushmarks conveys depth—long, tall strokes (as in grass) advance, whereas narrow, broken lines recede.

Keep in mind that the mood of a scene takes precedence over accurate rendering. In this on-location oil sketch, sharply defined cast shadows were purposely not indicated in the foreground, as precise shadows would have been distracting.

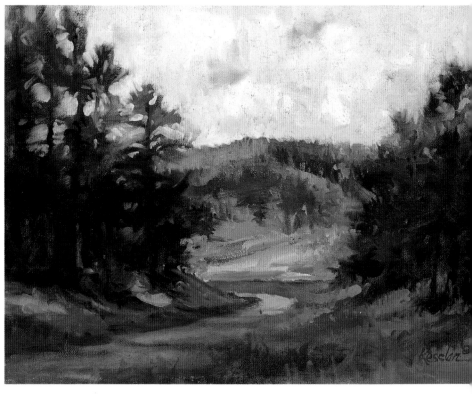

COPPER MOUNTAIN
Oil, 12 x 16" (30 x 41 cm), 1984.

Value Recession

In landscapes value recession, which is also called aerial or atmospheric perspective, is a major factor in expressing depth. By gradually changing the darks in your value scheme from very dark darks in the foreground to relatively light darks in the background, you can convey space and distance. Although value recession is more readily apparent in darks than in lights, light objects in the foreground—for example, near-whites such as snow, sand, concrete pavement, and reflected lights on water or clouds—do become slightly darker in the distance. You will find that veils of dust, smoke, and the general atmospheric conditions diminish the degree of light-dark contrast as you look into the distance; therefore, adjust your values, closing up the value contrasts, as you move, inch by inch, into the scene on your canvas.

If you place darks in the distance that are too dark, they will advance and compete with foreground objects for attention. (This is equally true of lights that are too light.) This rule applies to everything, including openings in buildings, cast shadows, and form shadows. Remember: Darks must gradually diminish in value as they recede.

You must establish a value plan that is so accurate that the scene would be believable if reproduced in black and white. Use this plan as a guide for colors and details. If the value foundation is properly laid, it will be easy to build successfully on it with colors and details.

STEP 1

STEP 2

STEP 3

For her painting *Spring Melt,* Margaret Kessler began by toning her canvas with a middle-value wash and placing the objects, as you can see in step 1. Next, as shown in step 2, she blocked in the darkest darks in the foreground (the contour shapes on the left bank), the middle-tone darks in the middle ground (the carefully spaced trees), and the lightest darks in the background (a wall of trees). (If your scene has a strong light source coming from one side, subtly apply value recession as you work from side to side, gradually diminishing the intensity of the light as it flows across the canvas.) Once she was satisfied with this preliminary value plan, Kessler established the location and the degree of drama for the focal point by washing off the original tone with turpentine and exposing the raw white canvas.

She then developed the value foundation from simple to complex, as shown in step 3. Notice the value recession, from light to dark, in the snow and the size reduction in the trees. Keep in mind that in scenes like this, due to the reflective properties of snow, the tree trunks are usually lighter in value near the ground.

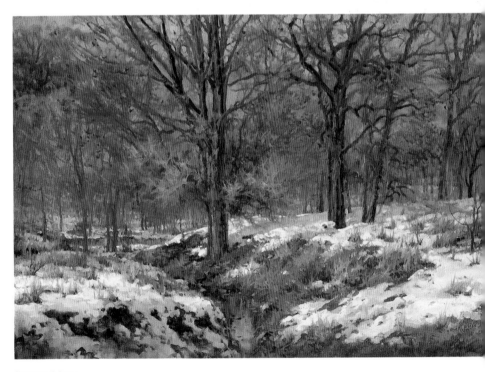

SPRING MELT
Oil, 24 x 36" (61 x 91 cm), 1985.

Margaret Kessler

Color Recession

Like value recession, color recession conveys aerial perspective. When you adjust a local color by neutralizing its brilliance and cooling its temperature to indicate changing lighting and atmospheric conditions, you are making colors recede into the background.

This is how it works. Bright colors at full intensity advance more than neutrals, so when the local color of an object like a green tree is neutralized, it begins to recede. Similarly, colors influenced by yellow generally advance more than colors that have been cooled by removing the yellow element. That is, as the yellow sunlight on a given object moves toward yellow-orange, orange, orange-red, red-violet, violet, blue-violet, blue, and ultimately to grays, the color tends to recede. When you combine color recession (both neutralizing and cooling a color) with value recession (fading the light-dark contrast into the distance) and linear perspective (diminishing sizes), you can fool the eye into seeing depth on a flat surface.

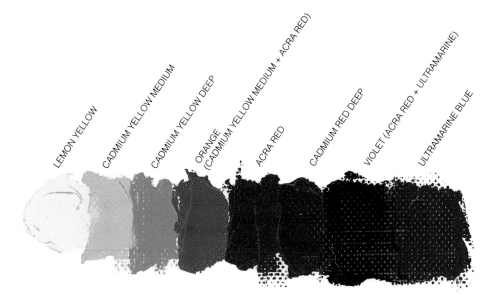

LEMON YELLOW · CADMIUM YELLOW MEDIUM · CADMIUM YELLOW DEEP · ORANGE (CADMIUM YELLOW MEDIUM + ACRA RED) · ACRA RED · CADMIUM RED DEEP · VIOLET (ACRA RED + ULTRAMARINE) · ULTRAMARINE BLUE

Move from the white-hot color of the sun itself on the left, through yellow, reddish yellows, reds, and on into the cool blue of distance on the right.

Start with the local color of the object. For these trees, you might mix a warm green (cadmium yellow medium with a tiny bit of phthalo blue) and a cold green (lemon yellow and phthalo blue). To adjust the local color, remove the yellow as you recede through the spectrum into the distance—moving from cadmium yellow medium through ultramarine blue in this illustration. As you progress through these colors, you should also mute the color intensity somewhat. Here, a touch of yellow ochre was added to the center tree to help neutralize the brilliant hues. The colors will be muted and cooled even more when you add a little white to adjust the values, as tube white is rather opaque and very cold.

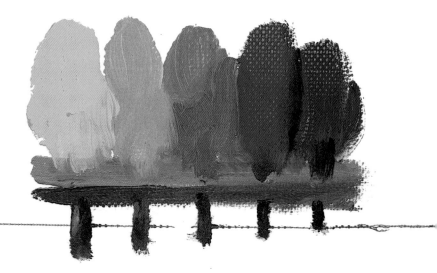

Put everything you have learned so far together. By overlapping objects that diminish in size and by gradating colors and values, you will create an illusion of depth. Details should progress from sharp, well-defined, large brushmarks to soft, fused marks as the edges change from ragged to smooth. Notice that the closest tree here is lowest on the canvas and that the colors of the tree trunks are also modified with the removing-the-yellow principle.

A Special Circumstance. Side lighting must be considered too. This tiny sketch illustrates how to remove the yellow element as the sunlight spills across your canvas. Notice how the light blue background moves from *yellow*-blue to *orange*-blue to *red*dish blue to pale blue. The next step into the distance would be a light gray.

When using the principle that warm colors advance and cools recede to depict depth, you must remember that the local color is usually a given with which you must work. If, for example, you have a boy in a blue jacket walking slightly in front of a boy in a yellow jacket, even though yellow naturally advances, the form in cool blue will, because he overlaps the other boy, appear to advance. Use the principle of removing the yellow to modify and adjust the local color, cooling and neutralizing it until that local color fits properly into the floorplan of the scene. (It might be easier to have the boys exchange jackets!)

Margaret Kessler

Taking a Closer Look at Trees

Using warm and cool greens for the local color, let's take a closer look at how to make colors regress in both sunlight and shadow by removing the yellow. Essentially the sunny branch shown here is warm green progressively modified with yellows, orange, and red. The branch in the shade is a combination of warm and cold green similarly modified—except for the lightest color (5), which shows the effects of reflected light. Here the value has been lightened and the intensity of the local color muted with cadmium red deep and white rather than bright yellow, as a branch in the shade reflects the coolness of the sky, not the yellow sunlight. By the way, if your colors look chalky, chances are you are adding too much white to create a lighter value. Try remixing that color by starting with lighter tube colors.

In the illustrations shown on the opposite page, notice that the branches are the same color as the foliage. This technique adds to the sense of atmosphere and harmonizes the branch and foliage colors. When you paint branches, start with the next-to-last dark value (2) and move up to light (5) as you taper from limb to twig. Save the darkest value (1) for accents on the limb.

Once you know how to paint branches in the sun and in the shade, you can paint a tree at close range. Just put the two branches together, side by side. Then, to the top of the tree, add some light, cool reflections from the zenith of the sky ("skyshine"); locate a spot or two of reflected sunlight (highlights); bounce some warm earth colors up underneath the lower limbs and adjacent colors into the tree itself; and tie the tree into the setting with a cast shadow.

BASIC GREENS

WARM: CADMIUM YELLOW MEDIUM WITH PHTHALO BLUE

COLD: LEMON YELLOW WITH PHTHALO BLUE

SUNNY BRANCH

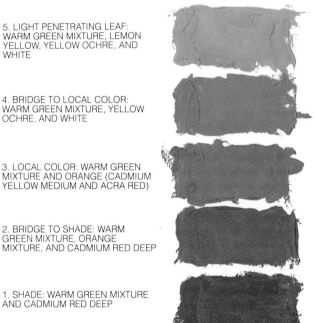

5. LIGHT PENETRATING LEAF: WARM GREEN MIXTURE, LEMON YELLOW, YELLOW OCHRE, AND WHITE

4. BRIDGE TO LOCAL COLOR: WARM GREEN MIXTURE, YELLOW OCHRE, AND WHITE

3. LOCAL COLOR: WARM GREEN MIXTURE AND ORANGE (CADMIUM YELLOW MEDIUM AND ACRA RED)

2. BRIDGE TO SHADE: WARM GREEN MIXTURE, ORANGE MIXTURE, AND CADMIUM RED DEEP

1. SHADE: WARM GREEN MIXTURE AND CADMIUM RED DEEP

BRANCH IN THE SHADE

5. REFLECTED LIGHT: WARM GREEN AND COLD GREEN MIXTURES WITH CADMIUM RED DEEP AND WHITE

4. BRIDGE TO LOCAL COLOR: WARM GREEN AND COLD GREEN MIXTURES WITH YELLOW OCHRE

3. LOCAL COLOR: WARM GREEN AND COLD GREEN MIXTURES WITH ORANGE MIXTURE (CADMIUM YELLOW MEDIUM AND ACRA RED)

2. BRIDGE TO SHADE: WARM GREEN AND COLD GREEN MIXTURES WITH ORANGE MIXTURE AND ACRA RED

1. SHADE: WARM GREEN AND COLD GREEN MIXTURES WITH ACRA RED

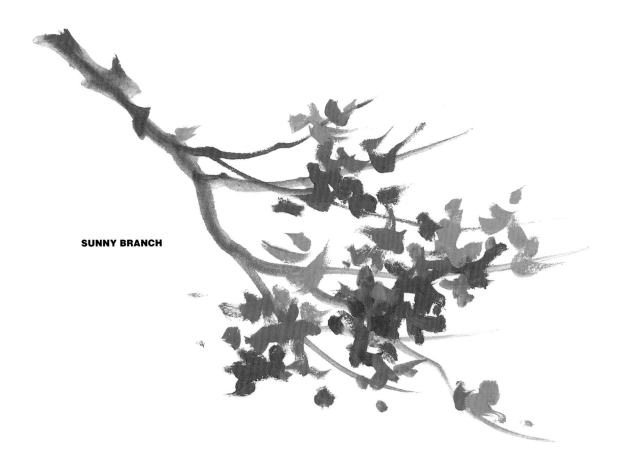

SUNNY BRANCH

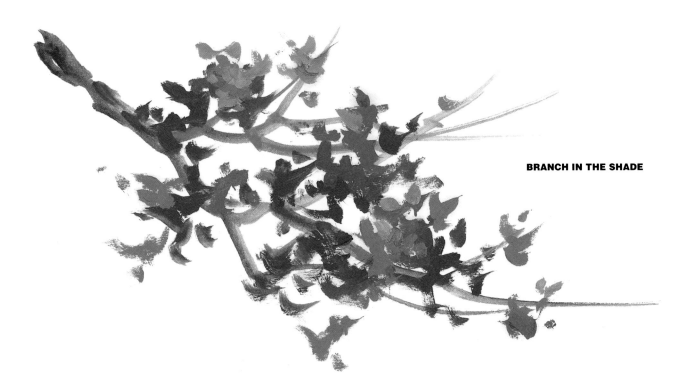

BRANCH IN THE SHADE

Margaret Kessler

Handling Grass and Roads

The basic rules of color recession outlined for trees can easily be applied to other subjects. Start with the local color. For the grass in this illustration, Margaret Kessler began with a combination of warm and cold greens. She then modified this, putting the yellowest color in the foreground and gradually removing the yellow element, cooling and neutralizing the local color as she worked into the distance. She used the same technique on the road, beginning with

yellow ochre as the local color. Since the road is so much lighter than the grass, Kessler worked with tints of the modifying colors—diluting her tube colors with white. (She prefers titanium-zinc ever-white, as its pearlish luster is not as transparent as zinc white or as opaque as titanium.)

By the way, although the emphasis here is on color recession, don't forget to modify the values and details as things recede into the distance.

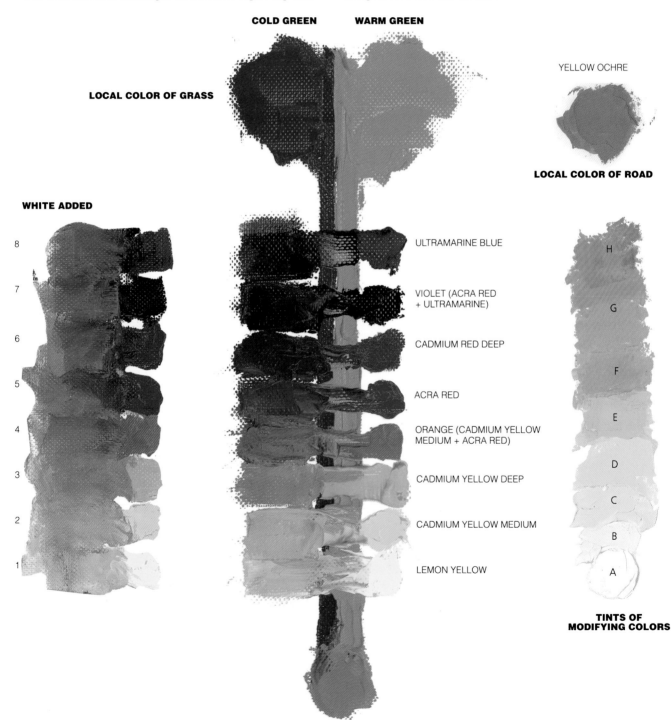

COLD GREEN **WARM GREEN**

YELLOW OCHRE

LOCAL COLOR OF GRASS

LOCAL COLOR OF ROAD

WHITE ADDED

8

7

6

5

4

3

2

1

ULTRAMARINE BLUE

VIOLET (ACRA RED + ULTRAMARINE)

CADMIUM RED DEEP

ACRA RED

ORANGE (CADMIUM YELLOW MEDIUM + ACRA RED)

CADMIUM YELLOW DEEP

CADMIUM YELLOW MEDIUM

LEMON YELLOW

H

G

F

E

D

C

B

A

TINTS OF MODIFYING COLORS

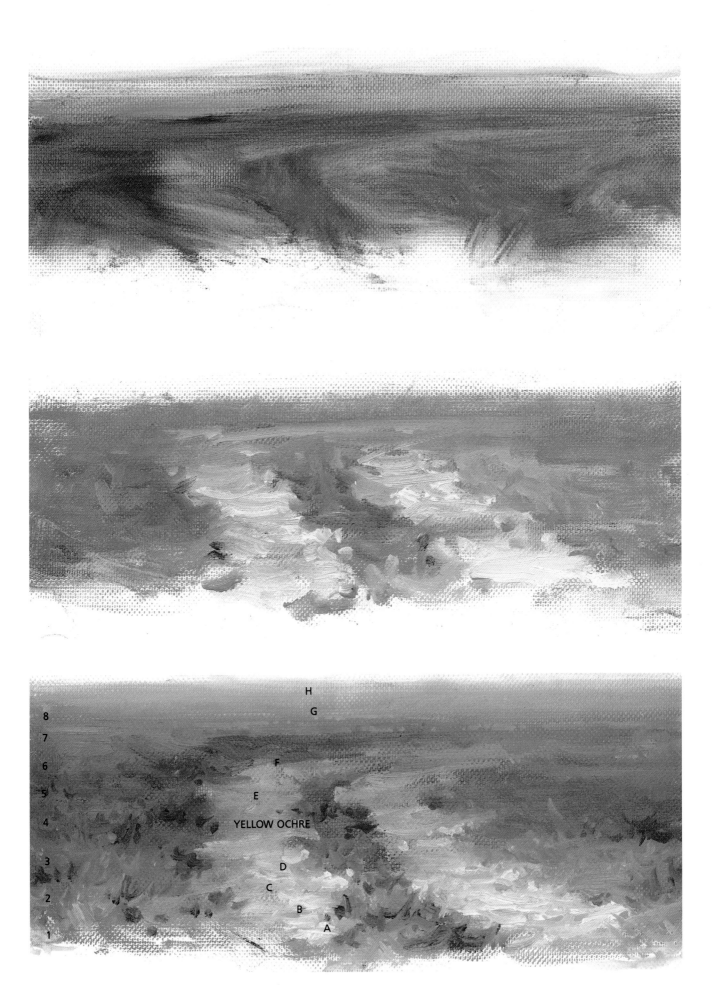

Margaret Kessler
Handling Clouds and Sky

Since clouds are made up of moisture particles reflecting the lighting conditions of the moment, simply use the colors of the light as a starting point when painting clouds on a sunny day. The illustration here provides a guideline. As you can see, the sunny highlights in the cloud closest to the viewer are nearest the color of the sun—lemon yellow (A) in this illustration. As the clouds recede into the distance, you should make the lemon yellow regress to cadmium yellows, oranges, and then reds (B through E). In like manner, modify the dark form shadows in the clouds,

receding from warm to cool grays, with less red and more blue. When you finally arrive at the horizon, combine a muted red (F) with a modified ultramarine blue (the zenith of the sky) to create a pinkish gray, suggesting dust, sand, and pollution.

Since clouds are rounded forms, the lightest lights are *not* at the edges, touching the blue sky—unless backlighting penetrates the form. As on any sphere, use skyshine on the top, reflected earth tones underneath, and bouncing lights along the sides to indicate the mass and the form.

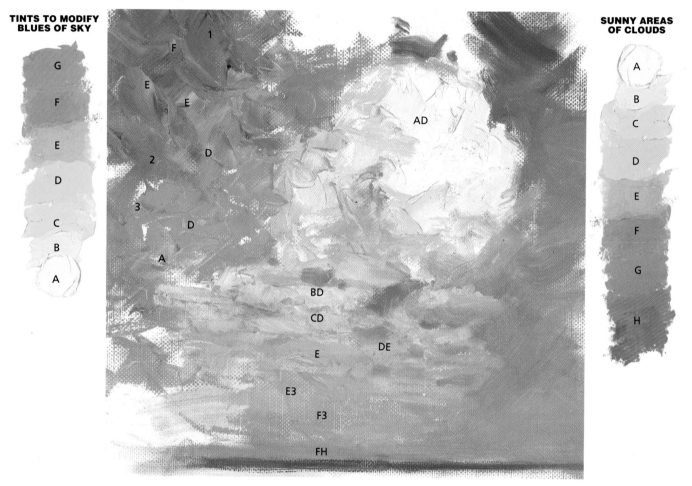

TINTS TO MODIFY BLUES OF SKY

SUNNY AREAS OF CLOUDS

1—ULTRAMARINE BLUE
2—PHTHALO BLUE
3—COLD GREEN

A—LEMON YELLOW
B—CADMIUM YELLOW MEDIUM
C—CADMIUM YELLOW DEEP
D—ORANGE
E—ACRA RED
F—CADMIUM RED DEEP
G—VIOLET (ACRA RED, ULTRAMARINE BLUE)
H—ULTRAMARINE BLUE

Now look at the sky. Since ultramarine blue has some red in it, it is somewhat cooler than phthalo blue, which has some yellow sunshine in it. Therefore, if you are painting a skyscape that includes some of the sky's zenith, use ultramarine blue near the top of the canvas, changing to phthalo blue as you work your way down. As you approach the horizon, add a little lemon yellow sunlight to the phthalo blue, creating a transparent cold green. (Remember to indicate some pollution just above the horizon.)

Keep in mind that rays of warm sunlight reflect off the earth, cooling as they bounce upward. In the blue of the sky, use the yellow-orange-red modifiers, working from cool to warm (G through A) as you move from outer space to the horizon. Specifically, in this illustration, the local sky colors (ultramarine, phthalo blue, and cold green) have been modified, working from the top downward, with grayed red (F), red (E), orange (D), and finally yellow (A). Don't overmix your colors, by the way; broken colors are more fascinating.

Be careful not to make the blue sky too dark or the clouds too light. Chalky white clouds need more pigment. Compare the values of the clouds and the sky; then compare these values with the general value of the landscape, relating all three values accurately—sky, clouds, landscape.

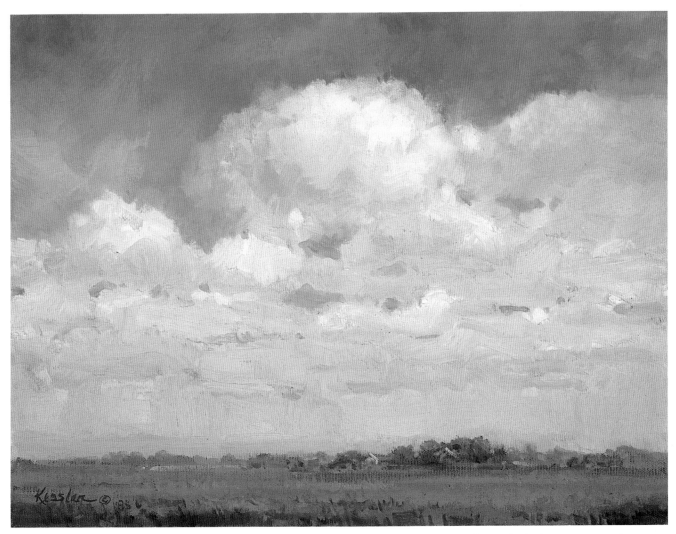

BILLOWING CLOUDS
Oil, 12 x 16" (30 x 41 cm), 1985.

Now that you know how to use color recession, disregard color for a moment and observe the values in the clouds themselves in this finished painting. Notice that the light areas of the clouds progressively grow slightly darker, as well as duller and cooler, as they recede into the distance. This phenomenon is due to the numerous veils of atmosphere blocking your view of the distant horizon. Conversely, dark form shadows in the clouds appear lighter and cooler as they approach the horizon. In other words, lower the intensity of the value contrast as the clouds vanish into the distance. Then define a few outer edges and refine some contours to create furrows and ridges within the clouds themselves. Keep in mind that explicit details like ragged edges project forward, while smooth or lost edges recede.

Charles Reid

Light and Shadow in Landscapes

Students often find their snow scenes more successful than other landscape efforts. Of course, it's because they're forced to paint simple light and dark shapes. It's natural to focus on details and miss the overall value difference between two adjoining areas. But a snow scene forces us to see the differences. It's the same with fog and any scene that's backlit. They help us simplify and see shapes rather than details.

Backlighting distills subjects to their essential silhouettes. There's no apparent modeling to distract us. In this composition, value stays pretty constant within the silhouettes of tree, barge, and horizon. These silhouettes are clearly darker than the water and sky. Carefully drawn shapes are the keys.

PUSH BOATS, BATON ROUGE
Oil on board, 24 x 24" (61 x 61 cm), courtesy Munson Gallery.

Charles Reid did these two paintings from the same spot in front of his house in Nova Scotia. The first was done at high water in the fog and was to be an exercise for his next day's painting of the same subject. He did the second painting when the tide was out and the light was rather bright, conditions that made it easier to see more details. In spite of this, though, Reid remembered the straightforwardness of his first version and kept things simple here, too—note especially the foreground and the distant spruce.

TRAP SKIFF #1
Oil on panel, 18 x 16"
(45.7 x 40.6 cm).

TRAP SKIFF #2
Oil on panel, 16 x 16"
(40.6 x 40.6 cm).

Charles Reid
Backlighting in Landscapes

This scene was painted on infamous Cape Sable Island, the very southwestern tip of Nova Scotia, where even Canadian fisheries officers fear to tread. Cape Islanders are a fearsome lot, a breed apart. In the picture, the sun is off to the left and under a cloud, illuminating the boats and foreground in such a way as to make them relatively simple, dark shapes. You do see some value differences, but the overall impression is that of dark shapes on a light background. Charles Reid used ivory black with a little titanium white on the undersides of the clouds and in the reflection of the lobster boat. He uses rather bright, "sweet" colors on occasion, and using black instead of complements to make grays tempers the sweetness. It's interesting how a touch of pure cadmium red right out of the tube—note the figure in the foreground—can spruce up a picture.

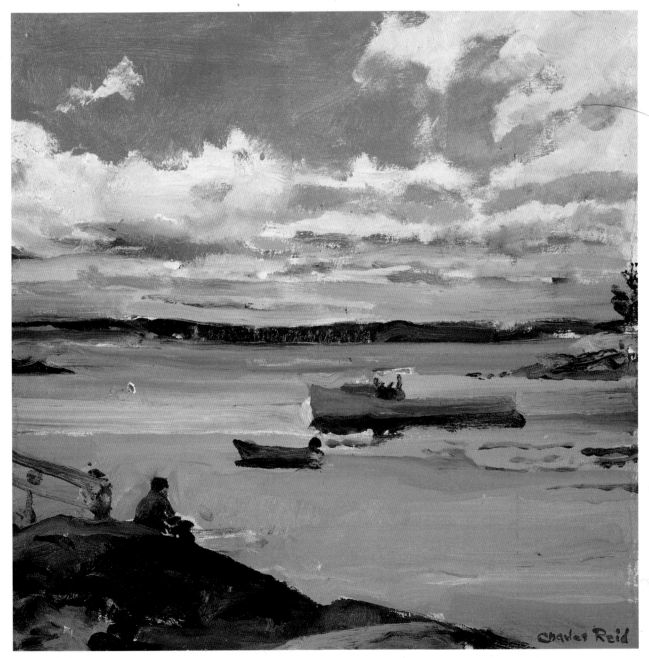

CAPE ISLAND
Oil on canvas, 16 x 16" (40.6 x 40.6 cm).

THE CREEK
*Oil on panel, 18 x 24" (45.7 x 61 cm),
courtesy Munson Gallery.*

Charles Reid likes this picture because it was fun to paint. He borrowed the idea of painting the sun from Fairfield Porter. He also borrowed the almost Oriental simplicity of Porter's style. Note how the strong sunlight behind the trees and boats helps define their shapes. There was a lot of action in the water, but Reid managed to keep it simple so he could convey a sense of the sun's strong reflection.

Alfred C. Chadbourn
Simplifying Nature for Impact

Chip Chadbourn's small painting of Boothbay Harbor resulted from a watercolor sketch he did during one of his classes. Before starting the painting session, Chadbourn showed the class a series of popular postcards extolling the cliché virtues of this coastal harbor. He asked the students to look at the subject in an entirely new light, as though they were seeing it for the first time, and to capture the essence of their emotions. He purposely asked them not to do a finished painting, but to experiment with new possibilities.

Back in his studio, Chadbourn started thinking of what he had told his class about seeing nature from a personal, more evocative point of view and decided to practice what he preached. He chose a head-on view of the harbor so the geometric buildings would stack up, one against the other, in angular patterns. As a foil for all the whites in the central part of the composition, he simplified the band of deep blue water in the foreground and the dark green hill in the background.

With the two dark areas in place, Chadbourn began to freely interpret light colors in the center. He picked out the red building at random and placed it slightly left of center. Then he began developing many subtle variations of white, mixing ultramarine blue, alizarin crimson, yellow ochre, and white in varying degrees. A few darks were spotted about, both to structure the buildings and to create a strong value contrast with the whites. Chadbourn kept going back and forth, readjusting and redefining areas until he felt he had captured the overall pattern.

Later, he added some warm notes of color near the wharf, against the darks of the water, and suggested the shapes of the boats in simple terms,

using the same rich textures as in the buildings. To energize the overall white patterns, he introduced a few light, horizontal strokes of ultramarine blue to the water and a few bright spots of blue to shadows around the buildings. A few details of masts and windows then helped to clarify the scene without disturbing the painting's semiabstract quality.

A Different Viewpoint
The painting on the facing page shows an exaggerated, almost elevated view of the harbor in South Bristol, Maine—commonly called "The Gut" because of its narrow boat passage through a drawbridge in the center of town. Chadbourn tried to reduce the clutter of small houses, piers, and boats to a sweeping pattern cutting across the canvas and surrounded by the expanse of bright blue water. To flatten the picture even more, he omitted the sky and used thin, horizontal bands of

dark and light blue running across the top to close the composition. By repeating the curve of the road in the curves in the foreground water and upper portion, he enhanced the circular motion of the design. The slight angle of the piers and buildings on the right then acted as a wedge, pushing against the strong direction of the road and helping to hold the viewer within the picture plane.

The light blue in this painting isn't very typical of Maine waters. It was chosen more as a color idea than as a faithful reproduction of the scene. Chadbourn was thinking in terms of a light blue field of color juxtaposed against all the busy activity of the village and wharf. Notice how some of the buildings and piers have been reduced to thick slabs of hot pinks and cool violets, forming an array of lively shapes. The offbeat light green strokes in the center represent the drawbridge and the small, deep blue verticals

BOOTHBAY HARBOR, MAINE
Oil, 12 x 12" (30 x 30 cm), collection of Mr. Larom B. Munson.

translate as reflections of the pilings. The dramatic impact of the village is further intensified on the right, where squares of bright yellow-green play against the angular shapes of the houses and small accents of pink light flicker against the cooler cast shadows. Finally, notice the small white boats sitting on top of the water. Even though Chadbourn treated the water as a flat plane, adding these boats contributes to an illusion of depth.

Some of the liberties the artist took depended on his familiarity with this scene—a very important factor in taking liberties with nature. Obviously, the more you know about a subject, the more you will feel at liberty to take a few chances in characterizing it.

THE GUT, SOUTH BRISTOL, MAINE
Oil, 30 x 30" (76 x 76 cm), collection of Carol and J. L. Wishcamper.

Alfred C. Chadbourn
Reinterpreting Sketches

The challenge in interpreting an over-painted subject like this active harbor in Portland, Maine, is to bring a fresh sensibility to the material and to open up your creative instincts.

Usually Chip Chadbourn tells his students to prowl around the wharfs and make several sketches before they start to paint, in the hope that they will warm up to the subject by looking at it from various points of view. While they do this, he furtively makes a few rough notes of his own and, when possible, takes a few photographs as well. This painting of workboats, completed in his studio, was the result of one such expedition.

When you compare the sketches to the painting, you can see how many changes took place. At one time part of the wharf showed on the right, but finally Chadbourn took it out, as it detracted from the overall pattern of the boats. As he worked, he also made many changes in the color of the water, moving all the way from a murky green through various shades of blue until he finally ended up with gray-violet tones.

As Chadbourn kept squinting at his canvas, the dominant pattern he wanted to capture involved the play between the small, intense, light-struck areas of light pink and light green on top of the boats. He was thinking primarily in terms of shapes, rather than trying to make an accurate rendition of the boats. That's all part of taking liberties with the subject to strengthen the painting. Had he tried to do this painting on the spot, Chadbourn feels he would have become bogged down in lots of meaningless detail. Relying on his sketches made it possible to create a freer interpretation.

When you compare these sketches to the final painting, you can see just how many liberties were taken with the subject.

WORKBOATS, PORTLAND, MAINE
Oil, 36 x 36" (91 x 91 cm), collection of Mr. John Soley.

132

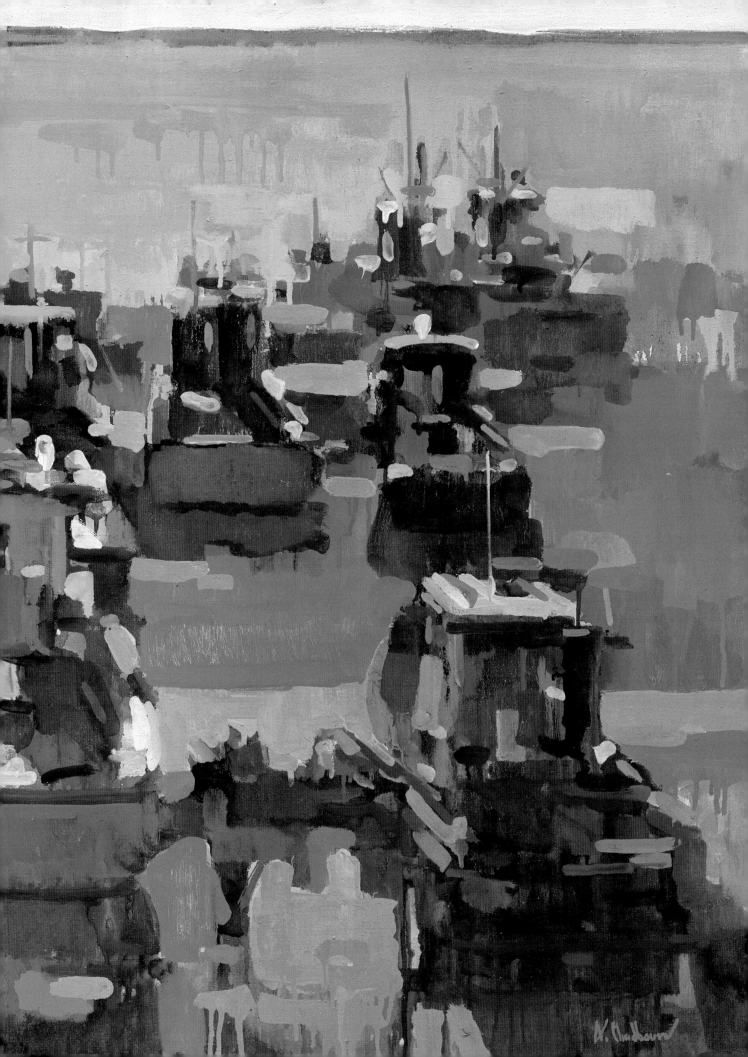

Albert Handell
Capturing the Essence of a Seascape

Monhegan Island, located eleven miles off the rocky coast of northern Maine, is a magical place that has been known to artists and landscape painters for many generations. The heights are numerous and the sights breathtaking, and at all times you are surrounded by the most beautiful, varied coastline found anywhere.

At low tide early one morning, Albert Handell was overcome by a moment of peacefulness of the sea. There, rocks covered with seaweed and mosses were lying exposed, revealing a brilliance of color often hidden by the rolling sea. A fog was lifting, but the sun had not yet made its way through the clouds. The moisture-laden air gave a soft beauty to the atmosphere and a sense of distance to the rocks and sea. The colors and shapes created a delicate, flowing design, simple yet tremendously powerful, as the fog gradually and silently lifted. He realized he would have to work quickly to capture this moment before the sun would break through and the scene before him would disappear.

Thus, Handell centered the composition of his painting on the element of design, combining abstract shapes and patterns with a delicate but muted harmony of colors. His prime concern was with the shapes of the rocks and how they related to each other seen in the light of a lifting fog. To ensure the painting's carrying power, it was particularly important to reduce the composition to only a few values.

Step 1. With a mixture of ivory black, titanium white, and a touch of yellow ochre, Albert Handell lightly sketched in his design using a #2 round bristle brush and turpentine as the medium. Note the arc of foreground rocks that frame the middle foreground, setting it back a bit. He then began the transparent color wash-in. With a #4 round bristle brush he scrubbed on the tannish-gray tone of the rocks, letting the brush follow their sweep.

Step 2. Picking up a smaller brush for more rhythmical strokes—a #2 round bristle—Handell laid in the color wash of the seaweed-covered middle-ground rocks. This was done with a mixture of permanent green mixed into a middle-value gray composed of black and white. As he painted the green seaweed, he took careful note and delight in the rhythms and patterns it was left in by the receding waters of low tide. As the green of the middle-ground was put in, the foreground greens were reinforced and strengthened.

Step 3. By now all of the shapes had been established with color as Handell laid in the distant red rocks with a #5 flat bristle brush and a mixture of cadmium red light and gray (made from black and white). He again took careful note of the patterns and shapes. The positive shapes were all laid in with color; the negative shapes were left unpainted. The design of the picture was now set.

Step 4. This was the last phase of the transparent color lay-in, which forms the basis for the finished optical color mixtures. Still using turpentine as the medium and a #4 round bristle brush, Handell laid in the sea with a mixture of ultramarine blue toned down with a very light gray so it would stay in the background. He also reestablished and strengthened the seaweed area of the lower left with a combination of the permanent green and middle-tone gray mixture, but a touch thicker now and more opaque.

The beautiful colors and textures of this subject suggested the use of optical color mixtures. Simply stated, optical color mixtures are harmonious layers of color placed one on top of the other, allowing lower layers to show through in order to achieve a color impact. The final effect is achieved carefully, with delicate glazes, scumbles, and selective overpainting.

With this method, you begin with a transparent full-color underpainting, diluting the paint with turpentine and laying in the colors of the painting in thin, free-flowing washes. The underpainting should establish the entire tonal (value) and color range for the painting before the overpainting is begun.

When this is done, the painting is ready to be developed with opaque and semiopaque colors applied over the transparent color wash, this time aiming for more accurate color mixtures. As the painting is carried toward completion, some of the transparent layers of color from the underpainting are allowed to show through. Finally, when the painting is dry, delicate glazes and semiopaque scumbles are used to bring everything together to a harmonious finish.

Step 5. With the transparent underpainting finished and relatively dry, Handell was ready to begin the overpainting. He cleaned off his palette and set out fresh paints. Taking a few #4 round bristle brushes to keep the colors clean and separate, he began working up the greens and reds in the middle foreground. He switched to Maroger medium (a gel medium composed of cold-pressed linseed oil, pure gum spirits of turpentine, mastic crystal varnish, and litharge) and, using it sparingly, established richer colors, using more pigment, to make a good, solid base for the subsequent optical color mixtures.

Step 6. Handell concentrated on massing together the green, seaweed-covered rocks and the distant red rocks so that they would flow into each other. Continuing to mass and unify the areas, he put touches of blue in the foreground and middle-ground rocks so as not to lose sight of the light source, although it was foggy and overcast. This also kept a hint of "bluishness" in the painting due to the cool light. With a gray mixed from black and white, he painted the puddle next to the rocks and added some of the textural details to the foreground rocks.

MONHEGAN ISLAND
Oil on panel, 18 x 24" (46 x 61 cm),
collection of the artist.

In the final stages, Handell glazed and scumbled on a light blue-gray mixture of ultramarine blue, a touch of white, and Maroger medium. He floated it over the picture, unifying it through this bluish haze, letting the various underlying colors come through. By scumbling the bluish gray over the red rocks, he pushed them back a bit and softened and harmonized these well-defined shapes against the background sea. He scumbled a warm gray tone of the same value over the sea, pushing it back still further and creating an optical color sensation. The foreground rocks got richer and warmer as he added more Naples yellow and yellow ochre to his colors and worked more detail into the foreground rocks. Working a bit more opaquely with a little Maroger medium mixed into the paint mixtures, he continued to gently pull the entire painting together. The optical colors give a simple painting like this a luminous color play, yet the painting retains a subtle and harmonious unity.

Albert Handell

Understanding the Importance of Shapes

Everything has a shape. Shapes are terribly important. Without them, strong realistic painting doesn't exist. Shapes show how objects occupy space and how the essential characteristics of the object are perceived by the viewer. In realistic painting, shape is defined or composed by the visible parts of an object, that is, by what can be seen of an object or objects from a fixed or particular point of view. In turn, objects can also be defined by the shapes.

Objects considered as shapes and their relationships to each other come first in creating a composition. They are interwoven with the objects.

An important aspect of these shape relationships in realistic painting is seeing. Seeing objects as shapes and seeing the shapes within the composition requires a different vision from the vision that stares at details. It helps to squint your eyes to see past the detail and to see the shapes more clearly.

The shapes are three-dimensional, but in the composition of a painting are enclosed within designated areas by two-dimensional edges or lines. Lost and found edges profoundly affect the reading or seeing of the shapes. This process creates the illusion of three dimensions, which always includes two-dimensional shape relationships worked out to show the three-dimensional shapes of the objects.

Shapes and relative shapes can certainly be one of the most important elements of a painting. Their positioning alone and together, their action, balance or imbalance, and even directional thrusts can all create immense spatial variety in compositions.

Clarity of the shapes is essential for good composition. Underlying shapes must be clear so that objects are easily recognizable.

The major shapes are established fairly early in the painting and should retain their clarity and integrity in the composition right until the end.

Sometimes just one or two major shapes is enough. Subordinate areas may have other shapes in them, but they should not detract from the main shapes.

However, not every shape of every object needs to be as specific as every other shape. Some can be left vague with only enough definition for the viewer to become involved and conjure his own images. This will allow the eye to move through the composition from specific areas to suggested areas.

The activity of the shapes changes in relation to how and where they are placed in the composition. Alive, interesting shapes will usually create an alive, interesting composition arising out of the life of the shapes themselves and their relationships. Echoing shapes can create overall patterns in the composition of a painting. Repetition of certain shapes can create interesting possibilities for subtle variations later on. Introducing new shapes will tend to add a sense of movement and countermovement to the composition. And when they are solidly structured and harmonized, the shape relationships balance the composition.

The type of shapes and their arrangement could also determine the mood of the entire painting. Shapes can be exciting, original, and obvious, or subtle and hidden, but usually they all have very expressive personal qualities to them. How the shapes are related and positioned in space gives meaning and feeling to your personal visual expression.

Albert Handell's paintings are not begun with the idea of the geometric forms of shapes first. Rather, when the basic composition has been established (which includes establishing the center of interest and its placement), the geometric patterns become apparent and the forms are integrated to make the whole. The shapes evolve.

Shapes are basic emotional symbols

that carry a powerful impact and contain a strong unconscious power that should not be ignored. How to become aware of unconscious, already-existing intrinsic shapes; how to respect them and nurture them; and how to allow them to emerge calls for great care and sensitivity. They will emerge. They are part of your unconscious. That is what you want to tap. It's already inside you.

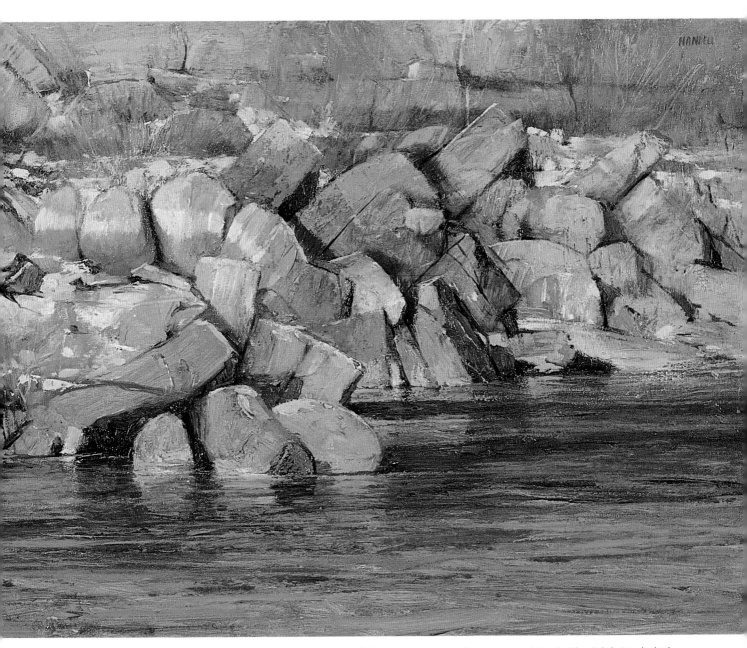

ALONG THE RIO GRANDE
Oil on Masonite panel, 14 x 24"
(35.5 x 60.9 cm), courtesy Ventana
Gallery, Santa Fe.

The shapes in this painting are simultaneously complex and simple. The tightly interlocked arrangement of the rocks gives a sense of their arbitrary clustering along the Rio Grande. Yet notice how the painting is practically divided into horizontal thirds. This gives relief to the array of complex shapes and colors that make up the rocks. The water, very green in color, flows horizontally through the lower third of the composition. The top third of the painting, basically a darker blue gray, also has a strong horizontal movement to it. This works very well as a background for the helter-skelter shapes of the rocks, which constitute the center of interest. Much work, detail, and love were painted into the rocks. Their elusive shapes and their changing colors and values further a certain subtlety in the painting.

Albert Handell
Positive and Negative Space

The shapes and the interrelationships of the positive and negative space are an important compositional principle. The placement of these elements into the format is what determines the composition.

The space of the positive shapes is composed of the subject matter, that is, the objects or persons that are the center of interest in the composition. The negative shapes are the areas surrounding the positive space.

When planning a composition, try to focus in on the positive space, the subject matter, right away, as it is often the most interesting area. Look at the space of the positive shapes as areas that can stand out by themselves as vignettes, and push and develop the positive shapes to be as strong as possible. Also consider when composing space that the positive shapes need not be only the foreground but can be a combination of foreground and background objects tied together to make up a truly complex and subtle positive area.

However, solid, balanced, interesting composition is terribly important. Never lose sight of the negative space as you are focusing on the positive areas. Maintain a sense of the entire painting as you work.

Negative space is more subtle, beginning wherever positive space ends. It is the peripheral area, the space surrounding the occupied area. The negative shapes are as important in the composition as the positive subject matter and should be given the same degree of attention that's given to the positive space. The positive space could not exist without the negative space that frames it.

When you are composing negative space, remember that negative space is limited by the format of the painting surface. The shapes of the positive space, in contrast, are usually centrally located. Negative space also often needs to be broken up into smaller shapes and then integrated with the balance of the painting. In this process, the shapes that are made up of the negative space evolve into shapes that have distinctive characteristics of their own, equal in importance to other areas. Giving them the same care and attention given to the positive areas of the painting will create strong balance in your composition.

SEDONA
Oil on Masonite panel, 30 x 36" (76.2 x 91.4 cm), courtesy Ventana Gallery, Santa Fe.

Sedona is a perfect example of a painting strong in composition. The shapes of the entire rock formation make up the positive space and the sky the negative space. The area of the painting surface given to the rock formation is almost twice the area given to the sky—a two-to-one proportion that makes an interesting composition.

First, Albert Handell laid out the painting by establishing the placement of the rock formation. He painted it high in value with warm, transparent colors. Later on in the painting, he used transparent and opaque applications as he developed the rock formation.

The negative space, the sky, was painted quite differently. Handell wanted the sky to complement the rock formation, not to compete with it. Therefore, he kept the area comparatively simple, using mostly one value of purple, varying the color from warm to cool throughout the sky and subtly blending it. The paint was applied opaquely, with the same consistency throughout. The purple complements the foreground yellows and oranges. In the lower part of the rock formation, some purple tones creep into the rocks and develop certain planes in them while maintaining the harmony of the positive and negative spaces of the painting.

OLD SANTA FE TRAIL
Oil on Masonite panel, 24 x 30" (60.9 x 76.2 cm), collection of Mr. and Mrs. John Stahr.

A feeling of depth in space is a natural part of the real world. Therefore, any realistic composition needs to have a sense of depth in order to achieve that desired effect of realism.

One way to create a sense of depth on a flat two-dimensional surface is to keep proper proportions and perspective in relation to the size of the objects in the foreground and the size of the objects distant in the background. Objects appear to decrease in size as they recede in space.

Another way to create depth is to overlap the planes of objects in the composition. But take care to see that the shapes remain interesting and that the reality has been well evoked.

Depth can also be created by eliminating details in the background and by having fewer value contrasts and more muted tones and softer edges. The background area will then recede. To add still more contrast to the background depth, keep the most interesting details, the strongest value contrasts, the sharpest edges, and the strongest colors all in the foreground.

There's nothing in the foreground of *Old Santa Fe Trail* to hinder the viewer's attention. Everything leads the eye into the painting to the group of suggested adobe buildings and surrounding dark piñon trees, which are all painted small and without details. This, plus their placement, creates an immediate feeling of depth in the painting. The sky adds to this dramatic sense of depth because it is painted in such a way that the viewer's eye is led to the thin, brilliant yellow band of light behind the adobe. This also pulls the eye into the painting and keeps it there. All combined, these elements create a rapid perspective, a rapid movement of the eye into the painting, thereby creating the sense of depth here.

Albert Handell

Composing from Drawings

Drawing is a sort of visual diary that readily reawakens a visual experience. The time spent with the subject matter helps to fix an experience in the mind.

Good drawing will always show you what you're seeing, and weak drawing will point out where you're not really looking. Try to draw without having preconceived notions, and try to see clearly and deeply.

There is a great difference between composing from life and composing from drawings. In the case of a drawing, the artist has already spent much time with the subject. A translation of the subject onto paper in black and white has already been made, and a certain grasp of the subject has been achieved. The composition has been explored. It also becomes clearer which areas of the painting should be developed earlier and which should be saved for later.

It's a good idea to draw often; it is a discipline and practice that will reveal much to you about yourself. It will reveal how you see things, how you feel about things, what your interests and perceptions are, all without the pressures of making a painting. You will soon find that you are looking deeply into the essence of things, and it is from this essence that your "sense" of composition will emerge. Slowly but surely you'll be able to compose and paint from your drawings, which is an art in itself.

When Albert Handell composes from a drawing, he knows he's on his own with regard to the creation of the colors of the painting. He takes this as a challenge rather than a handicap. When the drawing shown here was completed, he hung it on his studio wall. He enjoyed looking at it and wanted to use it in a painting. A couple of weeks later it snowed. Handell again visited the tree, and found that it took his breath away. The setting was so beautiful that he made another drawing, this time a quick sketch to capture the value patterns. Back in the studio, working from both drawings, he composed this painting. The drawing worked as a diary; every time he looked at it, it brought back vivid memories that he incorporated into the painting. Yet at the same time, he was able to compose freely on the canvas, since he wasn't restricted by his drawing.

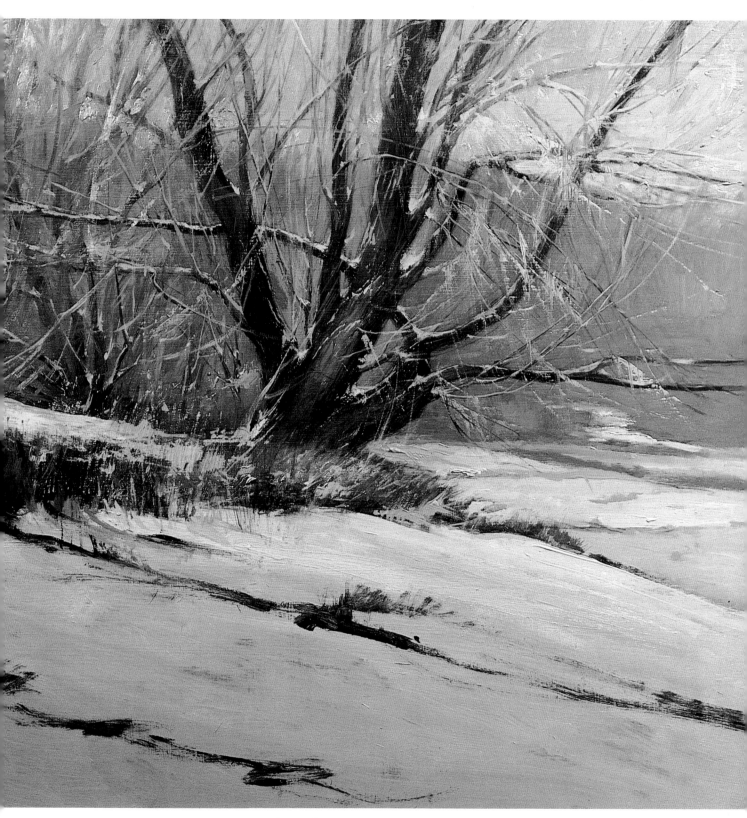

SANTA FE, SNOW
Oil on Masonite panel, 20 x 24" (50.8 x 60.9 cm), collection of Alan Frakes and James Young.

Albert Handell

Composing from Photographs

Once you have developed a vision all your own, you will find that using a photograph can aid your personal vision. At times Albert Handell begins compositions from photographs or slides by just looking at them and taking off from them, not copying them. This takes practice, years of experience, and previous work from life. When you work from a photo, it's a good idea to first make one or several pencil drawings of the composition from the photo before attempting to paint from it. This can facilitate the transition from photograph to painting.

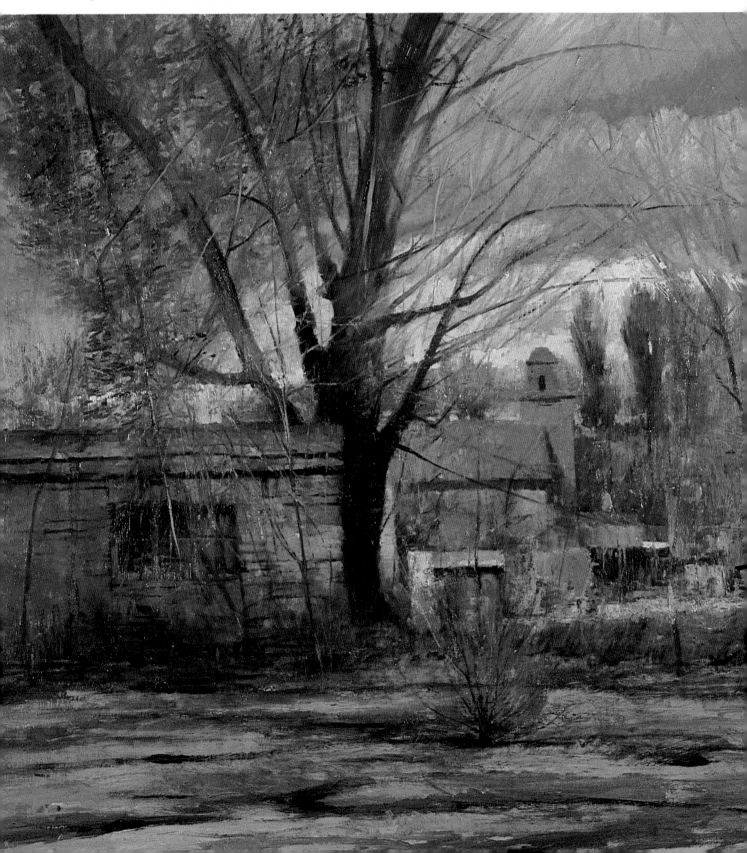

When you work from a slide, generally you use only one, so as much information as possible has to be there, since all the composing and painting will be done from it. Slides best show the color and light found in nature. They are the truest photographic images and have the most exciting impact. But there is no negative.

When you work from black-and-white and/or color prints, there are negatives, and lighter or darker prints and enlargements of areas can be made from them. A darker print will reveal patterns of the light and shade that make up the composition. But a lighter print will allow you to look into the shadow areas and see more information than you would in a darker print. Also, areas can be blown up to allow still more information to be seen. More information will give you more flexibility when composing. Because you want this flexibility, nothing compares to the basic information and detail in black-and-white prints. With color prints detail is not as good, but of course you will get an idea of your subject's color. However, it's best not to rely on the color in a photographic print as a guide for the color in your painting; this usually results in washed-out colors.

One of the main advantages of working with photos is that a number of different compositions can be done from a single image simply by changing the light and shadow patterns or changing the focus. This variety of possibilities can be very beneficial.

By knowing your subject and by gaining lots of experience from working on location, it is possible to work creatively from photographs. Although Albert Handell liked the photograph above just as it is, it didn't clearly show what he was interested in behind the foreground foliage—a suggestion of buildings surrounding the church. Thus, in composing the painting *Corrales,* he played down the foreground foliage and suggested the background buildings. You have the latitude to change what you want to when working with a photograph. In the studio you have time to analyze your painting as you are developing it. You can consider what the painting needs in order for it to be more exciting, more fulfilling, more resolved. Again, for this you will need familiarity with your subject, which is usually obtained by working regularly from life. But you must understand light, for you will be doing lots of creative composing with regard to lighting conditions and color. Photographs are good to take off from but not to rely on for color. Taking your own photographs of various subjects is a good way to learn how to use such images in composing paintings. This is how *Corrales* was done. While on location, Handell made a twenty-minute drawing and took black-and-white photos before and after the drawing was completed. Back in the studio, he relied on the photographs and his memory to compose and paint this image.

CORRALES
Oil on Masonite panel, 24 x 30" (60.9 x 76.2 cm),
1988, courtesy Ventana Gallery, Santa Fe.

Joseph Dawley
Capturing Reflections on Water

The pictures Joseph Dawley took on a rafting trip down a river in Jamaica were the basis for this painting and the one that follows. Unfortunately, there had recently been heavy rains in the mountains, so the river was very muddy—much more so than usual. When Dawley painted from the photographs, he had to add color and clarity to the murky water.

The man in the foreground of all the photographs was guiding the raft; Dawley eliminated him from the paintings and concentrated on the rafter in the distance, whom he found much more interesting. He also left out the tourists, as their presence detracted from the scene.

The wedge of sky that appears between the greenery of the two banks is what attracted Dawley to this scene.

He didn't want the overhanging effect of the trees to be too confining, so he broadened the triangle of sky and lightened and brightened the foliage to give the impression of light rushing through it. He also placed two separate branches of greenery in the upper left corner.

There are two blues in the sky: ultramarine blue and phthalo blue, both mixed with white. Dawley added tints of permanent mauve and cadmium orange—the latter color in the clouds only. He blended the brushstrokes fairly carefully for a smooth, atmospheric appearance.

The water, on the other hand, was painted with broken color to capture the shimmer of the reflections on its surface. Dawley used cerulean blue in this area because it makes the orange

come up a little stronger. The orange of the clouds is more prominent here than in the sky. The reflections of the trees are roughly the same colors as the trees themselves, but the intensity is reduced somewhat and the brushstrokes are more horizontal. Subtle highlights of white and pale blue define the surface, giving depth to the murky greens.

The sky is painted in carefully blended strokes of ultramarine blue, phthalo blue, permanent mauve, and cadmium orange.

The water is painted in broken-color fashion—small strokes of cerulean blue and cadmium orange.

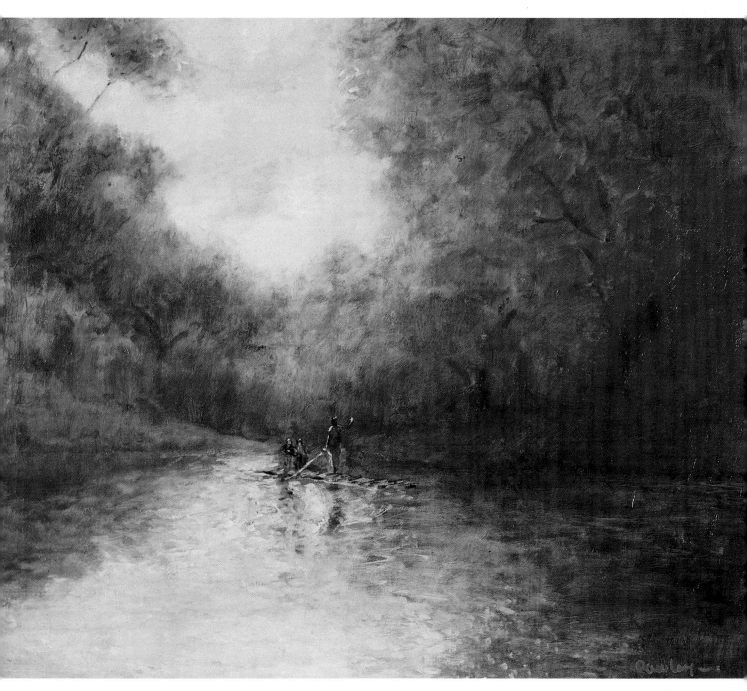

RAFTING IN JAMAICA
Oil on canvas, 30 x 40" (76.2 x 101.6 cm).

This river painting is larger than the preceding one, and it is richer in color and texture. The setting came from photo A, but Dawley used his imagination to really bring it to life. The rafter came from photo B; he is the same man as in the previous painting, but this time Dawley clothed him in a white serape that seemed to fit in with the design and color scheme.

Dawley opened up the landscape by showing the sky above the trees and in the distance. The sky is suffused with brilliant colors—blue, orange, rose—that are picked up and echoed by the river and the trees.

The reflections in the river are warmer here than in the previous painting because the water is picking up more foliage than sky. Thus, the colors are greens, oranges, and yellows, with horizontal strokes of blue to delineate the surface. The sky is reflected more strongly in the distance, where blue and rose blend into a lovely haze.

A

B

WASH DAY
Oil on canvas, 40 x 56" (101.6 x 142.2 cm).

Peter Poskas
Developing a Painting on Site

Here, Peter Poskas demonstrates the process he goes through when painting an intimate-size work. He begins small paintings on site using a random-size piece of canvas tacked to a drawing board, which he rests on his lap. In this case, he did a preliminary drawing to locate major objects and landmasses in the composition. Most attention is given to the trees and house in the middle distance. Minimal drawing information is needed in the background and foreground because the more general textures of these areas are better determined by the brush.

A ground color of burnt sienna, thinned with turpentine, is put on the surface in horizontal strokes with a soft two-inch brush. When the board is propped upright, gravity pulls the paint into a smooth tone. After five or ten minutes Poskas brushes away excess color from the edges of the canvas.

For the block-in, Poskas focuses on areas that are in the same spatial plane, proceeding from back to front. He begins with the sky, followed by the wooded far hill, then descends into the left middle-ground area. While his drawing remains visible, he paints in the shapes of any major overlapping objects—in this case, the large tree forms at left. In some areas, such as the lower edge of the trees at left, he paints certain elements in lightly, leaving the ground color to interact with subsequent paint applications. How much of the ground he allows to come through is a judgment call; to cover it completely defeats its purpose, to let it show everywhere would prove too monochromatic.

The heavier, more opaque colors of the snowfields are now put in, then the details of the buildings, trees, and landscape in their proper spatial sequence—once again working from back to front. Poskas paints snow color around and between the house and barns rather than over them, leaving the transparent ground showing in these areas until he is ready to paint the buildings; this is done to keep intensity and glow in their color. He then paints in the middle-distance trees, allowing their top halves to overlap into the far hill. Sometimes he exposes the drawing beneath by wiping away ground color with a worn-out brush. At this stage, the detailing of objects is just cursory.

The foreground is painted in now; in this case, there is a particular soft quality to the lower edge of the picture, so that the middle distance retains its importance. There are indications of furrows beneath the snow, their forms subtly catching the reflection from various parts of the sky.

LAST LIGHT, JOHNSON'S
Oil on canvas on board, 9 x 16"
(23.5 x 41.9 cm), private collection.

Once the block-ins are completed, Poskas considers color changes that will enhance space, light, and form. The sky is pushed toward yellow and aqua, the foreground snowfield toward blue and violet, the slanting field behind the house from cooler tones at left to warmer tones at right. Cool colors are also worked over the woodlot's warm underpainting, and the snow on tree branches is modified with transitions of warm and cool color. The red barn is made cooler and darker to set it back in space and bring the house forward. Further refinements include reducing the brambles in the lower foreground to a contained horizontal band that relates to the shrubbery at the far edge of the field, and darkening the shrubbery in the middle distance.

Peter Poskas
Expressing Complexities of Light and Space

This is the front of the Johnson farm in northwestern Connecticut, seen from the road's edge. The sun is starting to burn off the valley's heavy mist in earnest as cows meander toward the upper pastures. It is around eleven o'clock in the morning.

This painting is concerned with the peripheral and with the relative emptiness at the center of the canvas. The entire surface of the picture plane is important.

The role that a true sense of perspective plays here is minimal; the farmhouse extends out of the picture plane before the complexities of its three-dimensional form are

fully realized. In this case, the house's overlapping relationship with the apple tree behind defines its location in the picture plane more than the illusion of form. The frontal attitudes of objects and their strong vertical-horizontal axis make this a very formal and stable composition. This formality is reinforced by downplaying the dimensional aspects of the stone wall; its thickness is only hinted at by the darkness of its recesses and a few edges of direct light.

Aerial perspective bears the burden of defining space in this painting. It is used in an overlapping manner above the

stone wall and as a gradient going from the foreground through to the upper pastures.

The cows not only serve as a rhythm of shapes in the painting but also carry the high-keyed white of the house into the right side of the picture. Because he felt it was important to position one cow to the left of the foreground tree and to have other cows balance the right side, Peter Poskas found himself playing with their actual arrangement in the field. It is also important how the cows parallel the diagonal pattern of rock where the downspout's flow has undermined the wall.

Instead of the single tall tree you see here, Poskas had originally placed two trees parallel to each other on the right side of the composition, thinking that their echo of the house's twin shutters would be effective; however, the second tree polarized the composition much too rigidly into right- and left-hand sides. The single tree's contribution, by contrast, is more asymmetrical and subtle and allows the eye to move more easily through the composition.

Slow Burn is essentially about gradations of light, color, and atmosphere that are both accented and flattened by their arrangement as overlapping forms.

SLOW BURN, NOONING,
TOWARD HIGHER PASTURES
*Oil on canvas, 31 x 54" (78.7 x 137.2 cm),
collection of Mr. Orton P. Camp, Jr.*

Peter Poskas
Exploring Reflected Light

Light gradations are all-important and are the key to the success of the space in the frontal planes found in *Farm Cats*, especially those in the transparent, reflective surfaces of the porch windows. Without this road map, the intricacies of overlapping lost-and-found images would be reduced to confusion. Side lighting is also in effect here, reducing and flattening the color of the foreground grass, and giving a warm tone to the reflected light of the house's lower story. This light also provides a temperature contrast with the cooler reflected blues of the sky found in the porch windows.

The success of this painting relies on a few important linear accents: the double strands of clothesline that break the horizontal line of the porch; the rusty sliver of warm color in the porch rail above the black-and-white cat, so necessary in defining and clarifying the space of the receding wall behind it; the accent of red silo board that holds the firewood in place; and most important, the two downward-converging elements of window trim and rusted downspout that frame the tawny-colored cat.

Farm Cats is a combination of the subtle space of a facade and reflected images. It's a careful balancing of shapes, colors, and tones. Much thought was given to such concerns as how much emphasis to put on the separate sticks of the woodpile, so that there is a balance between the individual pieces of wood and a group identity; the degree of texture that goes into the grass, so that it doesn't detract from the texture of the twiggy reflections in the glass; or how much peeling paint to include so as not to make the facade a confusion of parts with no sense of the whole.

Of particular importance in the painting is its primary triad of color: the blue windows, the red silo board, and the yellow cat. This strong color concentration is then balanced by the sheer volume of the facade, with its gathering darkness of reflected trees, heavy foundation stones, and shadowed grass.

FARM CATS
Oil on canvas, 38 x 48" (97.2 x 121.9 cm), private collection.

Perspective plays an important role in *Spring Plowing*, and the frontal mode is very strong. A spatial sense is as much a product of overlapping forms as of truly three-dimensional rendering of individual objects. The correct spatial sequencing of forms on the porch is also a result of color-light gradients: The near post is darker and warmer than the lighter, cooler one behind it; the very subtle gradations of warm yellows shift from far (light) to near (dark) on the porch ceiling; and the color changes determined by reflected light on the vertical surfaces are warmer on the bottom, cooler on the top.

In this painting, the landscape has been integrated with the architectural form in several ways: The wire across the sky in the upper left parallels the plowed field, which is reflected in the left bank of windows; the exposed tree branches echo the color and thickness of the window mullions; and the rockers' cool copper blues pick up the rhythm and attitude of the plowed strip of land. There is also a similar lateral tie weaving through the lower portion of the picture, running from the rocker blades and seats of the blue chairs to the porch's plank floor and out onto the hedgerows and stone walls of the field and hill.

In general, this painting is about looking through a formally organized tunnel of reflected light out onto the direct light of the landscape beyond.

SPRING PLOWING
Oil on canvas, 48 x 38"
(121.9 x 96.4 cm),
private collection.

Peter Poskas
Studying Flowers in Subdued Summer Light

The prevalent leafy textures of summer can seem too light-absorbing, too overwhelmingly green. These phlox, however, were located on the north side of a woodshed, so a much cooler palette than summer usually dictates prevails here; the only note of a true summer green is surrounded and framed by the darkness of the woodshed interior, which intensifies its impact and gives it a jewellike quality.

This first sketch (top right) is quite small. It was done on white canvas, and, as seen most obviously in the clapboard areas, the paint covering is incomplete and dragged along the surface. In the area to the left of the window, an ochrish light gray is partially covered with a warmer lavender, and a cooler, lighter blue-gray has been brushed over the right. This is done not only for color modulation but also as a shorthand note to indicate the surface/color/light transitions. In his second sketch (below), using the basic composition of the first, Peter Poskas went on to clarify the various forms, the spatial sense, and the particulars of place. There is now a more refined gradation of light and shadow on each clapboard; reflected light is found at their lower edges, which are lighter and warmer at the top and darker and cooler as they near the ground. This general idea of the way light falls on the clapboard wall is much more important than any detailing of form; however, any detail work that incorporates this concept of space, light, and color will necessarily have a more meaningful impact. Of course, describing irregular forms is more complicated, but the theory of where the light and shadow should fall still provides a more flexible and creative way to paint forms. The flower heads of the phlox are a good illustration of this point: Some are in sunlight, some are in shadow, and the shadowed ones have varying degrees of reflected light.

THUMBNAIL SKETCH, WOODSHED PHLOX
Oil on canvas, 4 x 6" (10.1 x 15.2 cm), collection of the artist.

STUDY, WOODSHED PHLOX
*Oil on canvas, 20 x 22" (50.8 x 55.8 cm),
collection of Mr. and Mrs. Carlos Canal.*

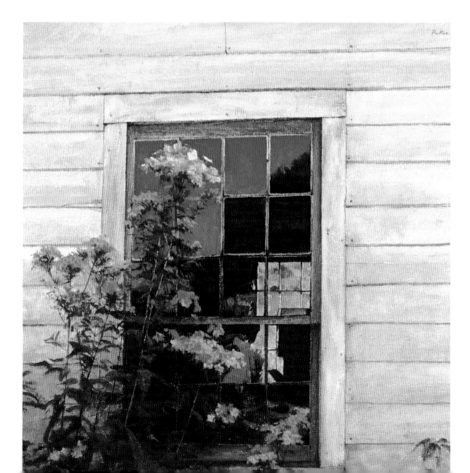

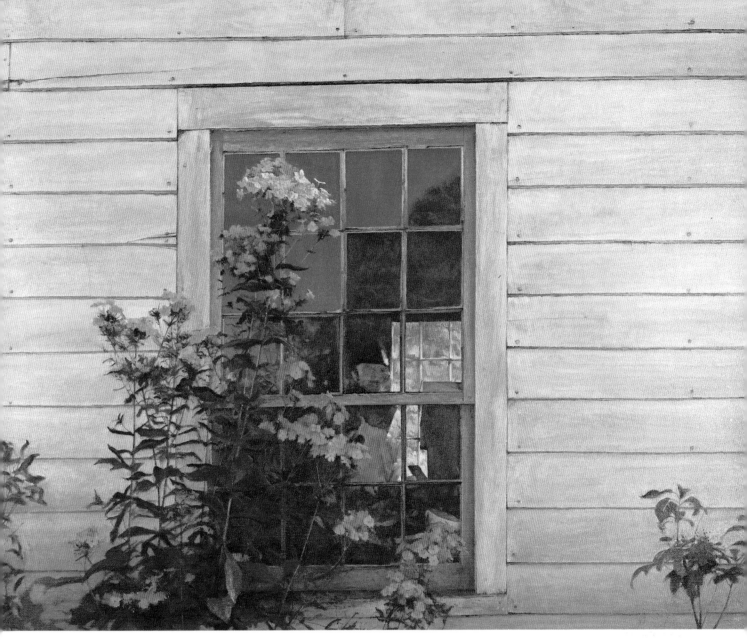

WOODSHED PHLOX
Oil on canvas, 38 x 48" (106.5 x 129 cm), private collection.

In general, however, those at right are lighter and warmer, while those at left are darker and cooler. A complicating factor is introduced by the shadowed areas created when the canopy of one phlox head blocks the light of a shorter one.

In the final painting (above), Poskas used a magenta wash to more effectively integrate the cooler temperature of the woodshed's north side with the vibrant tones of the phlox. He also opened up the painting by giving it a little more space horizontally. Here, the window is a little off center; he balanced the weight of the flowers by extending the clapboards to the right. This change prompted him to include the sprig of laurel at right, which compositionally provides extra weight to the vacant wall. The laurel also introduces an element of subdued light that ranges from warm ochre-greens to very cool dark greens. Its drooping, rounded forms, in contrast to the relative flatness of the phlox leaves, repeats the rounded forms of the phlox heads.

When he first painted the phlox blooms in this larger scale, Poskas felt the need to be more specific about their makeup, to show detailed parts of the whole. His first attempt was an agonizingly frozen, hard-edged portrayal of something whose nature was elusive, soft, and fragile, not porcelainized. He immediately wiped this version out and built up the phlox more slowly, being more considerate of how each individual surface contributed to the form of the whole cluster. In the end, the individual blossoms were left incomplete, suggested more at their edges, and accented by subtle color modulations. The highest contrasts and most intense color changes were reserved for the uppermost florets catching the daylight.

Peter Poskas

Capturing the Light and Atmosphere of Dawn and Dusk

The paintings shown on these two pages are part of a dawn and dusk series in which Peter Poskas explored, in the context of a single pure landscape format, the illumination of the sky and the nature and color of the effects of weather and the atmosphere.

DAWN, DECEMBER,
NEW ORCHARD SERIES
Oil on canvas, 10 x 18⅜" (26 x 46.7 cm), private collection.

The rich, warm hues of this particular dawn prompted Peter Poskas to execute this small work on a magenta-colored ground. He worked into the magenta ground immediately, wet into wet, rather than waiting several days for the wash to dry completely before beginning the actual painting, as he usually does with his larger works. The result is a greater softness and a visual sense of unity. This method is very direct and painterly, with a fusing and integrating of pieces into the whole.

The next day, after the paint had dried a little, Poskas went back and very selectively enhanced and accented certain edges and forms. He found he was more interested in responding to what was happening in the paint than documenting the specifics of place.

SUNSET, FERENCE FARM
Oil on canvas, 9³⁄₈ x 14" (23.8 x 35.6 cm), private collection.

This is a westward-facing view of a farm located on a ridge several miles from the artist's home. As indicated by the more obvious brushstrokes, this study was completed in a single session—alla prima.

Sunset, Ference Farm focuses on the concentration of sharpness and color found at the horizon line just after the sun has set. The cloud, land, and tree masses are secondary to this idea; their suggested textures are left in a relatively unfinished state.

Peter Poskas
Interpreting the Urban Landscape

This painting is a study of the space, light, and atmosphere of an urban facade in Waterbury, Connecticut. The suggestion of a tangible atmosphere here hinges on the interaction of many pieces making an overall statement.

The composition of *Corner Light* is relatively simple, something like the letter *L* laid on its back. Superimposed on this design is the theme of punctuated space found in the variations of windows, curtained and clear, some seen into and some not, either reflecting the sky or impenetrably dark as they parade across the facade. Note the large vertical rectangle of sky, which is like a window itself and is caught and framed into smaller windows between porch posts and brick in the building at right. There is also a curious juxtaposition of flatness and perspective in this painting; the frontal plane is dominant, and the dimensional sense is like a subtheme or an accent in the overall design.

Poskas's approach here was to imply yet at the same time very specifically suggest matter; for example, he painted the texture and color of the bricks but did not delineate each one. Central to this idea is to get the general color, tone, and texture correct so that it conveys the surface and space, then authenticate it with a few well-placed, telling details. Of course, the degree of specificity depends on how much the artist wants to play down or emphasize certain areas. This is a long, sometimes arduous process that requires stepping back a fair distance to better assess how newly painted passages can be assimilated into the whole. For example, Poskas was very concerned about how far to push the reflective effects of the aluminum storefronts without confusing their spatial placement. A painting involves many thousands of judgment calls such as this, all revolving around the needs of the specific object versus the framework of the design as it exists in light and space.

CORNER LIGHT
Oil on canvas, 31 x 47" (79.4 x 119.4 cm),
collection of Mr. and Mrs. William McTiernan.

163

Albert Handell

Learning How Shadows Behave

In his early years as an art student, Albert Handell lived in the area of New York City known as SoHo (meaning *South of Houston* Street), which is characterized by imposing old loft buildings. As he observed these structures at various times of day, he often saw them as still lifes with a great sense of weight, substantial proportions, and elegance of workmanship. When the buildings were struck by the strong light of a sunny day, the resulting shadows would sometimes cover large areas, allowing ample opportunity for studying their depths.

Handell finds shadows especially exciting and challenging to paint, and here demonstrates how to handle them in an outdoor architectural subject—how to view, simplify, and relate them to the other elements in the scene.

In establishing the composition of *SoHo,* Handell closely examined the building itself: its squareness, sense of weight, shapes and forms; the vertical, rectangular proportions of the doors; the squareness of the windows; the variety of the ledges; and the values and colors in the sidewalk. Although these elements could stand on their own to create an exciting composition, he decided to play down the architecture and instead emphasize the strong light-and-shadow patterns. That meant he had to establish the angle of the sunlight, lay it in, and then build the rest of the picture around it. Once the light and shadow were established, the remaining elements of the composition would fall into place.

When doing a painting that centers around the division of such strong light and dark areas, it is essential to pay close attention to values. The darks must be made dark enough and kept simple in order to establish the solidity of the light and shadow and to create the contrast necessary to hold the whole picture together. The shadow masses must not appear merely as a weak statement of shadow falling across an object; they must have strong angle and direction, and interesting shapes. To eliminate details and better grasp a sense of the shapes of the shadow areas, squint. Freeze the patterns of light and shade at a specific point. If you keep changing the patterns of the shadows as the light moves across the subject, you will destroy the values and shapes and weaken the composition. If this is happening, stop and reevaluate the shapes in your painting and make a firm decision as to what you want. Then reestablish them—and stick to it!

A transparent monochromatic underpainting—here, a tonal base of raw umber—is excellent for establishing the initial impact of light and shadow in a painting, since its emphasis on values and value contrasts makes it good for suggesting any subject in strong light. With the composition and other basic elements secure, it is then relatively easy to translate the monochromatic values into the correct colors using a semiopaque overpainting. Here, muted and subtle colors were used to help bring out the accumulated city grime of the subject and to keep the color harmony subtle.

Excited by the patterns of light and dark he saw, and knowing that they would change soon, Albert Handell did this quick sketch of his subject to plant the patterns more clearly in his mind.

Step 1. Working on a gessoed panel that he toned with a light gray, Albert Handell lightly sketched in the outline of his composition with pencil. Then, with a mixture of raw umber and turpentine, and using #2 and #3 round bristle brushes, he lightly massed in all the shadows. He immediately separated the light from the shadow, grouping each as a single average value. Since he didn't want the paint to run, but did want it to be transparent, he scrubbed the mixture onto the panel rather than washing it on.

Step 2. Using more paint and less turpentine in the umber mixture, and with more brushes of the same size, Handell accentuated selected shadow areas by darkening them. He brightened the area around the top of the right-hand door with a touch of ultramarine blue.

Step 3. Handell strengthened and redefined the shadow area within the doorway. As the shapes were strengthened and the shadows emphasized, the effect of sunlight grew. Notice the variation the artist achieved within the shadow area by using just raw umber. The sidewalk and window panel on the right-hand door have been left untouched, but they look lighter simply through contrast, because everything surrounding them has been made darker.

Step 4. Still working with raw umber, and turpentine as his medium, Handell continued building the monochromatic underpainting in preparation for the transition to color. He reinforced the left-hand door and began to put notes of green color on the pillars, muting a mixture of permanent green and sap green by scrubbing it thinly over the raw umber stain.

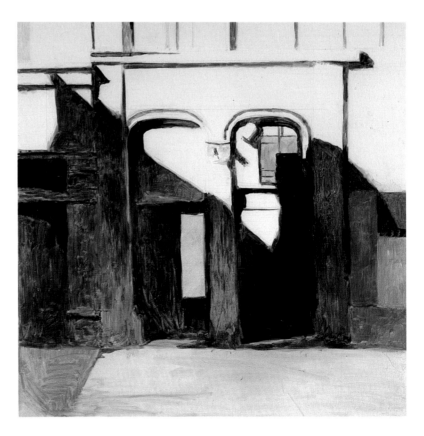

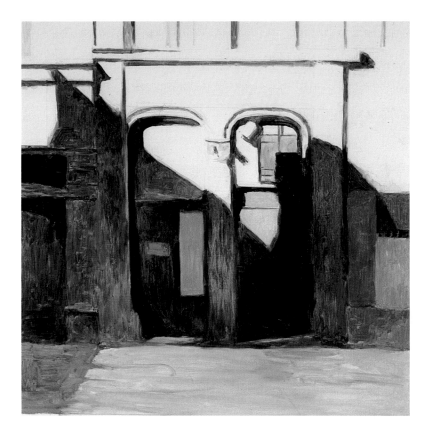

Step 5. With the monochromatic underpainting well developed, Handell completed building the shadow area with color. He mixed either a little Naples yellow or ultramarine blue with raw umber for the local colors of the doors and shadows, and let the tone of the canvas serve as the sunlit areas. This proves that, from the very beginning, the underlying effects of color can be indicated with little or no color.

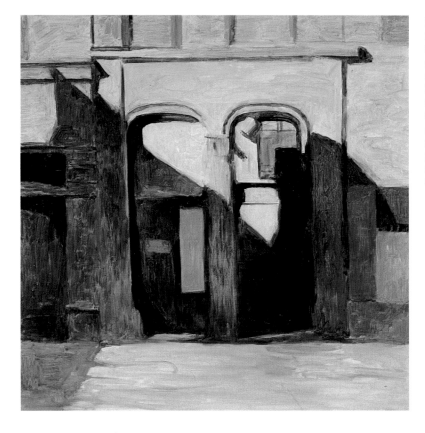

Step 6. Handell began to work opaque paint into the sidewalk and sunlit areas where they touch the shadows to create a dynamic effect. He used a mixture of ultramarine blue, Naples yellow, raw umber, and titanium white. The cool blue-grays he added to the sidewalk gave a luminosity to the shadow area by comparison. The blue-gray was darkened as it merged into the door and the side panel of the door, integrating the two areas and strengthening the overall harmony of the painting. At this stage, it was time to establish the remaining sunlit areas and carry the painting to completion.

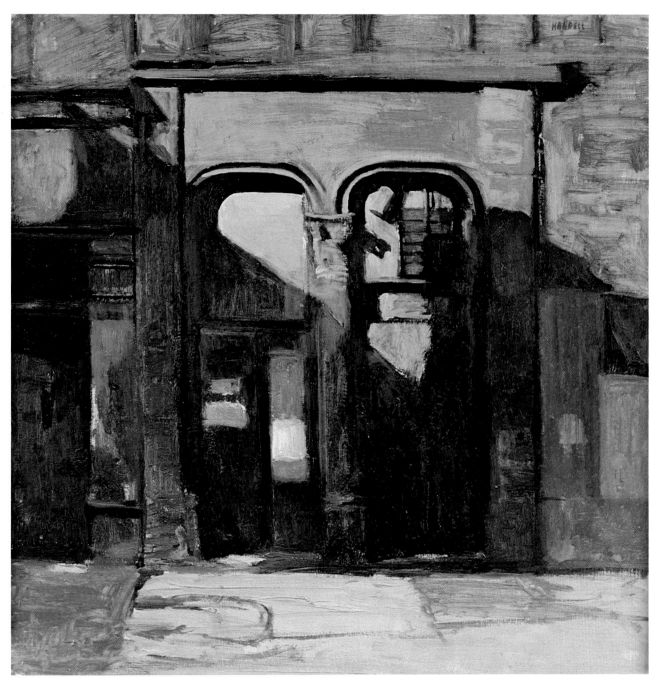

Step 7. Handell laid in the rest of the sunlit area with yellow ochre, Naples yellow, cadmium green pale, and flesh color (Grumbacher), scrubbing in the colors transparently and, in some areas, opaquely. A strong foundation for the final picture was now in place. He lightly noted some details in the shadow area of the doorways. Above the right-hand doorway, an indication of the railings of the grille was put in thinly so it wouldn't be confused with the shadow area.

SOHO
Oil on panel, 16 x 16" (41 x 41 cm),
collection of the artist.

Handell decided to leave the sunny areas loosely painted and concentrate on the details within the shadow mass. By keeping the values of these details within close range of the average value there—going only slightly higher or lower to indicate form—he was able to keep the large shadow area well massed yet achieve subtle variety by breaking up this mass with smaller shapes and patterns.

Joseph Dawley
Capturing Reflections and Color in Windows

The building on the right dominates this painting, and it pretty much dictated the rest of the scene.

The colors and shapes in the windows in the large arches are a combination of the interior showing through and the reflections on the glass. To capture this, Joseph Dawley painted the interior views first, then tinted in the reflections—actually overpainting, covering what was already there.

Dawley took the buildings from photos A and B; the space between them seemed to detract from the overall impression, so he moved them closer together. There was a lot of contrast in the photos—too much, he felt—so he deemphasized the shadows and lightened the dark areas, particularly in the building at left. He added a tree on the left to bring some greenery to this concrete-dominated scene, and added the fountain at right from photo C.

Dawley took bits of the crowd from the photos, but basically he made it up, painting it as one shimmering mass rather than as a group of individuals.

A

B

C

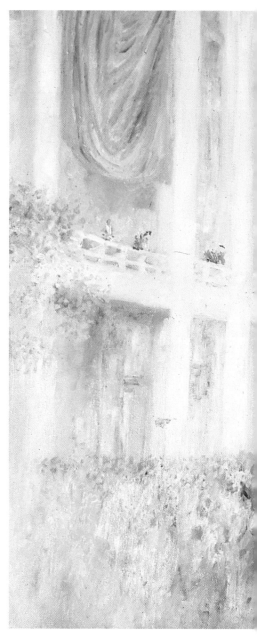

LINCOLN CENTER
Oil on canvas, 36 x 50" (91.4 x 127 cm).

170

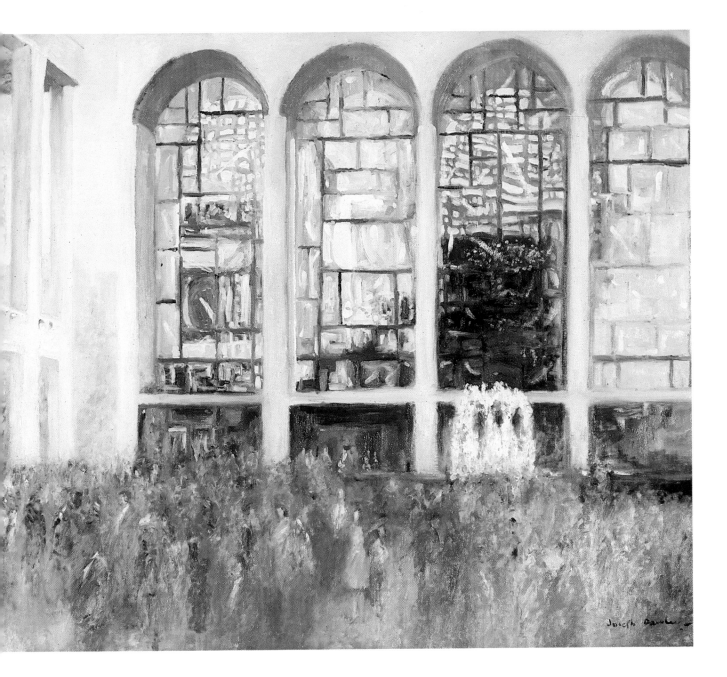

All Joseph Dawley wanted to do here was capture the basic shapes and the mood of the scene. He sketched in the windows and people using ultramarine blue and yellow ochre, thinned with turpentine, in various mixtures to get a range of values.

Still working with shapes and values, not details, he began blocking in color areas so he could get the feel and movement of the scene. His palette here consisted of ultramarine blue, cadmium red medium, cadmium orange, yellow ochre, permanent mauve, and white.

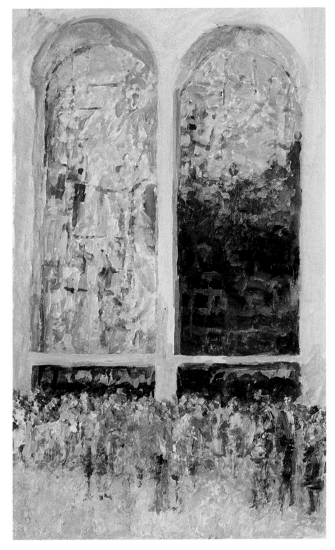

Next, Dawley started laying in the colors more accurately. For the windows he used permanent mauve, ultramarine blue, cobalt violet, cerulean blue, cadmium red light, cadmium red medium, cadmium orange, and white. The darks in the window at right were mixed from ultramarine blue and permanent mauve. He used this same mixture to define the shape of the window on the left, lightening the color with cadmium yellow deep.

The people were dotted and stroked in with the same colors as the windows; Dawley also used phthalo green mixed with yellow ochre and white in this area.

Before he started working on surface reflections, Dawley let the previous layers of paint dry almost completely. Then he mixed some blues and whites and brushed this across the windows in horizontal and vertical strokes; this effect is more pronounced in the window on the right. Also visible in that window is a group of yellow dots, the lights from a chandelier inside the building.

Dawley added more people and kept building up the crowd until it reached the fullness he wanted.

FIGURE
AND PORTRAIT
PAINTING

Charles Reid
Painting Thinly in Oil

Painting is filled with myths devised by people who want to make the process as difficult and complicated as possible. One myth is to use a big brush and plenty of paint. Now, a big brush and gobs of paint are fine for a virtuoso like the American painter John Singer Sargent (1856–1925) or the Spanish painter Joaquín Sorolla (1863–1923), but it just isn't good advice for a beginner. Instead of using thick paint, try the opposite: Paint as thinly as possible. Follow the procedure Charles Reid demonstrates here as he paints a portrait.

Working from Photographs
Shown here are two photos of Caroline, Reid's model for this demonstration. The shot at the top of the page was taken in the natural overhead skylight of his study, and the one below it was taken with a flash. Although Reid generally works from life, not from photographs, the pictures are included so that you can compare what the artist saw with how he painted his subject.

Since most beginners worry too much about color, this demonstration calls for a very simplified group of hues. You can use any colors you choose, but it's getting the values right, not the colors, that will give you good results.

Selecting the Best Lighting
It's important to recognize the difference between the two photos. For the moment, try not to think in terms of a nicer likeness. Look beyond the subject and compare the two pictures solely in terms of light and shadow.

The photo taken with natural overhead lighting is indeed harsh, but it has a very obvious shadow pattern. In other words, it's easy to see what parts of the face are out in the light and which parts are in shadow. The photo taken with a flash has a more appealing lighting, but the shadow pattern is harder to see. Of course, an experienced artist would be able to "see" the shadow shapes, but a less experienced artist might be confused. The problem with the second photo lies with the middle values, which are called halftones (tones too light to be shadow and too dark to be called lights). Painting halftones requires subtle modeling that can result in overworking. It also requires a knowledge of values. In this respect, you must have "perfect pitch," because if the middle value is too dark in what should be a lighter area, the light area becomes confused. Study the photograph. Would you paint the value under the eyebrows the same as the value along the left side of the nose? They look to be about the same value in the photo.

Sketching the Shadow Shapes

These two pencil sketches show the major shadow shapes of the subject. For the top sketch, Charles Reid decided that although some of the darker values on the left side of the nose and cheek are fairly dark, they are actually halftones. For the bottom sketch he was more literal in reproducing the darks as he saw them. Which of the two do you find more appealing? Squint very hard and perhaps you'll see why he decided to group some of those darker values as part of the light area. Both sketches could work, but you must become aware of what's really an important, necessary shadow shape and what other areas that look dark actually might hurt the picture if you insist on painting everything as it seems.

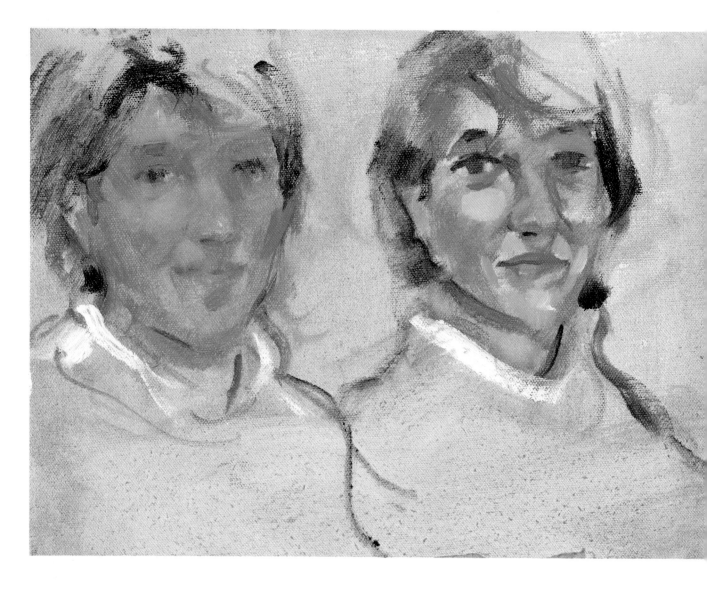

Oil Sketches

Here are two oil sketches of the photo of Caroline taken in overhead light. Simply stated, one looks "clean," while the other looks as if Caroline's face could use a scrubbing. The mistakes in the right-hand sketch were overdone deliberately so you can easily tell which one is better.

Notice that Reid has simplified the light values. He has aimed to bring all the lights and halftones in the light close together in value. The left side of the nose in the sketch at left is an example. Reid squinted at the photo and decided that the left side of the model's face was essentially lighter in value than the right side. Once he determined which was the lighter side of the face, he knew that the halftone on the left (light) side of the nose would

have to be compatible with his light values. A halftone that is too light in what should be a shadow area confuses the shadow and tends to destroy the sense of form or bulk in the face.

The terms "halftone" and "middle value" can be misleading and confusing. "Halftone" suggests something that is halfway between light and shade, yet when you are organizing values, halftones must choose sides. They can't stay in the middle. Instead of using the term "halftone," we could use the more cumbersome but more accurate "transitional value." This is illustrated in the right-hand sketch. There are no transitional values here. Instead, there are middle values that don't relate to or feel comfortable with either light or shadow.

Defining Form with Color vs. Value

Even though it's a good idea to simplify the lights here, you still have to show some form out in the light. One way to do this is to make the values similar and show a color change. Here, instead of having a darker value running down the left side of the model's nose, Reid made it cooler by adding a little blue (cerulean and some titanium white, mixed with cadmium red and cadmium yellow light or pale). The trick was to make a color change while keeping the adjacent values about the same.

Mediums

Charles Reid has two containers, one filled with one-third turpentine to two-thirds Winton medium for thick passages, and the other with turpentine for thinner sections. These mediums are for painting only. As he paints, he rinses his brushes in a third container filled with mineral spirits. You can also mix a medium of one-third each of turpentine, damar varnish, and linseed oil.

You may discover that some sections of your finished paintings look glossy while other sections look matte. The gloss results when you mix a lot of medium with your paints, while matte effects come about when you use just pure paint, or use turpentine alone as the medium. If you want an overall glossy finish, you can brush a final varnish over the entire painting surface. If you prefer a matte finish to your work, always use as little medium as possible. Here, the thicker passages are almost pure paint, with just enough medium or turpentine added to make it workable.

Preparation and Procedure

Put some rectified turpentine into a palette cup. On the palette, squeeze out some burnt sienna, and cerulean or cobalt blue. (For this exercise Reid also used cadmium green, but it's unnecessary.) You might also experiment with some raw or burnt umber. With a large bristle brush and using plenty of turpentine, alternate one of the earth colors with a blue. Let the colors work together on their own. Don't try to mix them together on the palette; apply them to the canvas separately. If they're diluted enough they'll mix by themselves. Then let the paint dry. Don't use any oil or other medium, or your work will take too long to dry.

Next, block in the shadow shapes using a little cadmium red, raw sienna, and very little cerulean or cobalt blue. *Don't* premix these colors on the palette. Instead, use your #6 or #8 brush to pick up each individual color from the globs of paint on the palette and bring it out to the mixing area. Be sure to rinse the brush carefully in brush cleaner and wipe it with a tissue, toilet paper, or paper towel.

Summary of Oil Techniques

1. Paint one section at a time and finish it before going on to another.

2. Use the full range of values on each section. Don't spot darks throughout first.

3. Keep all darks thin and transparent and the lights thick and opaque.

4. Mix your colors on the palette or directly on the canvas with a brush.

Observations

Look at the illustrations on pages 180 and 181. Notice that Reid's drawing is done not so much with line, but more with very thinly painted shapes. He combined the shadow areas in the face and the hair all at the same time. He didn't worry much about color; he was much more interested in getting the shapes correct in size and position. Make sure you don't let the paint build up. Your shadows should be the consistency of watercolor.

In terms of color, Reid used mostly raw sienna and just a little red on the cheek. Under the nose he exaggerated the red, because he likes to get a color in his shadows so that he doesn't have to make the shadows too dark to get strength. Note that he used mostly warm color in the flesh shadows, adding some cerulean blue in the shadows around the eyes and in the eyes themselves. Stressing cool color in flesh can often result in harsh, brittle shadows unless done skillfully. The same colors were used in the hair, but with more blue (cerulean or cobalt) added and little or no red. He also used some raw umber for the darkest value in the hair. Again, as you paint, don't worry about color. Just make sure you get the shapes and values right, because these shadow shapes won't be repainted or corrected. Remember not to use any white pigment in the shadows. You're supposed to control the value with the amount of turpentine you're using.

Notice that Reid has held on to his shadow shapes, being careful not to invade their territory. (Once you paint lights in the shadow areas, you lose the form of the face.) Notice how much of the canvas shows through and hasn't been covered with opaque paint. Although indeed opaque, the lights are still relatively thin. Compare the lights in the flesh tones with the lights in the sweater. If they had been painted as light as they appeared in the photo, the flesh tones would have appeared washed out and dead. (The colors in the lights are titanium white, cadmium red light, yellow ochre, and cerulean blue.)

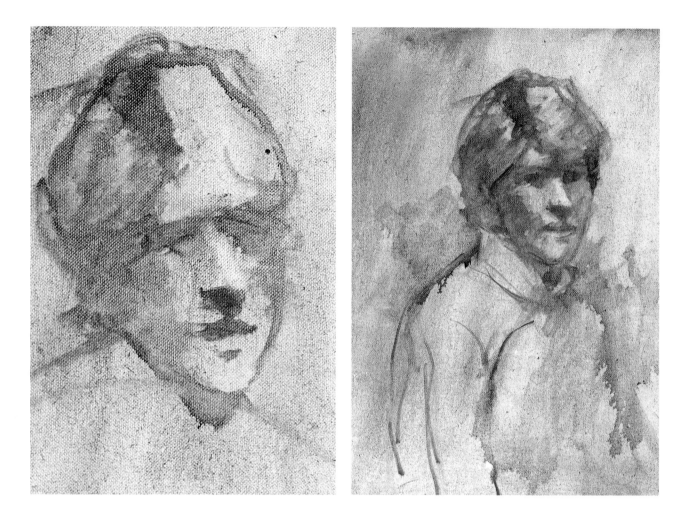

Charles Reid used the photo of Caroline taken in natural overhead light for this painting. Unfortunately, his "likeness" of the model isn't successful, because he didn't take the time to get the particular characteristics of his subject; it's important to do this and not to paint generally out of the imagination.

 The point here is to show you how to establish simple but accurate shadow shapes that describe the head. These shadow shapes were painted with thin darks using turpentine as the medium. No opaque white was used. These shadow shapes are the foundation for the portrait, and once they're done, they shouldn't be touched again. Shadow-shape pictures are good practice, especially if you're new at oils. The approach used here is almost identical to the handling of watercolor; if you add too much turpentine to your paints, you'll have the same trouble a watercolor painter would have when too much water is used.

CAROLINE
Oil on canvas, 18 x 24"
(45.7 x 60.9 cm).

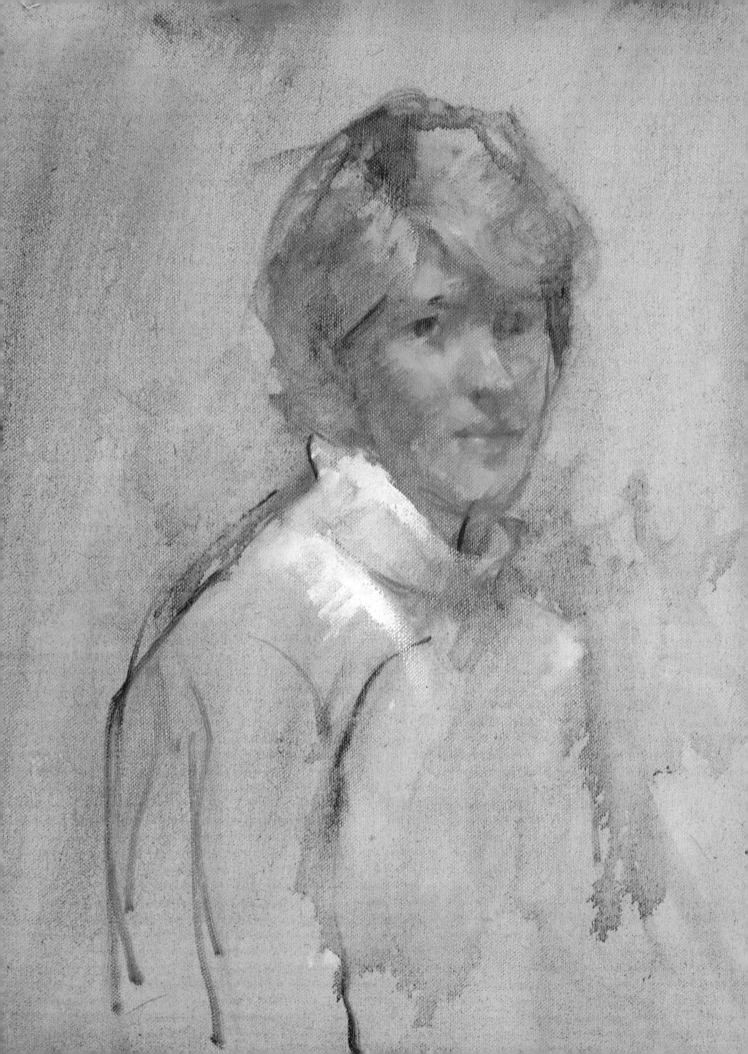

Charles Reid
Working with High-Contrast Values

In this photograph, light and shadow are in very high contrast—a necessary and useful factor if you're new to painting people. The model was lit with a 100-watt household bulb and a photographer's reflector. The photo shows only two values, and that's all you should start with. Trying for subtleties is the cause of most student failures, so stick to the obvious.

Because it's not always feasible to stop in the midst of painting to photograph the work in progress, Charles Reid has re-created his key steps with the oil sketches you see on these two pages.

Reid started by making a drawing on white canvas, applying burnt umber with a #3 bristle brush using lots of turpentine and no white pigment. For this kind of work, don't mix an oil medium with the paint or it will take forever to dry. The turpentine wash lends the background some nice texture and variation. Reid has used an angular drawing style—sort of a contour drawing with a brush. This makes you start out with definite shapes. If he hadn't articulated the cheek, he wouldn't have known where to put the nose. It's important to get a strong silhouette shape, so don't be sketchy when you draw. You might want to practice this on cheap paper pinned to a board.

Charles Reid
Integrating a Double Portrait

Charles Reid asked his son, Peter, and daughter, Sarah, to pose together for the initial sketch for this portrait, then had them pose separately when he painted. It would have been better to have them pose together the whole time so he could keep a good color and value relationship between the two and not overwork one person more than the other, but that wasn't feasible.

Look at this painting and think about contrasts and differences. Note how Reid has stressed Peter's silhouette, but Sarah's silhouette is lost and her white shirt, cuffs, and hands stand out. This wasn't intentional, nor were the differences in their poses.

How has Reid drawn attention to some places and made others less interesting? Do you see how the warm

red in Sarah's sweater is picked up on the right side of the picture? Note the values in Peter's chair seat. Where are they darkest? Where have they been lightened? Why? How has Reid disguised Sarah's "leggy" look so he could stress Peter's?

PETER AND SARAH
Oil on canvas, 40 x 44" (101.6 x 121.7 cm).

FANNY
Oil on canvas, 18 x 15"
(45.7 x 39.4 cm).

In the finished painting, values are closer and subtler; there isn't as much contrast between the lights and darks as there seemed to be in the actual lighting situation (as seen in the photograph). Yet this is what most of us see when we decide to paint someone. Still, Reid couldn't have managed this picture if he hadn't first seen the model's face as a simple, two-value problem. The subtleties were secondary and didn't sway him from maintaining one shadow and one light.

FANNY
Watercolor on cold-pressed paper, 9 x 14"
(23.5 x 35.6 cm).

In this watercolor of the same model, which Reid did before painting her in oil, he used backlighting. You can see minor value variations, yet he has still managed to keep the integrity of shadow. It's clear that light is light and shadow is shadow. *Rule:* All values in the shadow must be darker than values in the light, even if the shadow contains reflected light. Reflected light must be darker in value than main light.

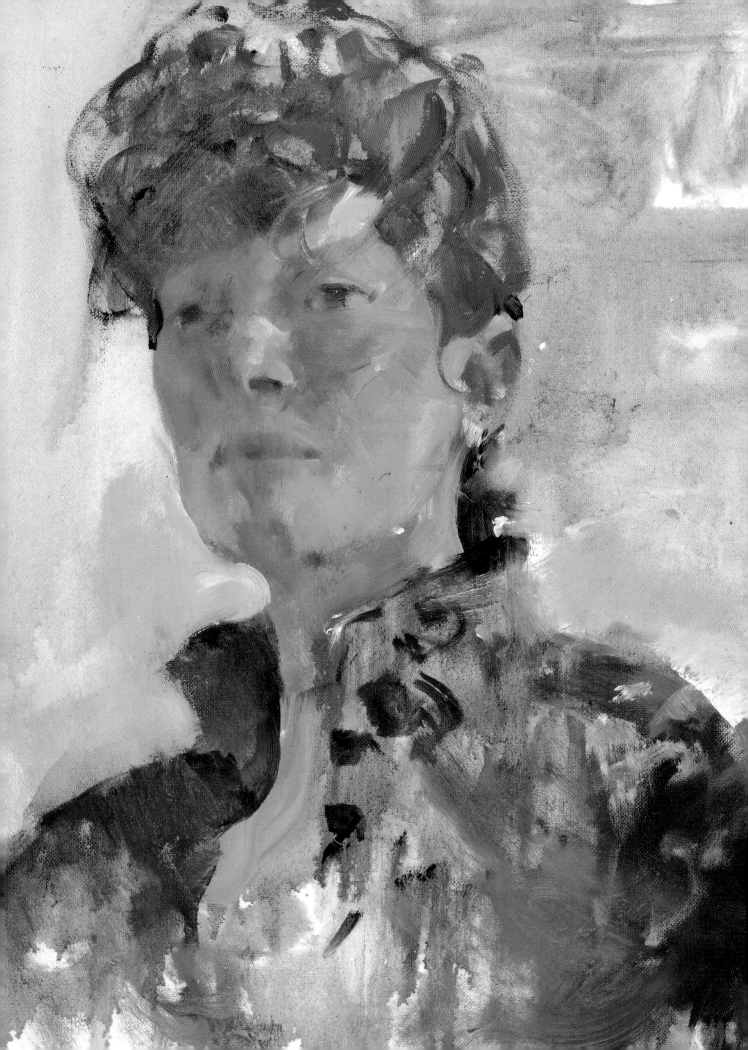

Switching to a #5 long, flat-bristle brush, Reid blocks in the hair using burnt umber in shadow, adding a bit of cadmium orange to the areas out in the light. He keeps his paint thin. The parts of the skin in shadow are cadmium red light and raw sienna, with just a bit of white. The collar and background get a wash of cobalt blue. Notice how he lets some canvas show and varies his strokes—they're T-shaped. When painting in oil, always start with your mid-darks; they are your foundation. Don't mix colors with a palette knife; use your brush instead—otherwise you'll waste a lot of pigment. If you're following the steps outlined here, at this point, take a bit of cadmium red light out to the mixing section on your palette, then rinse your brush in turpentine and dry it with a tissue. Now mix some raw sienna with the red, and don't let one color overpower the other. Clean your brush and add white as needed—sparingly. Your shadow shapes should describe the human head without the help of individual features. *Don't* try to correct with light values.

In this stage Reid adds some lights. With a clean brush, he takes some white out to the mixing surface, cleans the brush again, and adds just a tiny amount of cadmium red and cadmium yellow. He strokes a bit of cerulean blue along the chin line and in the lower and upper parts of the shadow. (Don't do this yourself if you have trouble mixing correct values. When you add a complement, your value darkens and you have to add more white.) The main thing is to keep the integrity of the shadow shapes. That's why Reid lays the light values alongside the shadow shapes and doesn't attempt to soften or blur the structure of the head. Think of *pieces of paint,* a phrase that describes so nicely the placing of strokes of the right value and color next to each other. Blending is fine, but think of Seurat and the pointillists, who arranged dots of color and value to make the viewer's eye do the work.

Sculpting with Color

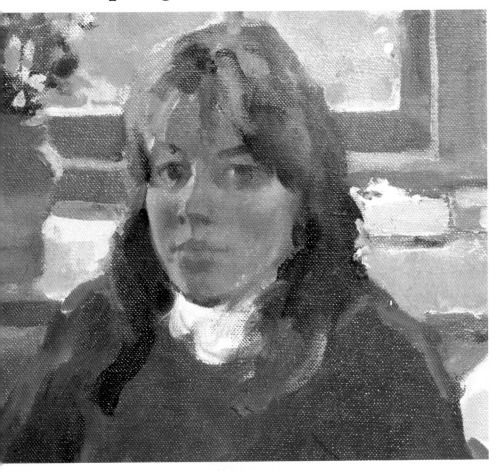

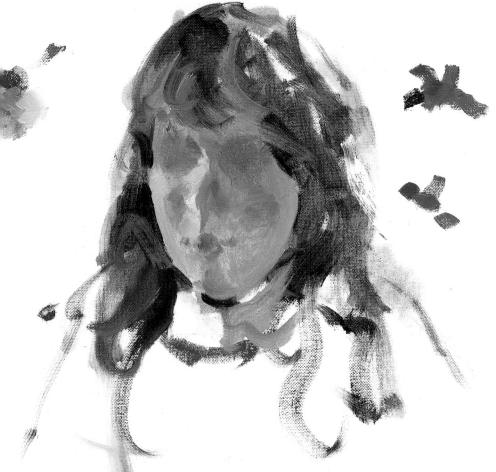

You can "mold and model" a face in paint just as a sculptor models in clay. To show you how this works, Charles Reid has made a sketch using a detail of Sarah from the double portrait on the facing page as a reference. In the sketch, note how the darker values and warmer colors project, while the lighter, cooler colors recede. Look at the left side of the head. It has light and shade, but the colors—the warm nose and cheeks with cooler colors on the side of the nose and cooler side planes on the face—are more important than the chiaroscuro in giving the face a form. This point is even clearer on the shadow side, where values are very close and you really only see color changes.

As an exercise, find a backlit or sidelit subject with enough reflected or bounced light to give the shadows luminosity. You've got to be able to see into the shadows, even though they may be murky. A good color photo would be a starter. Forget about features. Keep your values close. There will be value changes, but rely on color changes to make the face go around.

In the light, use warm color such as cadmium red light and cadmium yellow pale, or cadmium red light and yellow ochre. For cool colors in the light, a touch of cerulean blue mixed on the palette with a little of one of the warm combinations will serve. For the shadows, use cadmium red, raw sienna, or yellow ochre for warm areas and a touch of viridian or cerulean blue for cooler areas. For the hair, a good combination is raw sienna with a touch of raw umber, burnt umber, or burnt sienna. Cadmium red and Hooker's green dark also make a nice warm dark.

Charles Reid
Working Out a Painting Step by Step

Every painter has a different approach to starting a painting. Charles Reid begins with a brush drawing using turpentine alone as his medium. The drawing is very sketchy and loose; he tries not to think of the lines as areas to "fill in" but rather as broad indications for the massing-in of color areas. He treats the oil paint almost like watercolor in the beginning. He avoids white paint and uses only turpentine. Many beginners put on too much paint much too soon. It's a good idea to keep the texture of the canvas showing for as long as possible, because once its grain is lost the surface can become clogged and slippery.

This painting was started during a short vacation. Both Jon and Reid's daughter, Sarah, had just a few days to pose. Reid started by posing both together to get a very general layout of the picture (not shown). This took about an hour. The next day, he did Jon's face and washed in the shirt. He did add some painting medium to the turpentine (about two-thirds Winton painting medium with one-third rectified turpentine for the face).

Notice that Reid relies heavily on shadow shapes in the eyes and under the nose, upper lip, lower lip, and chin. Aiming for simplicity, he painted the area under the chin and neck in one value, ignoring any small, subtle value changes. Also note that the shadows were painted very thinly. Reid always squints when painting shadow shapes so that he can't see minor color value variations within the shadow. It is only out in the light that he places spots of color.

Reid left canvas showing through between these pieces of paint to make it easy to see how he places these spots of color. Overblending and painting thicker lights into the thinner shadow shapes causes a mess. It's excellent practice to learn to mix the correct color and value with the brush on the palette, then try to place the piece of paint on the canvas in

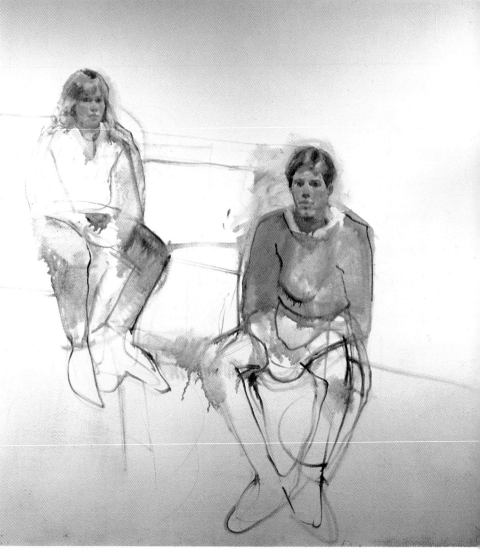

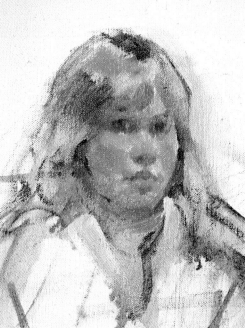

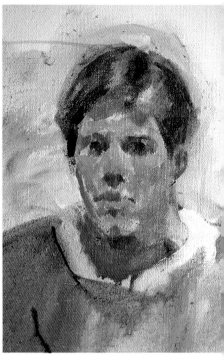

the right place. It'll look a bit patchy, but if the values are right, it will be okay. On the other hand, if the values are wrong when you apply them, no amount of blending on the canvas will help. Reid used the same approach with Sarah's face, but here he has worked the pieces of paint together.

For skin tones Reid generally uses the same colors: cadmium red light plus raw sienna and/or yellow ochre. To cool this mixture, use viridian green and/or a blue, either cerulean or cobalt. Remember, adding green and/or blue will darken the warmer colors. Try not to use white in the thin shadow shapes. A little might be necessary, but it's better to control the shadow value with the correct ratio of warm and cool. You'll be using very little green and/or blue. The ratio should probably be two-thirds warm to one-third cool color.

As you study the remaining stages, notice how thin Reid has kept the paint. Also notice how he has stressed local value in the clothing. (We're more aware of the light and shade on the faces.) For Jon's sweatshirt he used cadmium red, which could be darkened by adding a little viridian green or alizarin crimson. Because Reid wanted a rich red in this second stage, he avoided adding white, which tends to make cadmium red look pasty. If a lighter value had been called for, adding cadmium orange and/or a little yellow ochre would have worked. The jeans were painted with cobalt blue and ultramarine blue with a touch of burnt sienna in the lower legs. Reid did use a little white out in the light on the jeans, but if you do this, be sure to add just a touch of white to the blue on the palette first, combining it completely on that surface. Never add pure white directly to the canvas when you're painting middle or dark values.

Sarah's jacket was painted with cerulean blue, a little cobalt blue, and very little alizarin. Adding just a touch of cadmium orange would serve to cut the intensity of this mixture. Reid did use white in Sarah's jacket, and Jon's T-shirt is white. It's okay to use white in your lighter local color areas and in

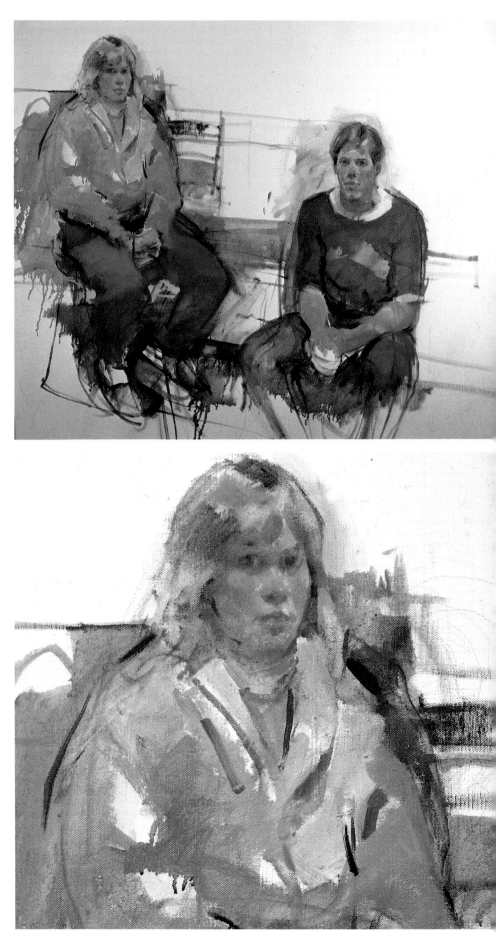

the skin out in the light. Sometimes you need it in middle-value areas, too, but try lightening with another color of the same family first. (For example, try using cerulean blue to lighten ultramarine before turning to white.)

Almost all of the darker areas around the figures are painted transparently, almost like watercolor. Remember, it's critical to keep your darks thin.

Experiment on your palette, always mixing small amounts of color with a brush, not a palette knife. Remember, always rinse the brush in mineral spirits or turpentine, and wipe it with a tissue before going to a new color.

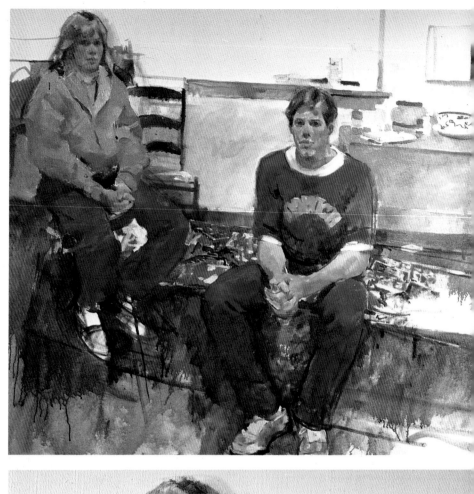

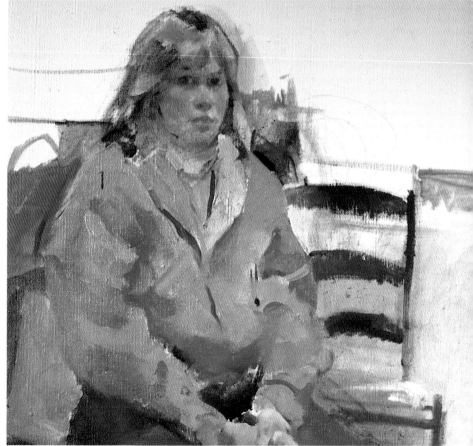

In looking over his painting, which for him was uncharacteristically large, Charles Reid found it somehow empty. He was bothered by the fact that Sarah and Jon appear isolated from each other. He tried to link them through the horizontal lines of the chair back and the bar near Jon's head, but this was not enough. So when his son, Peter, happened by, Reid decided to add him to the composition. Peter fell automatically into a casual pose that fit right in with Sarah and Jon's relaxed postures, yet his standing figure created a pyramidal effect. When Reid realized that he'd placed Peter too far to the right, he just redrew him again closer to Sarah. Peter's arms and legs link the other two figures and complete the grouping. Reid painted Peter's legs right over the chair (you can still see part of it in his dungarees).

With these changes in place, the painting has begun to work as a composition, and it contains enough information to permit subsequent completion when the artist's mood strikes.

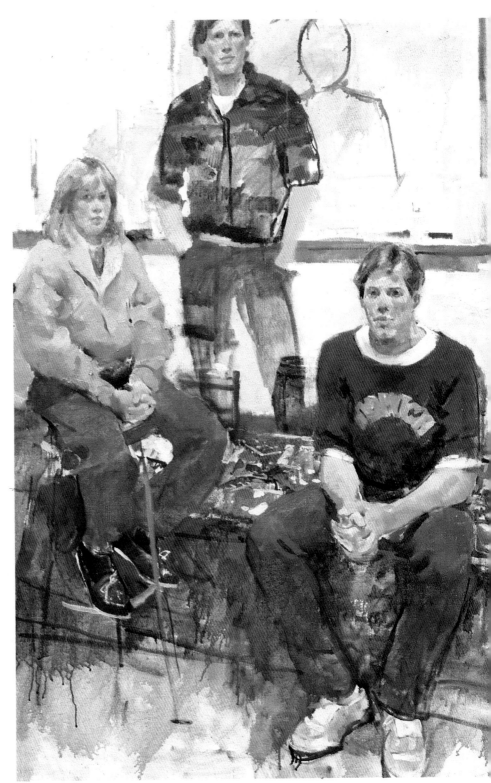

Charles Reid
Deciding What Should Dominate

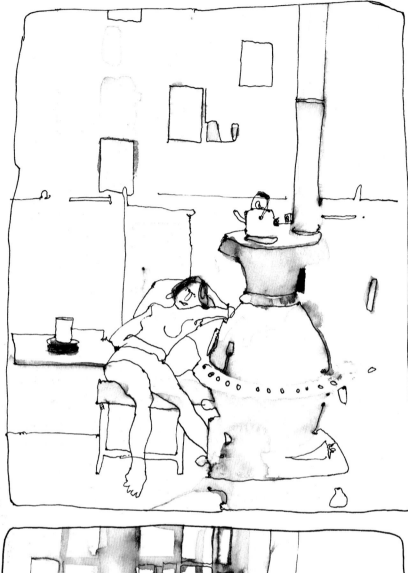

Charles Reid painted this picture in his friend Sperry Andrews's studio. The two artists have often shared a model, but, as in any class situation, agreeing on a mutually satisfactory pose can be difficult and sometimes results in a compromise that makes for an unsuccessful composition.

The main problem with this picture, as Reid explains, is the lack of connection between the model and the stove. They compete for attention because he was never able to decide which subject he was really painting. It would have been better to let one or the other dominate. An obvious solution would have been to put the model in the foreground, yet Reid wouldn't have been happy with that, since he loved the wonderfully mottled, rich brown of the stove.

In his two small pen-and-ink sketches, Reid shows what he would do if he had another chance at painting the same subject. One way to arrange the composition would be to put the model behind the stove and slightly overlapped by it. He would try to make her a part of the stove, in a sense. But the second solution—the back view with a very natural and awkward pose—might be a good idea, too.

SPERRY'S STUDIO
Oil on canvas, 50 x 50"
(127 x 127 cm),
collection of the artist.

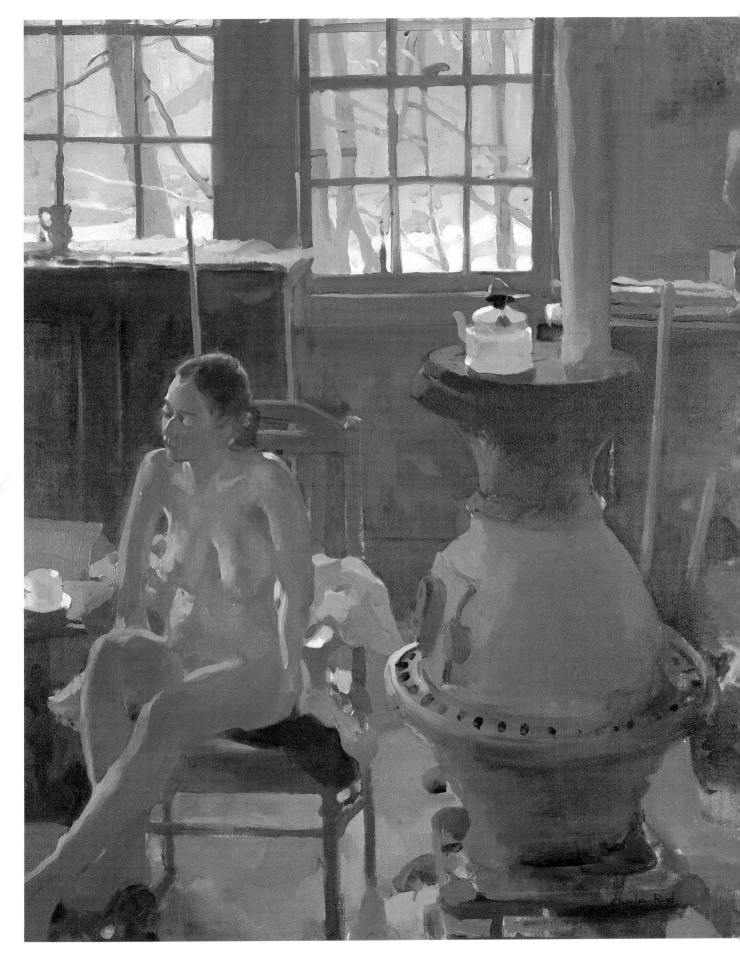

Depicting Blond Hair and Fair Skin

Getting a warm, lifelike flesh color—one with oranges and reds—is a problem when the model's skin is especially pale. To capture the pale skin tone of someone with blond hair and a fair complexion, you must work with conflicting forces in paint. To make the skin light, you add white, which cools the skin's tone; to give the skin warmth and to bring it back to life, you mix in red, yellow, and orange. Yet these warm colors cause the skin to darken in tone.

To meet this challenge, you need to use a high-key palette—colors that appear on the light, or high, end of the tonal scale. Also, work directly on the white canvas, as a dark undertone would only pull your colors down in value. Begin by laying in the figure using a thin wash of violet (a mixture of alizarin crimson, viridian, and white). By putting in the shadow areas only, you'll have drawn enough of the figure to establish its proportions.

Step 1. Douglas Graves delineates the figure with a deep violet wash and places the shadows on and around the model. He uses lots of turpentine and lays the canvas flat as he brushes in the colors—alizarin crimson, ultramarine blue, viridian, and black. To keep the colors from mixing too much, he uses two large brushes, one for the alizarin and ultramarine, the other for the viridian and black. In the background he uses the darkest and most saturated colors next to the areas he wants to stress, thus "punching out" the light edge of the figure. These rich, cool hues will make the pastel colors on the figure seem very warm by contrast, when actually the colors on the figure will be cool reds and yellows. The streak of light down the drape in front is done with yellow ochre and black. The hair is started with cadmium yellow. Where light directly hits the model's chest, a high-key mixture of white, yellow, and alizarin crimson is applied.

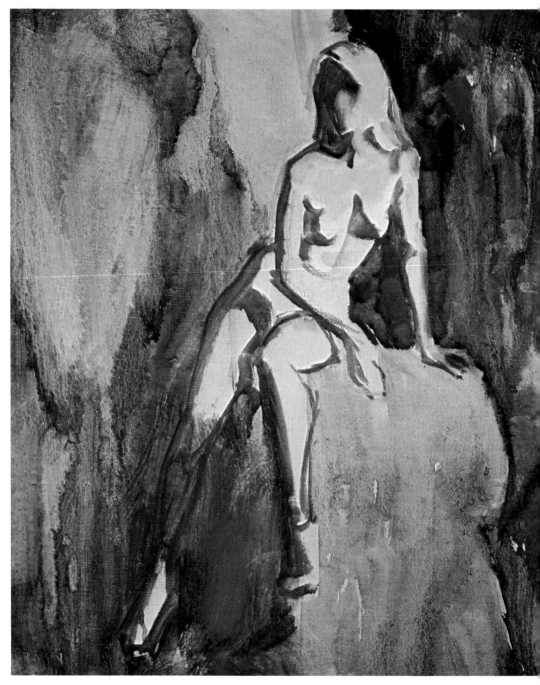

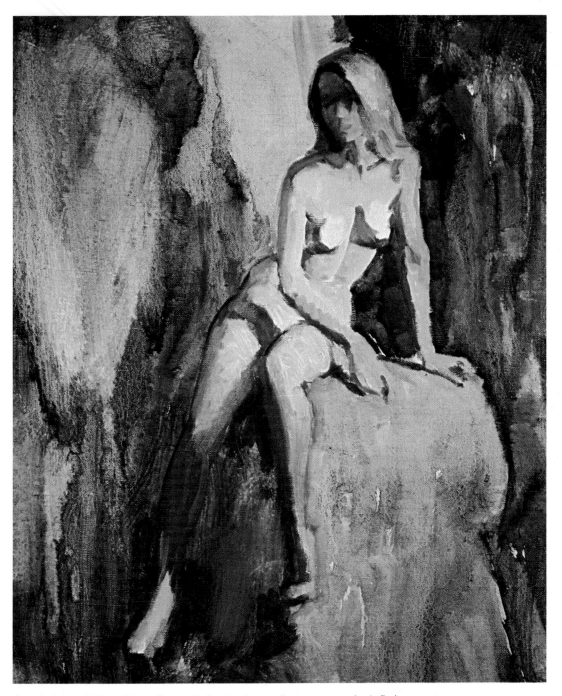

Step 2. By combining white, yellow, and alizarin crimson, Graves creates a basic flesh color. He keeps varying the balance of these colors as he picks them up. One stroke he pushes to the pink side; the next he makes slightly more yellowish. They must be the exact value, however. Combinations of white, alizarin crimson, and now viridian green and yellow ochre will comprise most of the shadow areas. Substitute yellow ochre for cadmium yellow in the shadows, because cadmium yellow will make the mixture too greenish. By varying the amounts of those colors, you can get shadow tones that conform to all the various local colors found on the figure. For instance, on the head and shoulder, the shadows are less yellow; some are even quite blue. The legs are warmer in tone and the shadows have more yellow ochre and red in the paint.

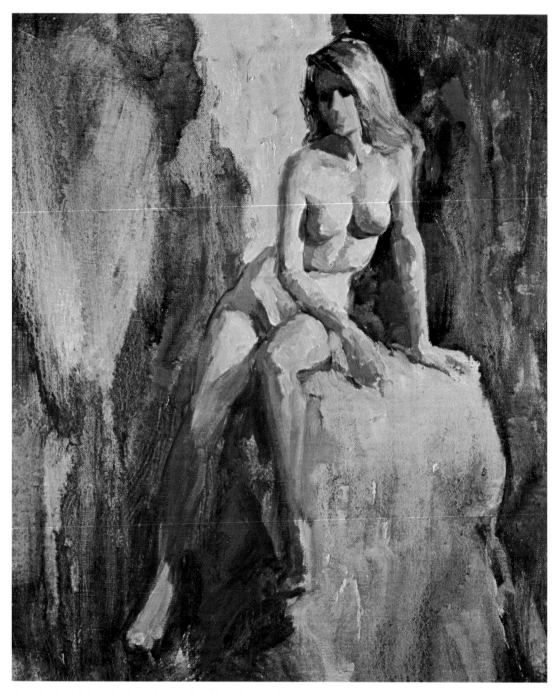

Step 3. The hair has a variety of colors, but it's basically cadmium yellow in the light and yellow ochre in the shadows. The breasts are the lightest and coolest parts of the torso, and so should be left alone until it's time to put on final dabs of paint. The shadows on the breasts are quite cool and bluish or blue-violet. For these shadows, Graves mixes a bit of alizarin crimson and viridian with white. Extremities like the arms and hands have a ruddier quality, calling for more alizarin and a bit of yellow ochre. On the arm that rests on the thigh, there's lots of warm light bouncing around, so the turning shadow needs just a little blue. Where the arm and leg meet, you can use a pure alizarin with some burnt sienna in it for the accented line. The lower part of the chest is more yellowish and shaded somewhat; yellow ochre is useful there mixed into the basic, light flesh tone.

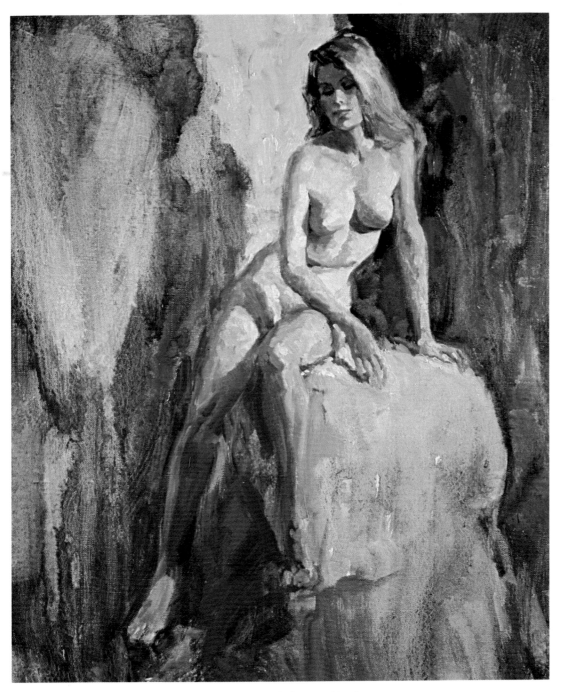

Step 4. In the final step, Graves merely suggests the model's features. Her downcast eyes are easy to render as nothing more than the lashes. For this he uses black paint, making it a little heavier where the pupils would be. Where the eyeball turns into the corners, he uses deep violet. Just above the lashes, a dab of blue-violet completes the eyelid. The shadow that shapes the form of the nose and runs across the cheek is lowered a bit because the nose seemed too long. The front plane of the cheek is redder both because of its local color and because it doesn't face the light fully. That plane runs into the mouth, for which Graves uses almost pure alizarin. Cadmium yellow is added to the lower lip, making it brighter and warmer. Small touches of cadmium yellow and white are added as highlights on the nose and chin. The hand on the left is slimmed down with spots of cadmium yellow, viridian green, and more white.

Douglas Graves
Depicting Red Hair and Fair Skin

Red hair is a conglomeration of many colors that vary from person to person. The dominant hues are red, orange, and brown, though ochre, cool red, and a touch of green may also be present. Redheaded people tend to have light, freckly skin whose basic color is a cool, illusive pink. As with painting blond complexions, the challenge is getting a high-key skin tone. However, this figure's skin tone will be a cooler, more pearly color.

Pay attention to edges that blend together, which must be of compatible hues so that they won't dirty each other. In this demonstration, note how Douglas Graves coordinates colors at edges. For example, the figure will have some green in the abdomen, so he makes the background edge green in that area. Near her back a pure violet works well into the shadowy color found there. The alizarin and brown around the legs mixes nicely with the flesh tones there.

Step 1. On medium-textured white canvas primed with acrylic gesso, Graves lays out both background and figure, aiming to keep the whole painting moving at once. He starts with the skin tone, a diluted mixture of white, light red, a touch of cadmium red light, and yellow ochre. He brushes in some of this into the background. The cadmium red keeps the skin mixture lifelike and the yellow ochre gives it just the right "grayness." With a mixture of burnt sienna and orange, Graves blocks in the hair. The right hand holding a mirror is done with alizarin crimson plus the flesh mixture. The legs have a richer light red and white hue. The background has many colors present: violet, green, white, and cool red.

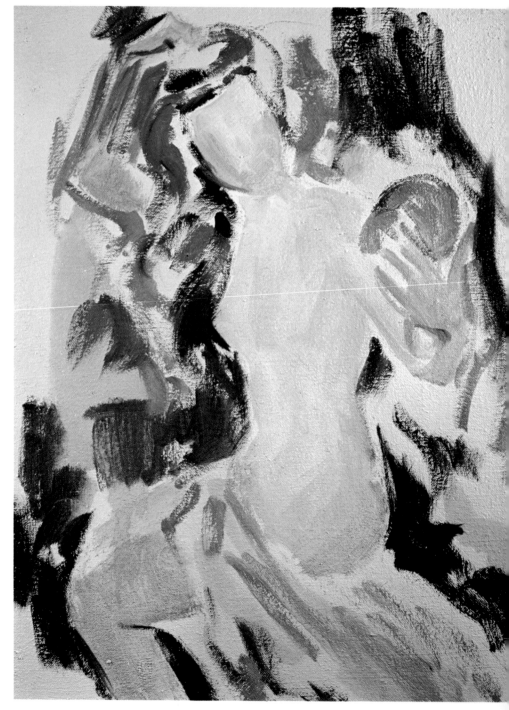

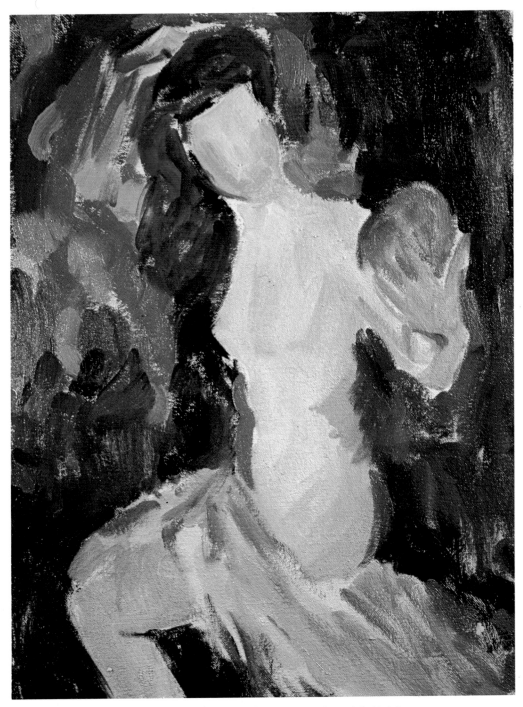

Step 2. Graves fills out the rest of the canvas with color so that no white is left. He brings edges of the figure and background together, putting related colors next to one another. Notice near the model's lower back that the background is a red-violet, and that the halftone on the body is a grayed red-violet. Likewise, the front torso has a greenish cast that coordinates with the background color in that area. Graves darkens the lower part of the model's face with a light red and cadmium red combination. The upper arm should be worked into the atmosphere, because it's somewhat in shadow and it's farther back than other parts of the body. Graves strokes some of the surrounding cool gray tones right over the bottom of this arm. The legs will be reddish brown, so a tint of that is laid in now. The mirror is a grayed yellow ochre.

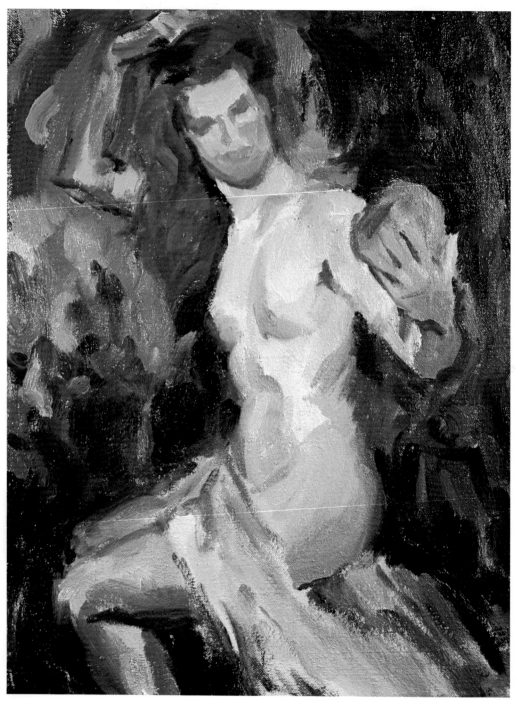

Step 3. The whole picture is enlivened with richer paint in essentially the colors that were first brushed on. Care should be taken here to not overbrush edges. Cool nuances on the body are mostly compounds of alizarin, viridian, yellow ochre, and white. In all cases, all three colors are used in varying portions. The third color always serves to take the "curse" out of the mixture. The slash down the center of the chest is mostly viridian and yellow ochre. The shadow under the left breast has less yellow in it. The shadow under the right breast is more alizarin and green. The zigzag tone on the abdomen is done with a lot of yellow ochre and viridian. Other grayed areas—under the neck, on the chest, and around the shoulder, and the warm strokes on the front of the abdomen and around the hip—are made with light red and white. The legs are painted with darker combinations of light red and burnt sienna. A little more of the drape is defined with cobalt, yellow ochre, and white in different strengths.

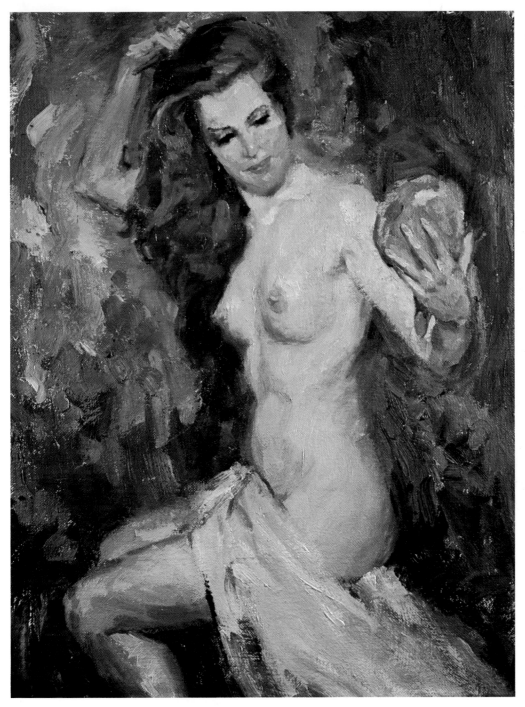

Step 4. In this final step, the position of the head is different because the first three steps were reconstructed from the final painting. Graves develops the hair by shifting the amounts of the red, brown, and yellow ochre in the mixtures, adding very little white to most of these. White will clearly gray the hues, such as the top right of the model's hair where a lighter tone of alizarin and white comes down to the part. Graves keeps only one highlight on the hair; it curves to the front and is almost pure orange. He uses pure alizarin and burnt sienna for accents in the hair. For the high-key tones on the breasts, he uses pure white tinted with the residue in the brush that he reserved for the warm flesh colors. The nose and lips are painted with cadmium red, white, and nothing else. The arm brushing the hair is a product of both the background hues and flesh tones brushed in together. In some places the periphery of the arm is strengthened. Any other details are achieved by adding the extremes of tonal values—the highlights and shadows.

David Leffel and Linda Cateura

Seeing the Topography of a Face

When you paint a portrait, the right bone structure or topography will give you a likeness. Think topographically; this area goes in, this area comes out. And if you get the depth of the ins and outs right, it will look like the person even before you put in the pupils, nostrils, or mouth.

In other words, the bone structure will give you a general resemblance. At 25 feet it is the bone structure that supplies the resemblance, because at that distance, you can't see all the details of the face.

Don't think of the features specifically as the mouth, nose, or eyes, but see them as part of the topography moving in and out of the depth of the picture. For example, for deep-set eyes, use deeper values; for a prominent nose, use a deep shadow value. When you're painting someone, you're evaluating the topography. Use values and colors that emulate the topography.

Don't work consciously to get a resemblance by copying individual features and trying to make them look exactly like the model's. Look at the person as a whole and try to understand what you're seeing. You'll get a resemblance almost automatically, without even trying.

Where the shadow meets the light in your portrait, find areas where you can add touches of color.

In the light part of the face, when you want to get more of a spotlight on the upper half, try lowering your values on the bottom half.

The muzzle (the area between the nose and the mouth) is basically the same color as the skin but cooler than the cheeks. Add a little red in the philtrum (the depression beneath the nose).

There is a highlight at the side of the muzzle near the canine tooth.

Shapes and Planes
The neck and throat are usually not too important in a portrait. Unless they are emphasized for a specific reason, leave them alone. Make your necks recede by adding some cool color; remember to simplify your objects.

Because the neck is further back than the head, it is painted in relationship to the background.

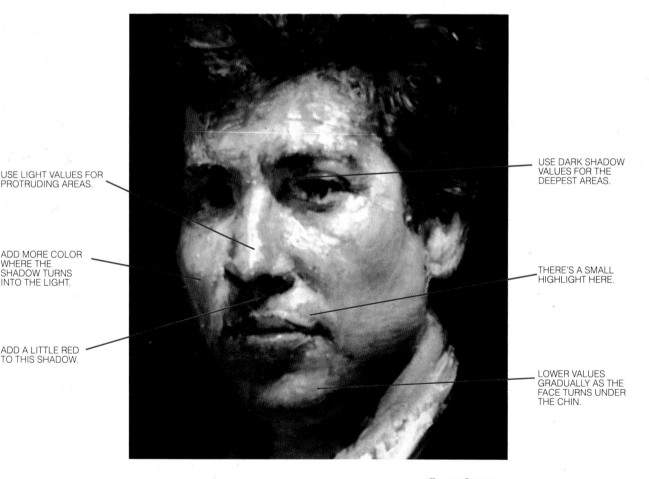

USE LIGHT VALUES FOR PROTRUDING AREAS.

ADD MORE COLOR WHERE THE SHADOW TURNS INTO THE LIGHT.

ADD A LITTLE RED TO THIS SHADOW.

USE DARK SHADOW VALUES FOR THE DEEPEST AREAS.

THERE'S A SMALL HIGHLIGHT HERE.

LOWER VALUES GRADUALLY AS THE FACE TURNS UNDER THE CHIN.

FRANK JANCA
Oil, 16 x 14" (40.6 x 35.5 cm), courtesy the artist.

202

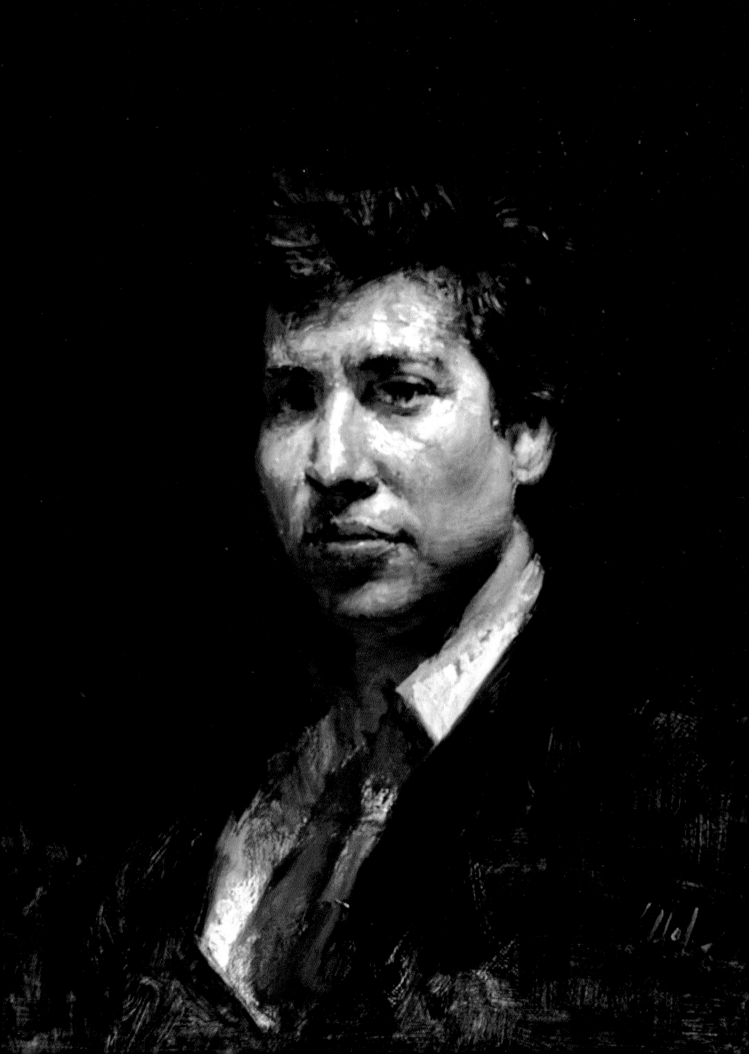

Here is a way to approach painting a face. First, see the face in terms of planes and colors. For example, the front of the forehead is one plane, the side (where the forehead turns at the temple) is another plane. Then decide on your warm and cool complexion tones. After you've applied your shadows, paint your complexion tones in regard to the planes you've assigned them: X planes, warm, Y planes, cool. Do this crisply. Then you can go back and do some modeling, or soften the edge between the planes for subtlety.

Closeup on Color

Try to avoid making your complexions too muddy. Use bright pigment for complexions. Try white and Venetian red, for example. Mix the two on your palette as though you were painting them together—with care, not as if you were making pancake batter. Don't mix them thoroughly. Set this warm mixture aside in one pile. Then put a cool color beside it in another pile. Now apply your colors in terms of the planes of the face. Apply on one side, then apply the same colors on the other side, and keep the values until later.

There is one constant and one variable; where each comes depends on its place on the face. On the cheek and nose area the color is mostly warm, indicating fleshier substance. The cool color then modifies or indicates plane or form change. On the lower part of the face, including the chin area, there is an abundance of cool color indicating a bonier substance, with some warm color modifying it.

In the light, the colors Venetian red and yellow ochre are good for the more sanguine area of the face (the cheeks and nose area).

Gray the lower part of the face, because here you're describing more side plane, more jaw. Follow the form. The mouth area has many small planes in transition, and transitional planes are painted cooler.

Use the same colors and values repeatedly to unify your paintings. For example, use the same shadow color for the hair as for the face, but darker. (Try painting all the hair with the shadow color and adding your lights later.)

The accents in the hair and eyes should be the same value. The darkest darks in the hair should be the same value as the pupils of the eyes.

Avoid using a variety of values in your shadows, too. Use the shadow value of the eyes for the nostrils, for example. In other words, repeat the same value as often as you can.

Keep the value of the pouch under the eye somewhat close to the value of the skin. Otherwise, they won't appear to belong together.

You can't have two separate colors or chroma—red and yellow—for the complexion. Use warm against cool, not two colors. The skin has to be red, or orange, or yellow ochre, plus cool—not two colors. This cool, or second color, has to be colorless. If it's too strong, say a blue, float skin color into it.

Skin color is a special thing. It has no local color. It's elusive; it doesn't hold still. You'll find skin warm in one place and cool in another.

When you complete the eye, you'll notice that other parts of the face will look somewhat finished as well. It's an encouraging stage in a painting.

FRANK JANCA (DETAIL)
Oil, 16 x 14" (40.6 x 35.5 cm), courtesy the artist.

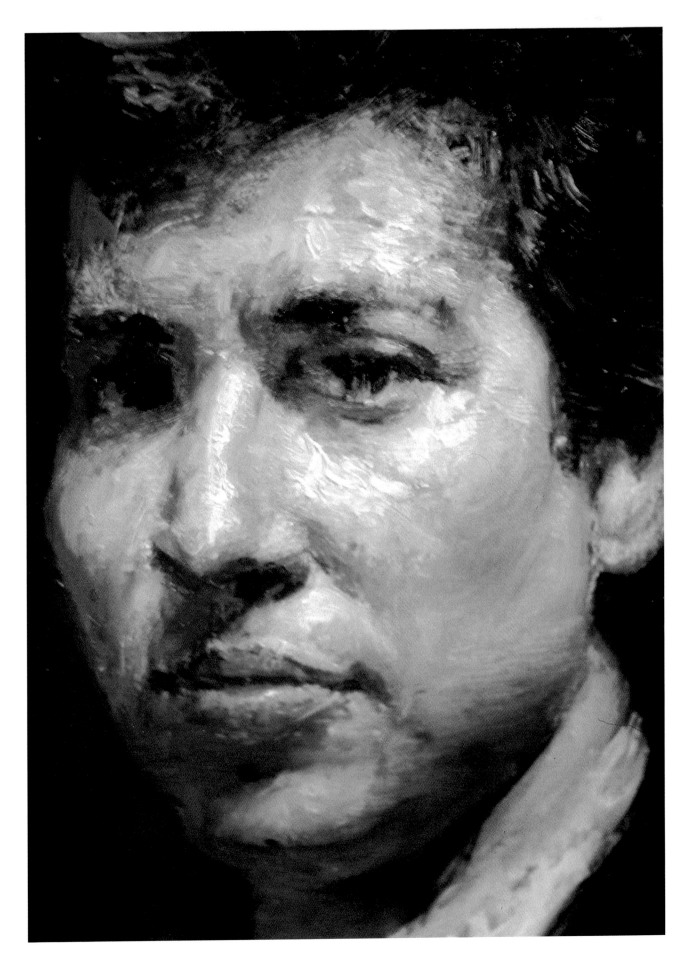

Gregg Kreutz
Communicating Underlying Form

In painting and in drawing, you must be attentive to and describe the reality under the surface, the substructure upon which the surface details appear. Getting a feel for that underlying structure can be difficult. The eyes, the nose, the mouth—these are the things we notice right away, but if we paint them in without first analyzing what is supporting them, they'll look as if they're floating, with nothing to anchor them in their proper places.

Don't be troubled if you can't see the skull under the skin; what you're actually looking for is *evidence* of the skull, not the skull itself. When you look at a face, instead of accepting all its protrusions and grooves as mere facts, try to analyze what's causing them. This makes it much easier to find the underlying structure. The flesh is taut against the bone in some places, sagging in others. Why? The face has a front plane and a side plane. Where do they meet? Is the brow ridge thick and bony, or soft and smooth? Are the cheekbones prominent, or subtly defined? Some people's skulls are less in evidence than others, but if you're looking, and asking the right kinds of questions, you can always find the causal foundation underneath. Obviously the idea holds for everything, not just the head. All objects have some internal form that dictates their external appearance.

A good way to get into this kind of analysis is to paint self-portraits. There's something about having that free model there that lets you get involved. You can really peer at and, if need be, feel the area in question. You have the luxury of spending weeks trying to get the forehead just right, and that effort will pay off on all foreheads from then on. Also, there's an inherent power in the very nature of a self-portrait; there's something about a picture of a person painting the picture that's loaded with meaning and resonance. It's a situation where form and content are one.

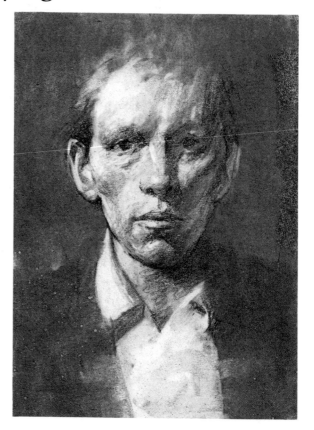

This head was modeled with an emphasis on the underlying structure. The model's physiognomy lent itself to that kind of treatment, and finding the skull beneath the skin was not a problem. The drawing shows the skull under the same lighting conditions.

Here, Gregg Kreutz shows how he establishes the underlying form of the human head when painting a portrait. He starts out with a rough, massed description of his subject's head, aiming to capture the general shape and structure of her front planes and side planes. At this stage no big commitment is needed, but it is important to get a fairly coherent description of the basic planes.

Now Kreutz concentrates more on value, trying to figure out how mysteriously he wants to play it. For the silver highlight to really shine out, the other values have to be kept low.

He brought up the model's face color a little so the picture wouldn't be too gloomy. The color idea is clearer now—blue and orange.

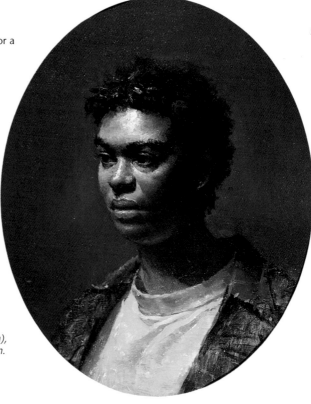

GAIL
Oil, 20 x 18"
(50.8 x 45.7 cm),
private collection.

SEATED NUDE (UNFINISHED STUDY)
Oil, collection of the artist.

The side of the model to the right of the picture is the near side, so it's fuller, more frontal than the side on the left. Kreutz was working back and forth here, thinking near and far as he built solidity into the figure's form.

Gregg Kreutz
Eliminating Clutter

The more cluttered your picture, the more difficult it is to read as one simple statement. As you're painting, it's tempting to keep adding things; big stretches of bare canvas beg to be filled, particularly if the center of interest doesn't seem that compelling. Filling in those blanks, while it can give density to the painting, doesn't help strengthen its impact. In fact, the more clutter, the weaker the image.

As your painting progresses, if parts of the canvas look bare or neglected, instead of adding things to the setup, try strengthening the central image. This may not be the most obvious solution, because the central image may be painted perfectly well. But in a painting, accuracy isn't enough; intensity is the goal. If a figure in a room is depicted in a credible way, it's easy to say to yourself, "Good, that's over. Now I'll put in all the other stuff." But that's the wrong approach. It's valuing things over ideas. It's thinking of the picture as a collection of objects instead of as an expression of a concept.

SUNDAY MORNING
Oil, 12 x 16" (30.5 x 40.6 cm),
collection of Richard and Anne Arnesen.

There was so much going on here—so much content—that Gregg Kreutz felt he had to let some part of the painting remain undefined. He could have underpainted the material at right, or thrown it into shadow, but he liked the way the newspaper and sheets look as though they're growing out of the canvas. This was an on-the-spot painting, and consequently the lighting wasn't very controllable. The model, the bed, and the bedside table are frontally lit, while the chair in the back is lit by the little opening in the shaded window.

Painting Effective Shadows

How do you paint shadows? The key is to figure out what distinguishes shadow from light. Shadows aren't just dark versions of what's in the light. They have a recognizable quality of their own that's different. They're mysterious. Our eyes naturally focus on the light and consequently render the content of the shadows less coherent. For the light to look crisp and luminous, the shadow must be vague and evocative, and if that's the quality we're after, the picture is easier to paint because a quality or an effect is more paintable than a thing.

The general feeling of mystery that all shadows have is best depicted with warm, dark colors. Warm tones suggest shadowy depth. Cool tones suggest light. There are complications, however, because of air. While the general tone of a dark interior is warm, the air is also being illuminated, and therefore cooled, so as things go back into depth, there's more and more lighted air in front of them, rendering them cooler. The shadows represent the unilluminated parts of the environment; therefore they are warm. But to the extent that they are in the distance, or to the extent that they have light reflected onto them, they get cooler.

In other words, it's always a tricky balance. For the shadows to convey richness and mystery, they need to be warm. But for them to look airy, they need to be somewhat cool.

Outdoors, on a bright day, because there's so much light, everything is cooler. It's still a good idea, though, to treat the shadows as basically warm entities. This runs a little against the grain of accepted wisdom, which says that outdoor shadows are cool. However, it could be said that their basic nature outdoors is warm but that they have a lot of cool light reflected into them. A car, for example, out in the sunlight would cast a warm shadow directly under it, but where the shadow extends away from the car it gets cooler because it reflects the color of the sky.

A cool, grayish tone was used for the shadow color in the face above, and while it doesn't look unnatural, it seems dull when compared with the warmer tone used in the face below. The warmer shadow creates a richer look, and that gives a greater feeling of depth. It also makes the light look more vibrant, because its warmth contrasts with the light's coolness.

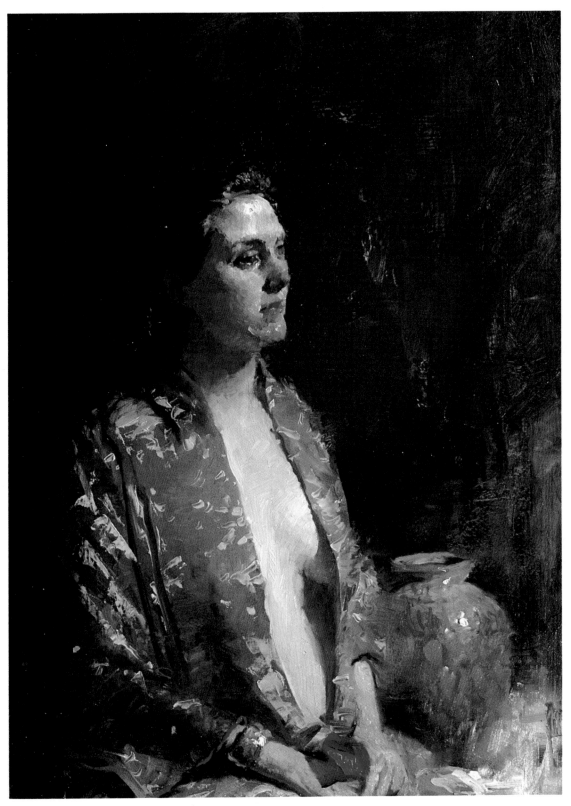

GREEN KIMONO
Oil, 16 x 12" (40.6 x 30.5 cm), collection of Burdett and Michel Loomis.

The shadow on the head is shaped so that it echoes the head's general structure, beginning where the front plane becomes the side plane. This picture also illustrates a way to suggest detail without laboriously putting it in: The intricate pattern on the kimono was suggested by dashing in some vague strokes with the palette knife.

David Leffel and Linda Cateura

Creating Interest in a Nude Portrait

With an ordinary nude pose, you must create interest by how you paint, what you put in the light, how you contrast. Otherwise, the painting will be dull.

Try to think in terms of just painting edges, not features. Remember, flesh has a soft edge; bone, a hard edge. For example, there is a sharp shadow line along the nose where the bone is, and a softer edge at the lower part of the nose where the cartilage is.

It's important to paint a good visible highlight in the beginning as a guideline. It will tell you instantly more about the middle tones.

For a better composition, avoid painting too many different angles in a portrait or figure painting. The hand and the leg, for example, might go in the same direction rather than at askew angles.

Make your figure solid-looking. Build it up. Make a definite statement. Put more dark in the torso, more light on the lap. Decide where the light starts and where it turns into shadow.

Choose significant things to paint. The fold in a jacket or shirt should have some meaning; it should relate to the form underneath. Be selective.

Work symmetrically, first one side, then immediately after, the other side. Paint across, from side to side. Painting this way also keeps your colors consistent and symmetrical.

The head should be smaller than life-size. Be sure there's space around it. Everything in life has space around it. Paint it that way.

The body follows a natural design.

Be sensitive to your model, whether it's a person or a still life. Give yourself time before you start painting to be sensitive to the pose, lights, shadows, and the various concepts you might choose. Painting is a relationship between you and the model.

When your model's stomach muscles recede, make them cooler by adding some background color. The chest muscles come forward, so make them more colorful.

Don't put anything (a brushstroke, a piece of color—*anything*) in a painting thoughtlessly. Find a pictorial reason to add everything.

Wherever a form ends, another begins. This is described with a hard edge or crisp brushstroke. Where a form continues, you have a soft edge or soft brushstroke.

A good artist portrays life in universal terms. Ideally, you're looking for the basic, universal, human structure. Personal qualities should be subordinated to the universal. Painting universal qualities makes a good painting, whereas personal qualities in a painting make it weak.

THE GREEN KIMONO
Oil, 20 x 17" (51 x 43 cm), courtesy Grand Central Galleries, New York, New York.

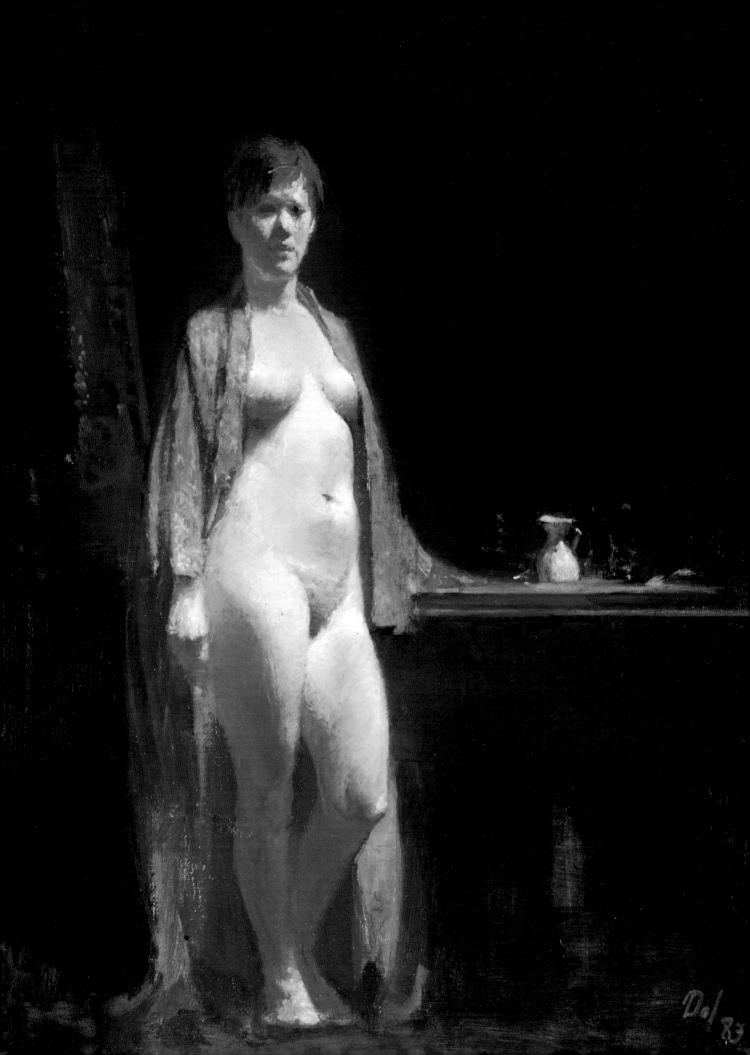

David Leffel and Linda Cateura

Sculpting on Canvas

Paint an abstraction, a shape or color, and then make it whatever it has to be—an arm, hand, knee.

Starting from the head and going to the torso, the gesture (the pose itself) is all important. Do the gesture in broad strokes.

Painting is like sculpture. When painting an object, you're painting not roundness but the illusion of dimension.

Use light to make form come forward—the nose, breasts, thighs.

A shadow on the stomach should follow the swell of the stomach. It should not be painted straight across the abdomen at an angle.

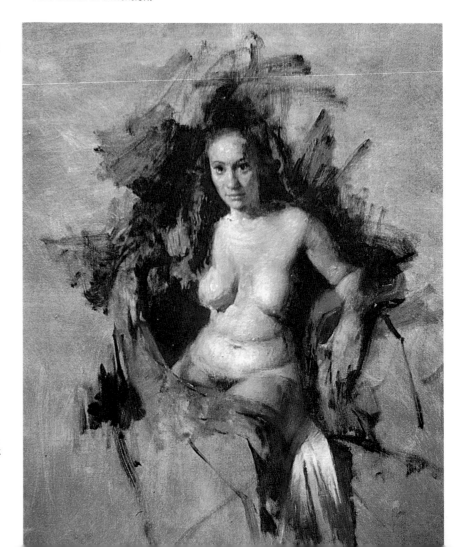

EMERGING NUDE
*Oil, 30 x 23" (76.2 x 58.4 cm),
collection of William Macomber.*

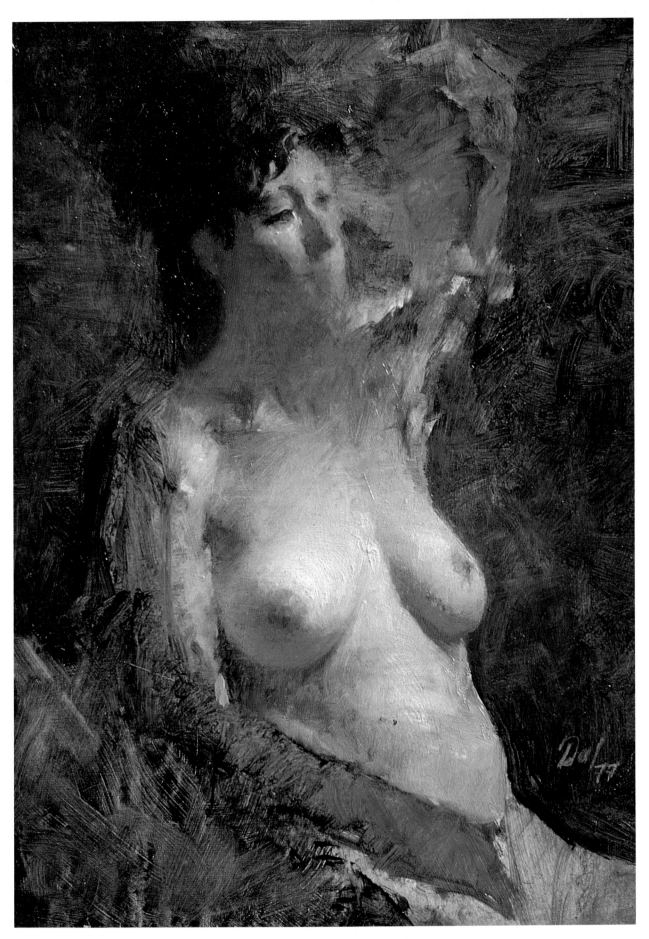

DOLORES
Oil on panel, 12 x 9" (30.5 x 23 cm), private collection.

STILL LIFE

Alfred C. Chadbourn

A Basic Approach to Still Life Painting

Here, Chip Chadbourn demonstrates one basic approach to the problem of painting a still life. As he describes his technique, he also discusses various mistakes he makes along the way so that you can share some of the trials and errors he—like any other artist—normally encounters when painting.

In setting up the still life for this demonstration, painted in New York City, he chose some fruit and flowers in a nearby market. Combined with a few odd bottles from his studio, they offered a variety of shapes and colors.

Sketch

First Chadbourn does a simple black-and-white sketch of the subject using a fine-point Pentel pen. In making this

composition, he decides to incorporate some of the old buildings outside as a background for the still life, which provides an unusual challenge. Notice that he keeps the architectural details to a minimum, because he doesn't want them to dominate the scene. On the right side of the interior, he suggests a huge green plant in a bowl— actually, he uses only the leaves, which add to the pattern of the whole.

The early morning light is beginning to perform all sorts of magic on the windowsill—creeping over the light blue cloth and casting deep, slanting shadows to the right. Although the drawing is just a suggestion of what Chadbourn sees in front of him, it catches the essence of his initial response.

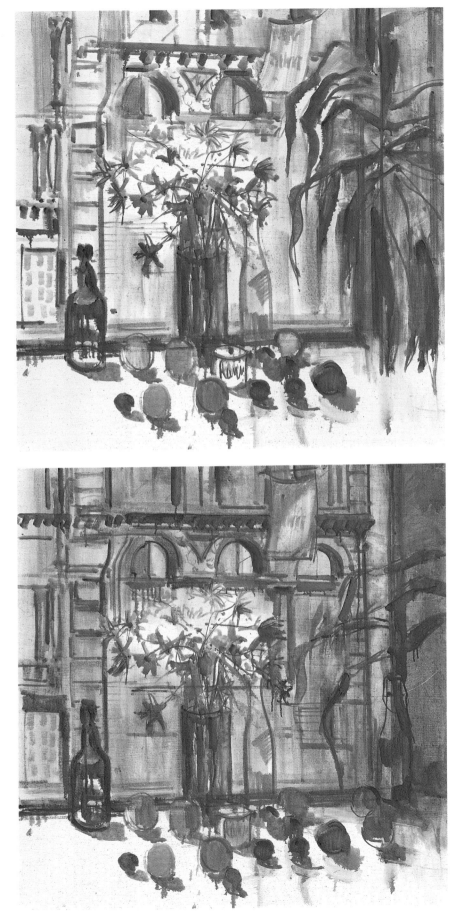

Step One

Using straight ultramarine blue and turpentine, Chadbourn starts laying in the picture with two large, flat bristle brushes (#10 and #5). Because the canvas is fairly large—three feet (91 cm) square—he uses the large brushes throughout the blocking-in period. When he makes a mistake in the drawing, he wipes it out with a rag and turpentine, leaving a light blue tone on the canvas. (Chadbourn doesn't always start a picture the same way. Instead of ultramarine blue, he may use orange or yellow ochre, if he wants an overall warm tone. And sometimes he rubs a tone over the entire canvas first, rather than drawing directly on the white surface.) Once the main features are in, Chadbourn takes a break and a long, hard look at how things are shaping up.

Step Two

Chadbourn's first reaction is that the large, leafy foliage on the right is too important and disturbs the balance of the picture. If he doesn't correct this now, it will haunt him later. After he wipes out the leaves with a rag and turpentine and redesigns them, the foliage seems less distracting. Now he feels the need for another bottle on the right. Also, with some of those disturbing leaves eliminated, he can describe more of the building, and he adds such architectural details as the three arched windows and the strong horizontal of the cornice above.

Note that Chadbourn leaves some of the bare canvas showing through around the flowers and in the foreground, as these are the lightest areas in the composition. Because he's using a lot of turpentine as he draws, some of the dark areas—like the cast shadows of the fruit—drip a little, but they can always be cleaned up later. After about an hour, he realizes that there is enough of an image for him to start painting some color relationships.

Step Three

Using a full palette of colors and a full array of flat bristle brushes (#s 2, 3, 5, 7, 10, and 12), Chadbourn begins applying color. Starting with the large background building, he mixes a large amount of violet, using alizarin crimson, ultramarine blue, and white. The varied warm and cool violets suggested by the sooty buildings then act as a foil for the bright color in the rest of the setup.

Next, he looks for the darkest darks—in this case, the greens in the vase and the leaves on the right, which are mixed with yellow ochre, burnt sienna, and Grumbacher's Thalo green (phthalo green). The dark plums are then painted with alizarin crimson and ultramarine blue. For some of the interior wall on the right, he uses burnt sienna darkened with a little Thalo green. He also adds this brown tone to the beer bottle on the left.

Chadbourn tries to cover as much of the canvas as possible, establishing large areas of color and value relationships. To define the bright pink flowers, he chooses a mixture of Thalo red rose and white, with a few strokes of pure white for the daisies. Next, he suggests the ultramarine blue banner and the red door on the left. With the door he experiments to see if he can get away with pure cadmium red light, even though it seems to jump a little at this stage. On the peaches he uses some cadmium orange, darkened with a little yellow ochre. Next to the peaches he adds some of the light blue cloth, mixed from cerulean blue and white. The painting may seem a bit sloppy at this stage, but Chadbourn is in a hurry to capture the effect of sunlight streaming through the window.

To keep his colors clean, Chadbourn generally uses one brush for the lights and one for the darks. He washes his brushes constantly while painting by dipping them into turpentine after each stroke. It's important to remember that you can't get clean color with dirty brushes.

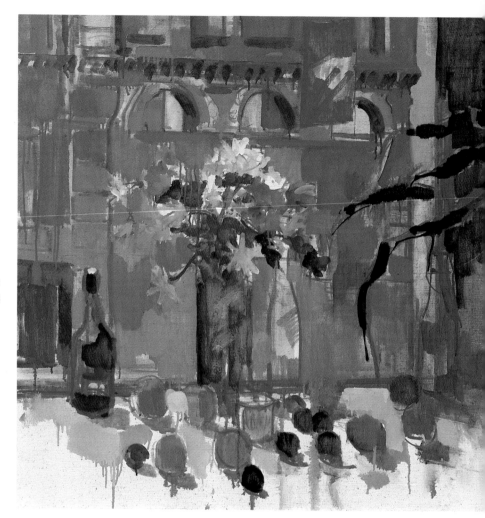

ULTRAMARINE BLUE

WHITE

ALIZARIN CRIMSON

THALO GREEN

YELLOW OCHRE

BURNT SIENNA

Once the preliminary color relationships are set up, Chadbourn takes a break, stands back, and compares the painting to the setup. He knows he has exaggerated some of the colors, but he has found that if he doesn't establish strong colors at the start, they always seem to fade when he embellishes their form. In this sense, he tries to stretch his colors as far as he thinks he can within the limits of the painting.

Step Four

Now Chadbourn can start adding light to the picture. First, however, he paints more violet tones on the building to cover up all those empty white spots showing through. Then he paints pure cadmium yellow on the apple and a mixture of Thalo red rose, orange, and white on the light side of the peaches. The chalky color on the light side of the herb jar is mixed from burnt sienna and white. Chadbourn also adds pure ultramarine blue on the bottle to the right. The light green vinegar bottle is a mixture of cerulean blue, yellow ochre, and white, while the daisies are painted with yellow ochre, ultramarine blue, and white— a reliable mixture for cool and warm off-whites. The strongest value contrasts are in the middle of the bouquet, with the white daisies against the dark greens of the vase.

Note that a lot of the original blue from the drawing shows through but doesn't jump out. Chadbourn hopes to leave some of this in the final painting, as it helps to energize large areas, particularly in the background building.

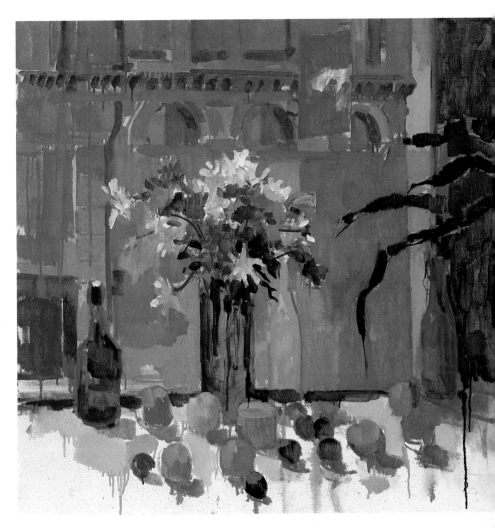

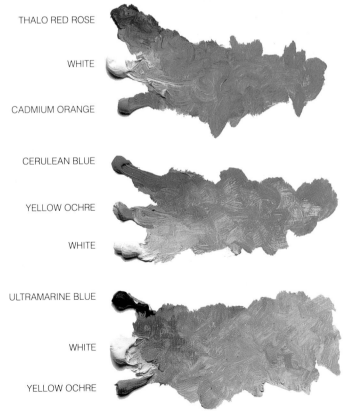

THALO RED ROSE

WHITE

CADMIUM ORANGE

CERULEAN BLUE

YELLOW OCHRE

WHITE

ULTRAMARINE BLUE

WHITE

YELLOW OCHRE

Step Five

Just as he is ready to call it quits for the morning, Chadbourn notices a diagonal shaft of light across the background buildings. Although the light continues to shift, he decides to introduce this diagonal by mixing a lighter tone of violet into this area. To carry this diagonal onto the vase, he lightens the greens by mixing a little yellow ochre and white into them. He also fills in the effect of light on the blue banner and adds more light to the windowsill, as well as the pink corner of the building.

Since light now plays an important role, Chadbourn establishes strong cast shadows on the blue tablecloth, using a mixture of ultramarine blue, cerulean blue, and white, with a little cadmium red light at the edge to create a vibration, or halation. He also adds some warmth to the cloth by mixing orange, cerulean blue, and white in the thicker, light-struck areas. Other small details that augment the effect of light include the light yellow on the apple and the light green on the dark leaves.

Although Chadbourn defines the brown and blue bottles some more, he keeps the vinegar bottle relatively flat because it isn't affected by the sunlight. Later, when he scrutinizes the picture, he observes that all three bottles and the vase line up on one plane—something he hadn't noticed during the heat of battle.

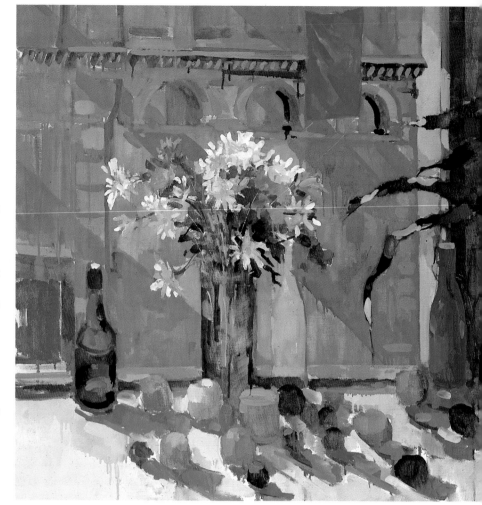

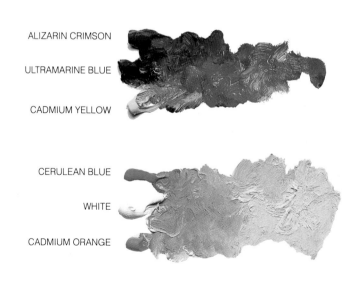

ALIZARIN CRIMSON

ULTRAMARINE BLUE

CADMIUM YELLOW

CERULEAN BLUE

WHITE

CADMIUM ORANGE

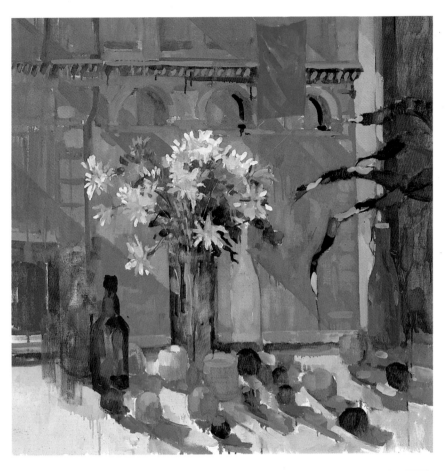

Step Six

The next day, taking a fresh look at the setup and the painting, Chadbourn decides to move the brown bottle further down into the picture. To do this, he wipes out the original bottle with a rag and plenty of turpentine. Inevitably this disturbs some of the surrounding area, but that can be repaired later. By rubbing almost down to the raw canvas, he leaves a thin surface, which will be easy to paint over.

The new position of the bottle helps to add depth by letting the eye go in and around the fruit in front of it. It also breaks up the static "lineup" of bottles that worried Chadbourn earlier. This is the only change he makes at this step. It's very important to change things if they don't feel right. The beauty of oils is that they allow you this freedom of choice.

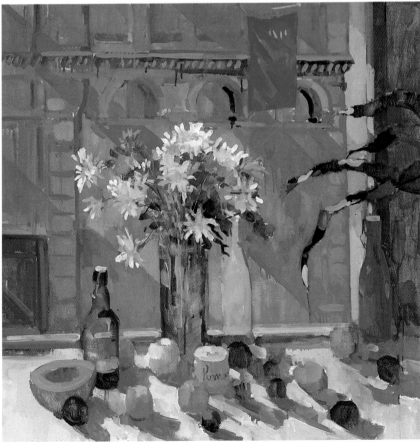

Step Seven

Even though Chadbourn prefers the new position of the bottle, the left corner still looks somewhat empty. On an impulse he buys a fresh, ripe cantaloupe, cuts it in half, scoops out the center, and places it in front of the bottle. Now this area has more weight. The cantaloupe also adds variety in shape and size to the fruit.

For the cantaloupe's outer shell, Chadbourn uses a mixture of yellow ochre, ultramarine blue, and white. For the rim, he uses straight cadmium orange and white. The deeper tones in the center are orange darkened with a little yellow ochre.

He then starts cleaning up some of the edges on the light side of the cloth, using thicker pigment at each step. He also adds more light to the windowsill and a slight diagonal of deep red on the door. To suggest the transparency of the brown bottle, he lets some lighter tones, including the blue cloth, show through the bottle.

Step Eight

Now for the final assault. The light is performing its magic again and Chadbourn wants to push the color and values as far as possible to bring this painting to its conclusion. Contrary to what many have said, he feels that the final stage of a painting should be just as bold and free as the initial steps.

With clean brushes, a jar of clean turpentine, and loads of freshly squeezed titanium white, he starts to darken some of the cast shadows on the table with ultramarine blue, alizarin crimson, and white. He then builds the light-struck areas of the cloth with a lot of thick pigment, continuing with his mixture of cerulean blue, orange, and white but adding more white as he goes along to force the value contrasts.

One of the biggest problems Chadbourn finds he always has in painting flowers is getting the darks soft enough, particularly with white daisies. Here he rubs some of the white petals with a rag on the halftone side. Generally, if you use too many hard edges, the daisies start looking like decals.

He also adds some pure orange to the halftones of the peaches and darkens some of the plums with pure ultramarine blue and alizarin crimson. To complete the cantaloupe, he loads the brush with a lot of the white and orange mixture, letting some of the rich pigment drip slightly over the darks. Turning to the background, Chadbourn suggests lettering on the blue banner and adds the small squares on the paneling of the red door. Then he develops the greens in the vase further and adds a few highlights to the flowers and some details to the background building. He also slightly softens the edge of the blue bottle as it meets the background by rubbing his fingers over the wet pigment. This keeps the bottle from popping out of the shadows.

For Chadbourn, it's always difficult to know exactly when a painting is finished. To some observers, the small blue areas showing through and the occasional drip here and there may be horrifying. For him, however, an attempt to "clean up" these areas would in some way take away from the freshness of the painting. The urge to "tighten up" during the final stages is something he tries hard to resist; it would be uncharacteristic of his way of painting and his way of seeing things. And in any case, slavish details wouldn't really help this painting .

Usually Chadbourn hangs on to a painting for two or three weeks before sending it to his gallery, just in case he notices something he hasn't seen before and wants to change it. Because this painting was photographed on the day of completion, he didn't have much time to scrutinize it carefully. But even after living with it in his studio for a while, he never determined what he would have done to change it, if anything.

FLOWERS AND FRUIT, LOWER MANHATTAN
Oil on canvas, 36 x 36" (91 x 91 cm), collection of Mr. and Mrs. Donald Sigovich.

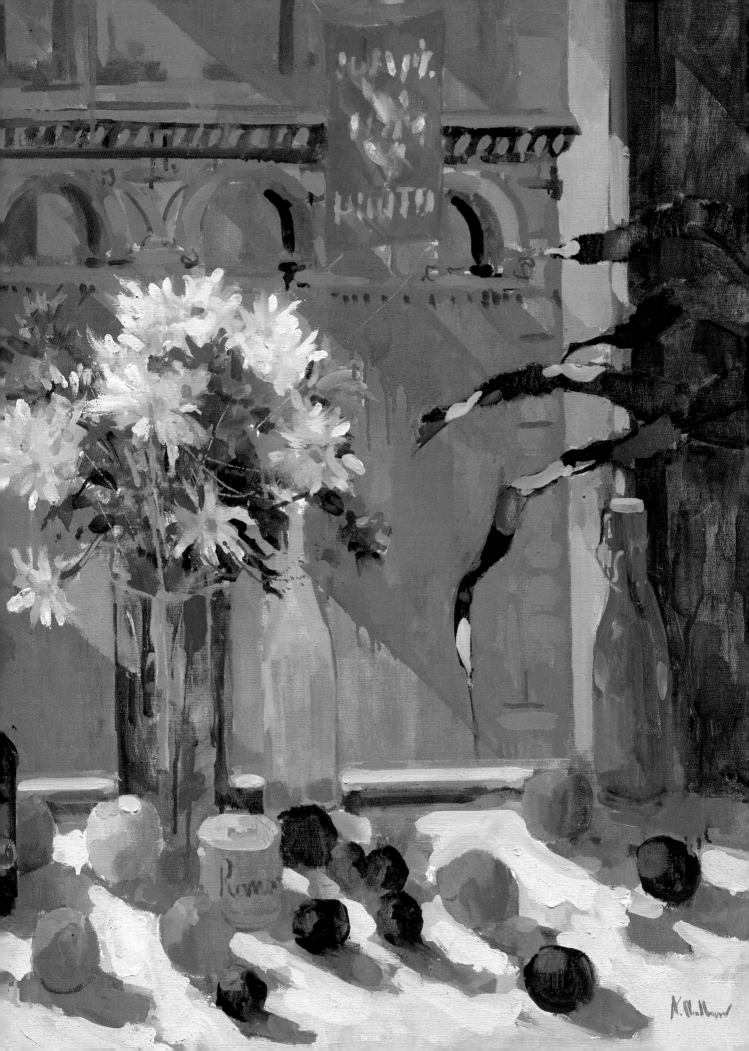

Alfred C. Chadbourn
Achieving Interesting Darks

This painting resulted from viewing an exhibition celebrating the two-hundredth anniversary of Jean-Baptiste Siméon Chardin. Chardin has always been a favorite of Chip Chadbourn's, ever since his early Paris days. In Chardin's breathtaking still lifes, ordinary kitchen objects take on heroic scale, and, under his peerless eye, everything falls naturally into place. Chardin is the kind of painter who lures you into looking at his paintings for a long time. He would spend hours arranging his still lifes, and this is evident in his paintings. One has the impression that if one wine glass or bowl of fruit were moved a fraction of an inch, the whole composition would be disturbed.

Both Cézanne and Braque were influenced by Chardin. If we compare some of the still lifes by these three artists, at first glance they may seem to have little in common. On closer inspection, however, it becomes abundantly clear that all were superb colorists and flawless composers. Another pertinent similarity is that they cherished the objects in their still lifes and painted them over and over, whether we refer to Chardin's clay pipes or Cézanne's scalloped kitchen table or Braque's compote.

For his own painting, Chip Chadbourn deliberately chose some simple objects and placed them against a dark background so he could explore the possibilities for a dramatic composition not unlike some of Chardin's monumental still lifes. He also decided to keep the colors somber but rich, with lots of siennas and ochres, as well as deep umber shadows reminiscent of the old masters.

Before starting the painting, Chadbourn did a series of black-and-white drawings, concentrating on the abstract light-dark patterns on the cheese, which would be the core of his composition. He did some drawings in a local cheese store; otherwise those large wheels of Vermont cheddar would have cost him a fortune! But he also bought some cheese to use as props while painting.

The direct influence of Chardin can be seen in the horizontal emphasis of the table plane and the shallow perspective. Most of the objects in Chardin's paintings are placed within a confined area on the table, guiding your eye within a limited space. Arranging the cheese on a horizontal plane, right across the picture, allowed Chadbourn to concentrate on the dramatic light-dark contrasts in the central part of the composition.

Notice the variety of color in the background and how the drapery folds break up into abstract shapes, keeping this large area from becoming too flat and two-dimensional. Chadbourn wanted the background to be dark, but not so dark that the viewer couldn't see into it. His use of ultramarine blue, ochre, violet, and alizarin crimson was all more or less tied together with sweeping strokes of the darkest dark—in this case, a mixture of Thalo green and alizarin crimson. He repeated this mixture on the front of the table and let a little pure alizarin violet show through the circular designs. As you can see, he worked quite wet in this area, with plenty of turpentine. Drips inevitably developed and he purposely left them in, as they seemed compatible with the general spirit of the painting. Note that, in contrast, most of the rich textures occur on the light-struck areas of the cheese.

This painting suggests one way of painting darks with a fresh eye. When students have difficulty seeing color in the darks of their still lifes, Chadbourn invariably pulls out some reproductions of works by Cézanne, Braque, and Chardin to show how each of these artists created luminous darks and how each, in his own way, orchestrated these darks into the overall design of the painting.

CHEESE AND GRAND MARNIER
Oil on canvas, 30 x 60" (76 x 152 cm), collection of Mr. William Ballard.

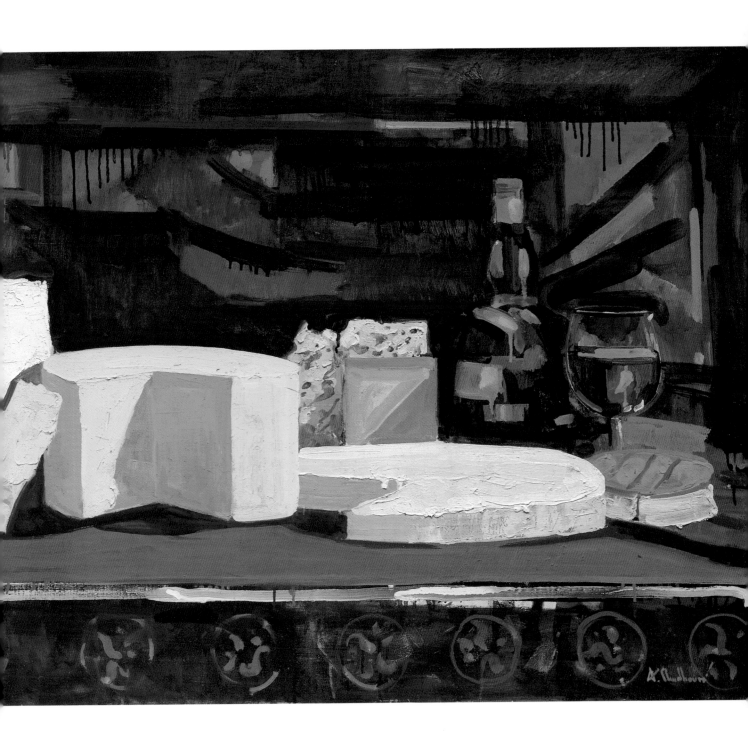

Alfred C. Chadbourn
Relating Objects with Pattern

While visiting his friend, the artist John Muench, in Maine several years ago, Chip Chadbourn did a series of sketches of the marvelous cast-iron stove that dominated his kitchen. These sketches eventually became the basis for several paintings, with the stove as the paramount attraction. In the painting shown here, Chadbourn also referred to some sketches of a baked red snapper served on a Victorian platter and incorporated this image into the composition. In addition, he found a wallpaper design that he thought would enhance the distinctive Victorian aura of the picture.

The related shapes of the stove, fish, platter, and wallpaper pattern formed the basis of the composition. Chadbourn started by laying in the dark forms of the stove with thin washes of turpentine, keeping details to a minimum. Next, he pasted on several cutout pieces of wallpaper with Hyplar acrylic medium. He then painted a thin film of Hyplar over the paper, making it possible to go back over this area with oils.

As the painting developed, Chadbourn started building up thicker pigment in the platter, fish, and background, trying to keep a free interpretation of the objects through an emphasis on pattern and color. No attempt was made to use perspective; instead, he wanted an overall flat design, which

he augmented with the vertical shafts of light and dark over the stove and platter. Some of the actual pattern of the wallpaper was painted to fool the eye—*trompe l'oeil*—so the identity of some objects is diffused.

It was important to tie the background pattern in with some of the other elements. That's why the stove, platter, and fish have various design patterns running through them. Notice how in some places Chadbourn incorporated the wallpaper design into the structure of the fish. Had he painted a realistic fish on top of the platter, it would have destroyed the decorative feeling.

Introducing some of the swirling patterns on the platter into the stove helped to relate these two elements. Another way he tied the stove into the rest of the picture was by adding some deep grays into the darks so it would gain a certain feeling of depth, yet still read as an overall dark shape. If Chadbourn had painted the stove a flat black, it would have looked too much like a cutout.

Because of all the visual activity with the patterns in this painting, Chadbourn felt the need for a restful, flat area. This is what prompted him to add the large white area on the left of the composition. The white is then repeated in the wallpaper design and the platter.

In these two details you can see the interplay between the painted pattern and the wallpaper design.

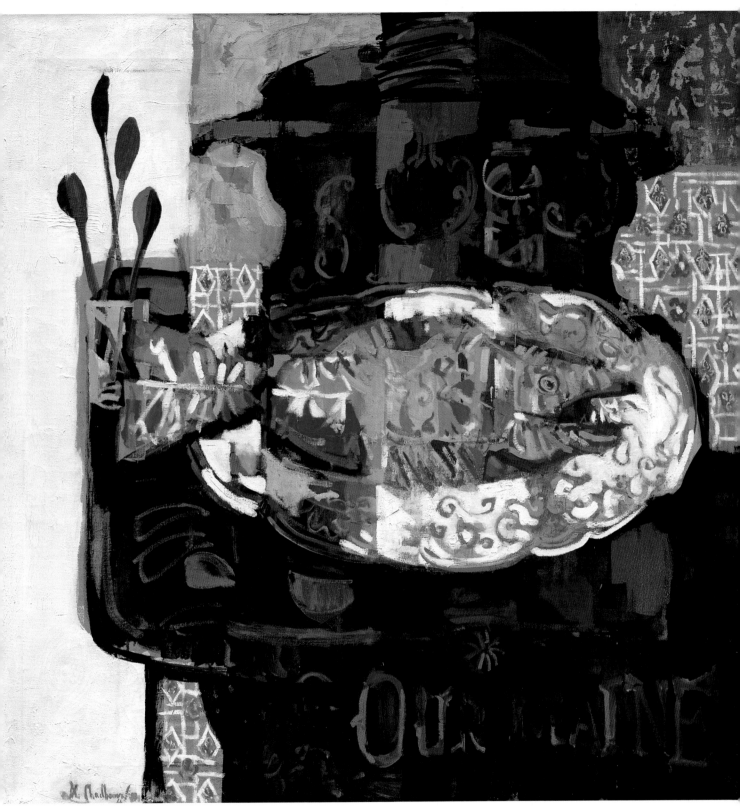

RED SNAPPER ON STOVE
Oil on canvas, 40 x 40" (102 x 102 cm), collection of Mr. John Muench.

David Leffel and Linda Cateura

Working Out Shapes, Color, and Design

Getting Good Shapes

Keep the shapes of your objects. Hold on to them. If they're part of the background, don't let them disappear into it. All shapes should be distinct to give your picture a sense of design and structure.

Everything has a shape. Each shape must retain its integrity throughout the painting.

Arrange your shapes with some geometry—all the darks and lights necessary for painting into that shape, the shape of the light, the shape of the dark, and so on.

When you are painting a series of objects, put in your center of interest first! This is very important. Size and place your center of interest first, then work back from there.

Handling Color

We impute color to things according to our conditioning. As children we learn grass is green, plums are purple. We should test our eyes and minds more and learn to see things as they actually are.

You can either put color in one place or deemphasize color in another place. Remember, it's color against colorlessness.

For local color, which is the color of the object itself, use the richest colors you can find. Generally, think in terms of more, brighter color for your areas in the light.

Try to decide on the colors of your painting before you make your first brushstroke.

If your background is too warm, try a touch of Naples yellow to give it an opaque, airy look or to make it go back so that the objects come forward.

Working It Out

On any warm surface, such as the warm wood of a table, you get some cooler light. Cool light on warm wood—it's how you see it. Separate what you see into how you can paint. And go with that.

The best way to paint objects is by section or entity, rather than by outlining the entire piece. With a bottle, for example, shape the bottom part as one entity, the neck as another, and so on. Paint the component parts to form a whole instead of drawing a line around the whole bottle.

When an object, say a jar, has a design, the design wraps around it and conveys form. Consequently, you don't have to paint too much form into it.

Whatever you did the first day, do it better the second day. If the grapes you did the first day are not dark enough, you can make them darker the second

day. The paint is too wet to do this on the first day.

You're not a mechanical camera: Select from the myriad facts about the objects and shapes out there the ones that fit your particular context.

In a still life, the ground plane is the most important plane. Establish it as soon as you can. Then work up from there.

Make the shadows on your objects more distinct. See how a shadow gives any object dimension. Without a shadow, nothing is going to look solid.

The orange is a solid object; put a line of shadow underneath it.

BITTERSWEET WITH
PERSIAN VASE
*Oil, 28 x 23" (71 x 58.4 cm),
private collection.*

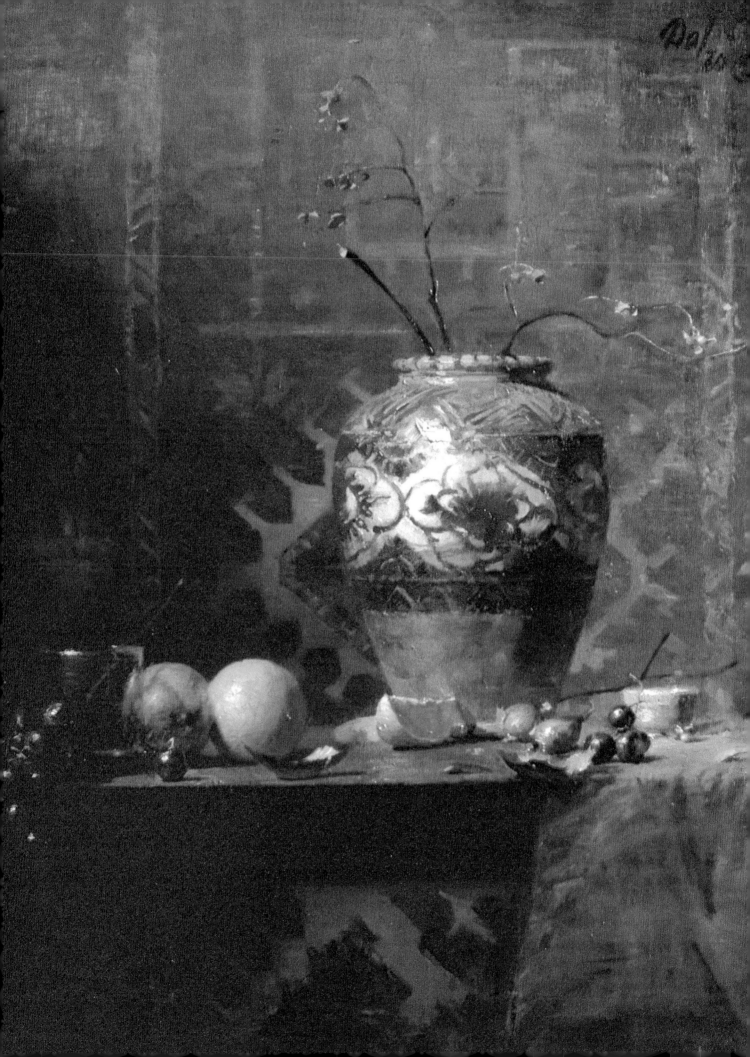

Gregg Kreutz

Establishing Variety in Shapes and Values

In many ways, a painting is a synthesis of opposites: light and shadow, warm and cool, sharp and soft, coarse and fine. These polarities, when integrated into the picture, create vibrancy and dynamism. If everything in the painting is warm, the picture will have a hothouse look. If everything is coarsely painted, the eye is given nothing to settle on. Putting in the opposite of each of its qualities will open the picture up and expand its range.

Shapes need this polarity as well. Having all the shapes the same size robs a picture of scale; the viewer can't tell how big or small anything is. Also, having all the shapes of a similar type can look monotonous.

In a similar vein, values need variation, too. Beautiful things can be done with middle tone; it can be a nice stage upon which to play out a subtle, carefully nuanced effect. But for vivid drama and excitement, a strong contrast is needed between the lights and the darks. Contrast—one element pitted against another—is what gives a picture its tension. For that contrast to be effective, the two end values, dark and light, must be made distinct from each other.

It is important to always be aware of the option of increasing the value range. When a dark or light is firmly stated, it's easy to be fooled into thinking that that's it. But as someone once said, "You don't know what's enough until you've done too much." If it looks bright, see if it could be brighter. A picture gets exciting when it looks as though it's been pushed to the limit, as though everything is as dark or as bright or as colorful or as mysterious as possible.

JOEY'S DESK
Oil, 24 x 32" (61 x 81.2 cm), collection of S. J. Lenerz.

Gregg Kreutz wanted to counter all the little delicate things on the desktop with larger surrounding shapes, so he draped the window curtain over the chair and moved a potted plant over to fill in the left-hand corner.

THE KITCHEN
Oil, 20 x 16" (50.8 x 40.6 cm),
private collection.

Here's a wide value range. The rug on the floor is almost black, and the highlight on the stove is almost white. Gregg Kreutz painted this picture sitting in a corner of his kitchen. He started at the cereal bowl and worked back into the distance. With so complicated a subject, this seemed the best way to keep all that material under control.

David Leffel and Linda Cateura

Understanding the Importance of Edges

Edges help the painter convey the illusion of three-dimensional form on a flat canvas.

All objects in your painting have inside edges and outside edges. The inside edge of an object is where the plane or form changes direction. The outside edge is where a form begins and/or ends; it faces the source of light.

If you're dealing with the human form, the outside edge can be part of the same surface anatomy. For example, a vein that is raised from the surface of the arm has an outside edge where it hits a new plane on the arm, and an inside edge on the vein itself where the light and shadow come together.

There are two other kinds of edges—hard and soft. A hard edge is clear and distinct; a soft edge is fuzzy.

An important lesson to learn in trying to portray a three-dimensional form is that the eye will automatically focus on the cleanest, sharpest thing it sees. In addition, when the eye focuses on a hard, thin edge, it tells the viewer that the object it sees is not round or dimensional, but that it is very thin, because only very thin things—like leaves or a sheet of writing paper— have such sharp edges.

When a painter paints a hard edge where an object meets a background, that edge will be a strong place of focus. It follows, then, that if the focal point is away from the edge, that is, inside the material, the mind's eye is not conscious of edges, and the illusion conveyed is that of form or mass. Therefore, you have to get rid of the edge as a place of focus and give the eye a new focal point off the edge. How do you accomplish this? You can eliminate the outside edge by dragging two wet layers of paint (the light and the shadow) together, blending their edges.

The far edge of an object also can be removed as a place of focus by lightening the background where the edge and background meet.

Edges on the lighted side do not start darker. When light hits a surface, it is as lit up at the edges as it is inside.

Edges are wonderful. You can paint a flat plane, then, just by varying your edges, you can achieve a dimensional quality.

A soft edge shows continuity. The softer the edge, the duller the look. A hard edge shows ending. The harder the edge, the more riveting your painting is in that area.

CARNATIONS IN PEWTER
Oil, 14 x 12" (35.5 x 30.5 cm), private collection.

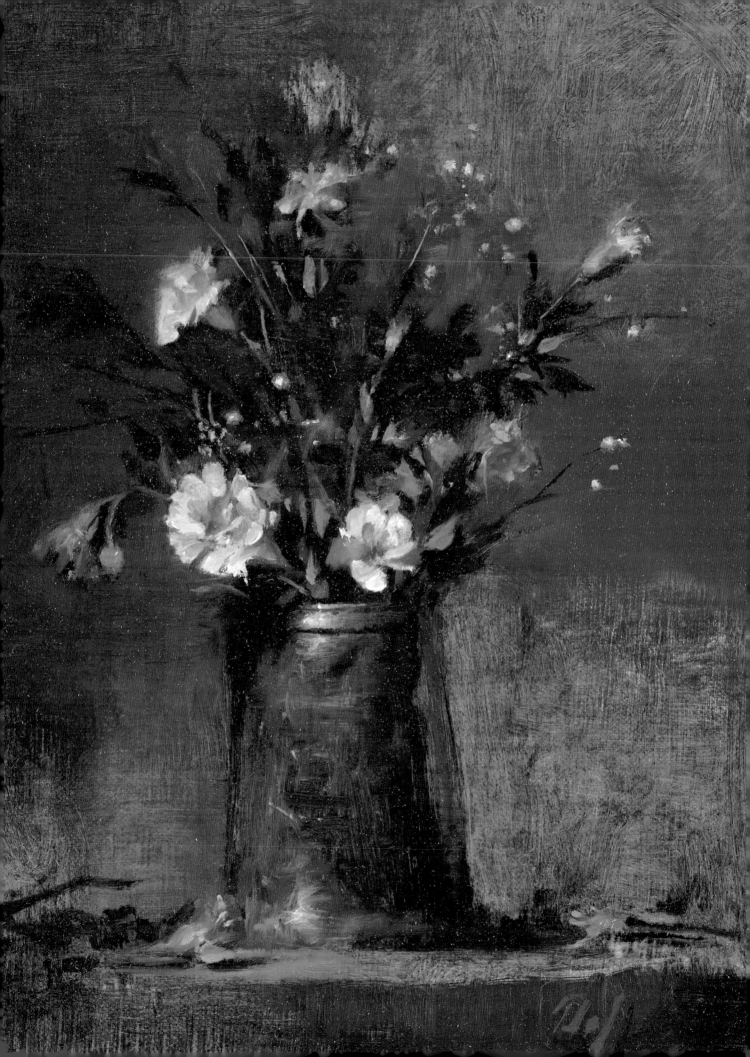

Gregg Kreutz
Using Edges Effectively

In the painting *Left-Bank Corner* (below), edge quality was used to create more depth. The edges harden as they get nearer to the viewer. The building across the street in the distance was rendered with soft edges and low-value contrast, which suggest distance.

Another thing edges tell us is what sort of substance is being depicted. *Still Life with Silver and Apples* (opposite page, top) is a good example of using edges to convey the quality of a material. Silver, being very reflective, appears as almost a composite of its environment. Surround it with a red cloth and it will look red, blue cloth and it will look blue. In this setup, so much of the background shadow color, a deep greenish brown, reflected into the silver cup that the cup's edges disappeared. The highlight on the lip and the apple reflections are the only evidence of the cup's whereabouts.

In *The Blue and White Pot* (opposite, below), the beginning edge of the orange (where the light first hits the crown) is bright and crisp. Where the light is turning into shadow, however, the transition is more gradual and softer. The new form (the tabletop) comes out of the cast shadow with a sharp edge. Soft, turning shadows and hard cast shadows are an effective way to describe form.

LEFT-BANK CORNER
10 x 15" (25.4 x 38.1 cm), courtesy Fanny Garver Gallery.

STILL LIFE WITH
SILVER AND APPLES
*Oil, 18 x 24" (45.7 x 61 cm),
private collection.*

THE BLUE AND WHITE POT
*16 x 20" (40.6 x 50.8 cm),
private collection.*

Charles Reid
Making Edge Tie-Ins

Most of us have no trouble making areas look isolated or separate. It's much harder to tie objects in with their surroundings.

Tie-ins can be achieved in several ways. You can create areas of similar value, for example, by putting a light object on a light surface, or a dark object on a dark surface. Or you can put objects of the same color in your setup. You can also tie objects together through light and shade. A light object, for instance, will merge with a dark table on its shadow side.

Another way to create tie-ins is by softening edges to join two areas or through other color and value modifications. (When you soften an edge you are actually mixing the values and colors of two adjacent areas, giving them a common color-value border.)

You should find at least one tie-in within each of the examples shown here. Notice that separations of color or value are also found on edges within the object itself as well as at its outer edges.

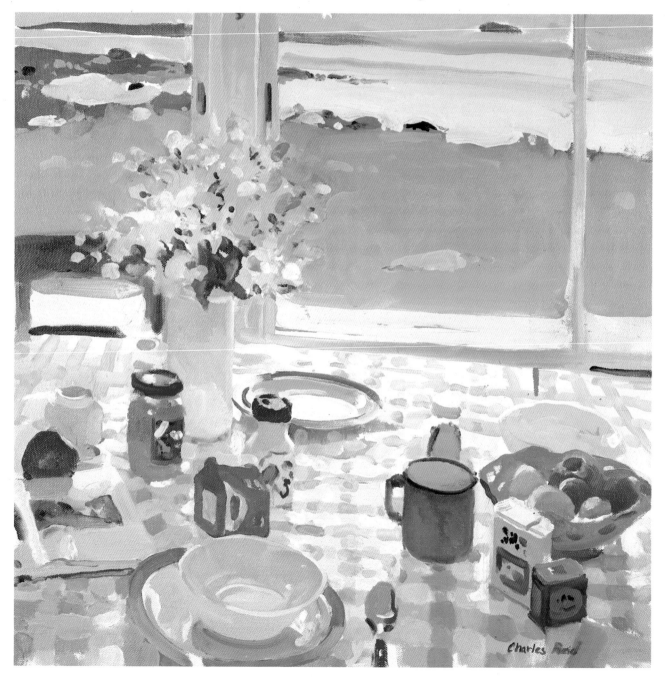

BLUE CUP AND FIELD FLOWERS
Oil on canvas, 26 x 26" (66 x 66 cm), private collection.

Many of the objects in this painting are related by similarities in their local colors. For example, the flowers, vase, and doorframe—and the bowl, plates, and distant water, too—are various shades of white.

To gain experience in handling edge tie-ins, try the following exercise. Set up a still life that contains objects with a variety of local colors and values. Make sure one or two are similar in color and value to the table and to the background. Overlap some objects, and leave one or two of them separate. When you paint them, try to tie in almost all the objects either with an adjacent object or with an area of the table or background. It doesn't matter if one or two objects don't relate in value, but make certain their color is picked up somewhere else in the painting. Try to tie in adjacent areas through at least one of the following:

1. Same local color

2. Same local value

3. Value connecting through light and shade

4. Modifications in value (for example, through soft edges)

5. Modifications in color (for example, through color temperature)

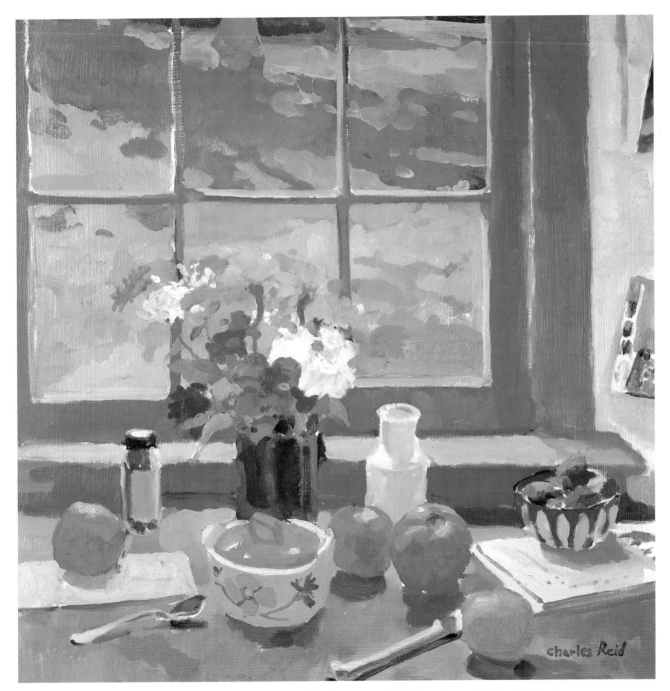

STUDIO YARD WITH ORANGES
Oil on Masonite, 26 x 26" (66 x 66 cm), private collection.

Foreground and background are linked here through light and shade. For example, the values of the white bowl in shadow and the darker table out in the light are almost the same.

Albert Handell
Translating Values into Opaque Color

In opaque oil painting, instead of mixing the colors in layers on the support, the various blends are premixed on the palette and then applied to the canvas (or panel) with brush or palette knife. Because the color is opaque and thus completely conceals what is beneath it, you don't have to worry about harmonizing it with the color below. However, every new color or color mixture applied to the canvas must work with the colors already on the canvas.

To begin a painting with the opaque oil technique, Albert Handell first lays in the entire composition with diluted and thus somewhat transparent color—that is, color mixed with a lot of medium (here, turpentine). Working thinly in the beginning, and from dark to light, he first establishes the composition and values. As he places the various objects on the canvas, he tries to get the right value of each color and notes the various relationships among them. When he has established the basic composition and values to his satisfaction, he works over this transparent color lay-in with opaque paint until the painting is completed. He makes the paint thicker by using less (or no) turpentine, or by switching to a thicker medium, such as Maroger. Because of this thick paint, opaque oil paintings have a very characteristic "meaty" texture.

After establishing the dark shadow areas first, Handell then goes after the obvious colors, such as a red shirt, green scarf, or white contrasting patterns. Because the paint is thick, the light areas stand out more. This is an advantage. The thicker the paint, especially where the subject is in the light, the greater the sense of light, energy, texture, and mass that can be achieved.

Using Opaque Color and a Limited Palette
Opaque color allows you to paint solid-looking masses with great varieties of texture. For example, in the painting for this demonstration, the opaque technique is the one best suited for expressing the strong light and shadow masses and the many varied textures of the baskets, crates, fruits, and vegetables.

Opaque color also allows you greater control of your color mixtures by increasing the range of tones of the same value you can mix. You control the variations of color here through careful attention to their proportions in mixtures with each other and with white.

The limited palette allows you to develop a thorough understanding of each color you use, both alone and in color mixtures, and in harmony with other colors. You'll be surprised at how much can be done with only a few colors, getting the most out of the least. As Degas once said, "One object of painting is to make burnt sienna look like vermilion." A limited palette forces you to explore the full range of mixtures possible and automatically harmonizes the colors in your painting. When a painting is done well, few people will realize just how limited the palette actually was.

Limited palettes are best for simple, direct statements, where you want to zero in on a particular aspect or section of the subject matter and build the entire painting around this.

In *The Marketplace*, Albert Handell chose a section of a fruit and vegetable stand and emphasized the baskets and crates there. He decided to play down the vegetables and fruits, because he would need a full palette to capture their diverse colors. Having limited himself to baskets and crates only, he could now express these elements directly and beautifully with the limited palette he planned to use.

To choose colors for a limited palette, first squint at your subject to lose the details. Determine the prevailing color of the subject and select the color you own that is closest to what you see.

Planning the Composition and Arranging Values
Albert Handell decided to look at his subject as an outdoor still life. He also decided to select only a section of the entire scene and focus on this as a single shape. Upon analyzing his subject, he realized that this shape was quite horizontal. He therefore chose a long, rectangular panel measuring 16 x 28" (34 x 70 cm) and developed the composition as one long, rectangular shape made up of varying geometric shapes of squares, rectangles, circles, and spheres. These would form a symphony, the square and rectangular boxes contrasting with the circles and spheres of the baskets.

Handell wanted the values to reflect his decision to make this painting a simple, uncomplicated outdoor still life. Therefore he chose a scene in bright sunlight, where the strong light and shadow patterns in the painting divided it into two parts: the light values of the baskets and white cloth and the dark values of the shadows and background. The dark background, which represents the windows of the store behind the stand, creates an effect of quiet simplicity. Normally, many objects of the outside world would be reflected in these background windows. But painting all that would create too many different values there, which would distract from the brightly lit shapes of the foreground. Instead, Handell simplified the background so that it would act as a foil for the busy shapes in the foreground. He reduced it to only one value and blocked it in as a single dark shape.

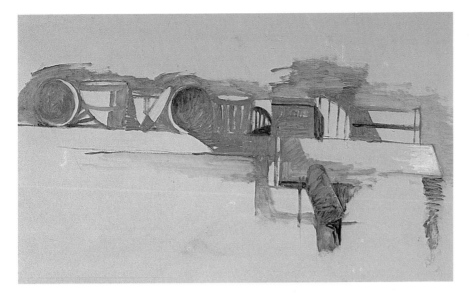

Step 1. With a #4 round bristle brush, Albert Handell thins out raw sienna with turpentine, draws in the objects, and lays out the composition. Once the outlines of the baskets and tabletop are established, still using the same brush, he mixes raw sienna with raw umber and lays in the warm, tannish shapes of light and shadow of the entire painting. He keeps the painting transparent at this stage, building up to the time he can paint opaquely.

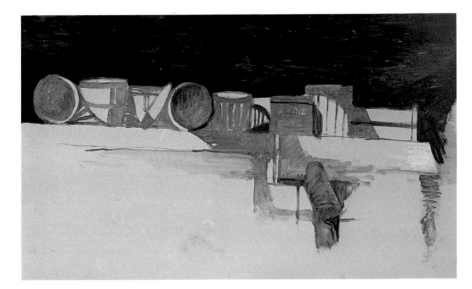

Step 2. Now, picking up a #7 flat bristle brush, Handell brushes in the entire background rather freely with Maroger medium mixed into ivory black (a warm black) and a bit of ultramarine blue to help balance the warmth of this painting. (The raw sienna and raw umber base is quite warm.) As he lays in the dark tone of the background, delineating the baskets, it causes a shift in the shapes of the painting. The contrast of simply working in the dark background intensifies everything that had been established on the painting surface already.

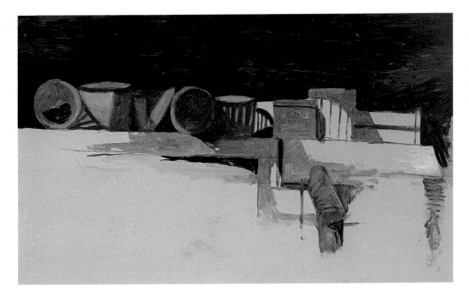

Step 3. Working more opaquely, using #2 and #4 round bristle brushes for smaller areas of the painting, Handell establishes more precise detail. With a #5 long flat brush he darkens the shadows of the baskets with raw umber mixed with Naples yellow. A sense of texture develops quickly.

Step 4. As Handell continues the buildup of opaque paint, he also establishes the rest of the shelf. Because of the opaque quality of the paint, the boxes and baskets take on a sense of weight. Notes of red are introduced now, as he begins to establish the color of the fruits and vegetables.

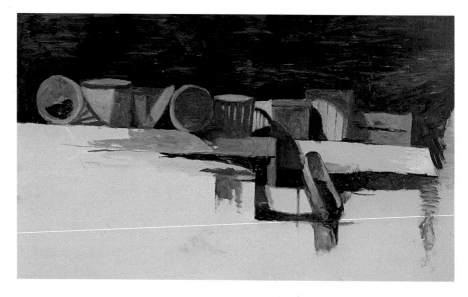

Step 5. With a bit of Maroger medium mixed into his paints, Handell works on the green broccoli at the right-hand side of the painting. He reworks the baskets to the left and begins to work in the white cloth on the shelf.

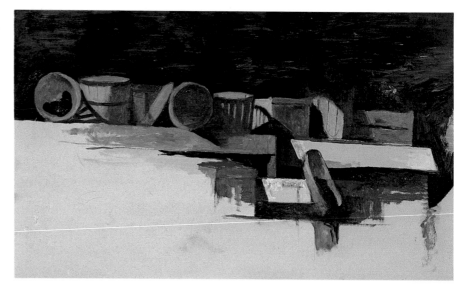

Step 6. The opaque paint buildup continues, as Handell slowly adds detail, makes corrections, puts in cast shadows, and defines and subtly develops the painting. He decides to lower the dark background on the right to improve the overall pattern.

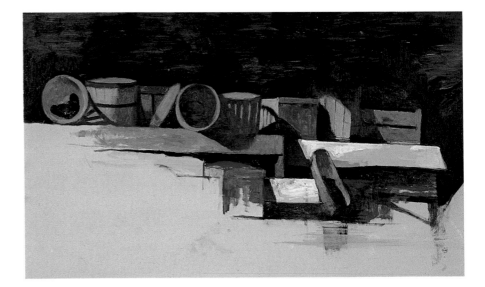

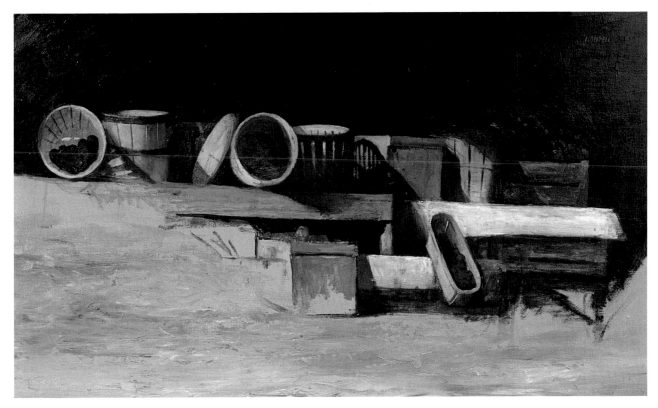

THE MARKETPLACE
Oil, 16 x 28" (42 x 71 cm), private collection.

Now that all the areas of the painting have been designed and laid out to his satisfaction, Handell concentrates entirely on textures and selected details. He builds up the textures of the broccoli on the right and the string beans in the center. With the back of a brush, he scratches into the opaque buildup of the baskets, following the rhythms and pulling out details. With a palette knife, he builds additional textural variety into the grayish foreground of the countertop covering. The horizontal strokes of this very opaque area create a simple yet striking contrast to the flat, dark background. The final touches, a careful accenting of the textures of the baskets, are done with a palette knife.

M. Stephen Doherty
Using Objects as Symbols

In planning this painting, M. Stephen Doherty's idea was to record his feelings about life and death using objects, lighting, and compositional relationships symbolically in a still life.

Doherty arranged a bunch of freesias in a brass vase placed on a satin napkin. He folded the napkin to mimic the flowers' triangular shape. A knife plunged into an apple adds a sense of uneasiness.

Step 1. Working on paper sealed with acrylic gesso, Doherty blocked in the basic shapes with thin washes of paint, using turpentine as the solvent, and left the white of the paper to define the large shape behind the floral arrangement. He recognized weaknesses in the composition, but felt confident enough in the basic arrangement to focus on the flowers. He recorded as much information as possible about their shape and color before they began to change and new ones opened up.

Step 2. Doherty used fairly thick mixtures of Liquin and oil colors so he could create the image of the blossoms as accurately and quickly as possible. He also had to give some definition to the strong cast shadow, because its shape was defined by the flowers themselves and because the contrast between the shadow and the blossoms defined the edges of the light-colored flowers. He also needed to establish the balance of light, middle, and dark values in the relationships between the flowers, the shadow, and the dark green leaves.

Step 3. As he finished blocking in the flowers, Doherty began to consider the plywood background and dabbed on different mixtures of cadmium yellow, yellow ochre, burnt sienna, and titanium white until he came up with the appropriate hue and value. He also added glazes of white over the pattern of shadows on the napkin to achieve a soft, subtle transition of tones that would make the fabric look like satin.

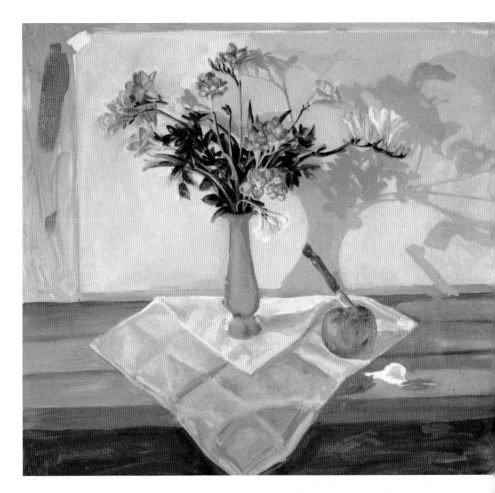

Step 4. Doherty began to use smaller brushes to record the specific appearance of objects. The apple and knife, for instance, were painted over the course of several days, allowing time for each successive layer of paint to dry.

Going back to mental notations he had made earlier about a certain lack of interest in the left side of the picture and the incompleteness of the ideas being presented, Doherty decided to slip a black-and-white photograph under the napkin. As visual records of special moments and people, photographs help us recall both incidents and feelings. Including this memento of a formal event in the still life, he felt, would underscore the idea that objects can become statements about the past and the present—of life and death. Note that Doherty blocked in the shape of the photograph with titanium white, making sure that it fit into the existing composition.

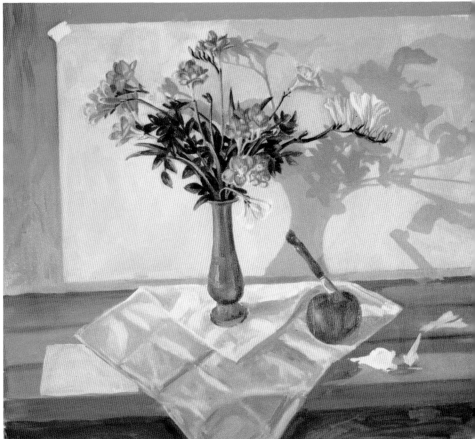

Doherty finds himself attracted to the order and balance of symmetrical compositions, though he recognizes that artists must guard against monotony when working with such arrangements in a painting. In this case, however, he felt he could use a symmetrical arrangement of central objects and play them off against a background and lighting situation that were asymmetrical. In so doing, he achieved the opposing feelings of balance and imbalance, harmony and discord, order and chaos.

Step 5. In the finished painting, you can see the detailing added to the brass vase, the texture imposed on the sheet of paper taped to the plywood, and the figures painted loosely into the shape of the photograph. The branch of freesia lying on the bench, and the bench itself, were also given further definition. Note, too, that Doherty decided not to have the satin napkin drape down below the edge of the painting; rather, he wanted the white shape in the background to be the only object to suggest the space beyond the picture plane.

STILL LIFE WITH APPLE AND KNIFE
Oil on paper, 22 x 23" (55.9 x 59.1 cm), 1986, collection of the artist.

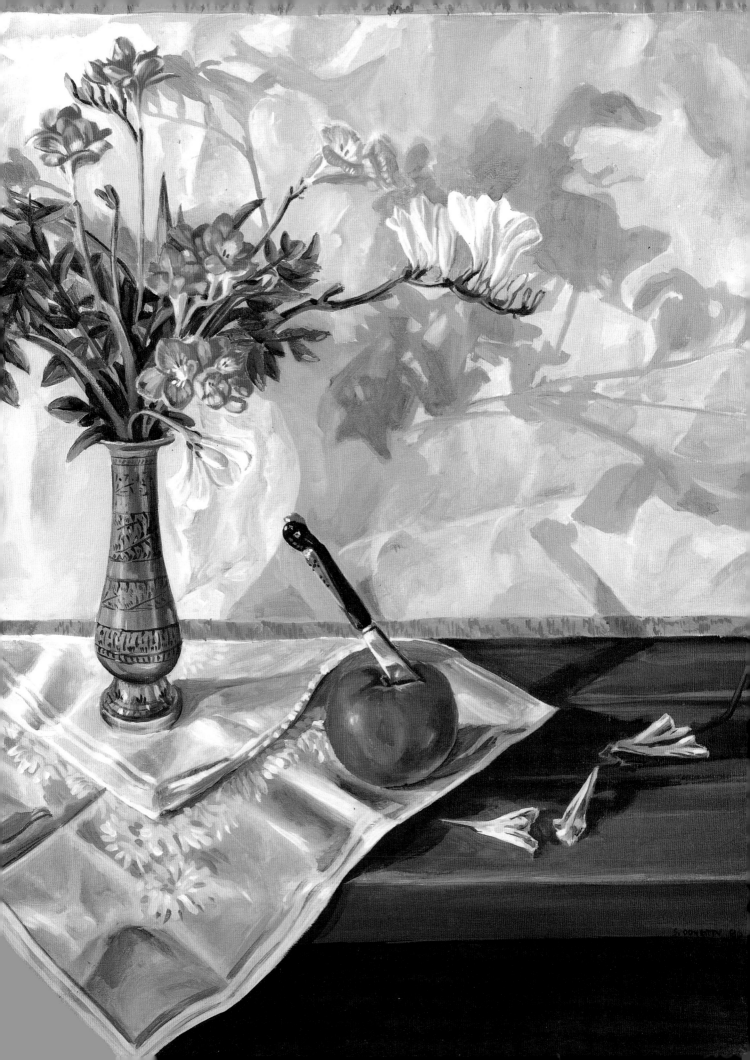

Charles Le Clair
Painting on a Tonal Ground

The traditional foundation for oil paintings is a tonal ground prepared with a subdued earth color. The idea here is to visualize an image dimly at first, as if in shadow, and then gradually pull bright colors into the light. The warmth and richness of ochres, siennas, and other earth pigments make them ideal for this purpose.

Charles Le Clair almost always begins an oil or acrylic painting with a ground tone—in part to establish an immediate sense of space, and also for the practical reason that, no matter how solid your brushstrokes, there are always nooks and crannies where the canvas shows through. If these spots are left white, the continuity of the paint "skin" is interrupted as if by facial blemishes, and touch-ups are awkward. A ground color, spread evenly over the canvas before you start, entirely avoids the problem.

Choosing the right color for this underlayer depends on your subject. For *Picnic on the Roof*, Le Clair used a fairly light mixture of yellow ochre and Venetian red to suggest a sun-bleached Moroccan locale. Although mixing still life with landscape seen through a window is fairly common, this picture is unusual in combining the two genres in a single, unified outdoor setting. Accordingly, the shapes of the distant city of Rabat, reconstructed from snapshots, and those of a still life observed in the studio, had to be brought together by a carefully planned design of interlocking planes and alternating warm and cool colors.

Developing a painting this way is a lot like developing a photograph from the first faint image that appears in the darkroom to the point where it is strong enough to be called "finished." Visualize here—particularly in the distant architecture—how the facets of the composition have been built up with colors that relate to, yet modify, the underlying ground tone. Some planes have been darkened, some lightened; some have been given a

PICNIC ON THE ROOF
Oil on canvas, 42 x 56" (106.7 x 142.2 cm), 1987, collection of Mr. and Mrs. John V. Quinlan, Bingham, Mass.; courtesy Left Bank Gallery, Wellfleet, Mass.

warm orange or yellow cast, others a cool blue or violet tint. In the process, the overpainting has been kept thin enough to let the ground tone show through and bind these separate colors into a harmonious chord.

To dramatize the space, Le Clair has emphasized the transition from thinly brushed background to solidly painted foreground by placing a wall between the two zones. This large,

abstract rectangle is an area of unmodified background color. It is brought forward, however, and given physical presence by a roughly scrubbed texture against which the leaves of a tropical plant can cast convincing shadows.

The ground color used for *Chinoiserie* has a quite different function. In this study of still life in an antique-shop window, a burnt

sienna ground is keyed not to the colors of the objects themselves but to the dark shadows that surround them.

Chinoiserie is one of a group of paintings of window displays Le Clair did a few years ago, when he became interested in "found arrangements" and the idea of tackling subjects he hadn't dealt with before. The unusual shapes and textures of curios like the Chinese vases, peacock feathers, and Oriental wallpaper shown here were exciting to paint.

The special challenge was to create order out of visual clutter. A dynamic perspective helps in *Chinoiserie*, but Le Clair's main organizing device is a veil of brown shadow that tones down much of the middle ground and background. Meanwhile, the space is energized by opposing light sources—cool daylight on the left and a dim interior bulb on the right. As in *Picnic on the Roof*, Le Clair has marked this contrast with a dividing point—this time the sharp edge of a Chinese vase with one side in bright light, the other in shade.

Look closely, and you will see that several passages had to be painted "normally" and then "transposed" to a darker or lighter key. The central vase, for instance, has a design of cerulean, cobalt, yellow, and amber on one face that is matched by shadow equivalents on the other side. And a vertical strip of window-glass reflections is painted from top to bottom with about twenty different mixtures that are cooler, paler versions of the colors of objects in the shop.

CHINOISERIE
Oil on canvas, 64 x 44"
(162.6 x 111.8 cm),
1984, courtesy More
Gallery, Philadelphia.

Charles Le Clair
Generating Dynamic Excitement

Everything about Charles Le Clair's painting *Amaryllis and Navajo Rug* is charged with energy. Because of the vantage point he has chosen, the eye enters the composition from high above, then sweeps down to the pot and ground, only to move up again following the surge of the flower and leaves. The strong geometric shapes that make up the rug and the way these shapes are painted reinforce the dynamic lines that run through the painting. To see how forceful this composition is, try turning the painting on its side so that what is now the right side becomes the bottom. You'll immediately notice how the strong diagonal composition is balanced by counterthrusts.

As you look at this painting more closely, you'll notice that in a sort of visual tour de force, the slab of dull plastic set beneath the rug and the flower pot reflects objects that aren't really present. The reflection of the peach is believable enough, but the swordlike leaves reflected in the plastic don't correspond at all with the actual plant. They do, however, accentuate the explosive energy that runs through the painting.

Detail, top. Le Clair lays his color on the canvas with such strong, expressive strokes that you can almost feel the paint being put down. Note how the edges of the brushstrokes are quite obvious and how the direction of the strokes helps emphasize the lines of the composition. This loose, gestural brushwork helps build the painting's drama.

Detail, bottom. Although earth tones dominate, there's a lot of rich color when you look more closely. Here the bluish grapes are tinged with touches of warm orange; it is the push and pull of warm and cool that gives three-dimensional form to the fruit, more than traditional modeling with lights and darks.

AMARYLLIS AND
NAVAJO RUG
*Oil on canvas, 48 x 36"
(122 x 91.4 cm), 1985,
courtesy More Gallery,
Philadelphia.*

Charles Le Clair
Articulating Shallow Space

Charles Le Clair's painting *Hearts and Flowers* is elaborately packed with flowers, signs, baskets, pedestals, curtains, hearts, and ribbons. Relatively light forms stand against a dark, mysterious backdrop, and Le Clair pushes everything very close to the picture plane and experiments with shifting layers. Color, too, activates the shallow pictorial space, keeping the eye moving about, looking first at one object, then at the next.

It is precisely because it is so densely packed with shapes and colors that the structure of Le Clair's painting seems, at first, difficult to grasp. Examine it carefully, though, and you will find that it has an underlying order. The architectural elements that frame the scene make it clear that you are looking at a window. This sets up a kind of visual tour de force: Since a painting is, in a sense, a window on the world, it is as if Le Clair were painting a picture of a painting.

Behind the pillar lies the glass of the window. Behind it hang the circles and the hearts, and behind them stand the bouquets on their pedestals. The lavender curtains seem just inches behind the pedestals. At some indeterminate distance, though certainly not very far back, is the lattice screen, and near the top you see reflections from outside.

All these levels create a sense of thin planes, moving back in space; the reflections then bring the eye forward to the picture plane. But there is also another way of seeing the order in this painting. Squint your eyes and try to see the painting abstractly as a combination of colors and shapes. Look at the interplay between horizontals and verticals, circles and rectangles, lights and darks, warm and cool colors. What makes Le Clair's painting so fascinating is the way the eye shifts back and forth from one level or relationship to another so there is a feeling of lively movement within the shallow picture space.

HEARTS AND FLOWERS
Oil on canvas, 58 x 38" (147.3 x 96.5 cm),
1985, courtesy More Gallery, Philadelphia.

INDEX